FIRECRACKERS

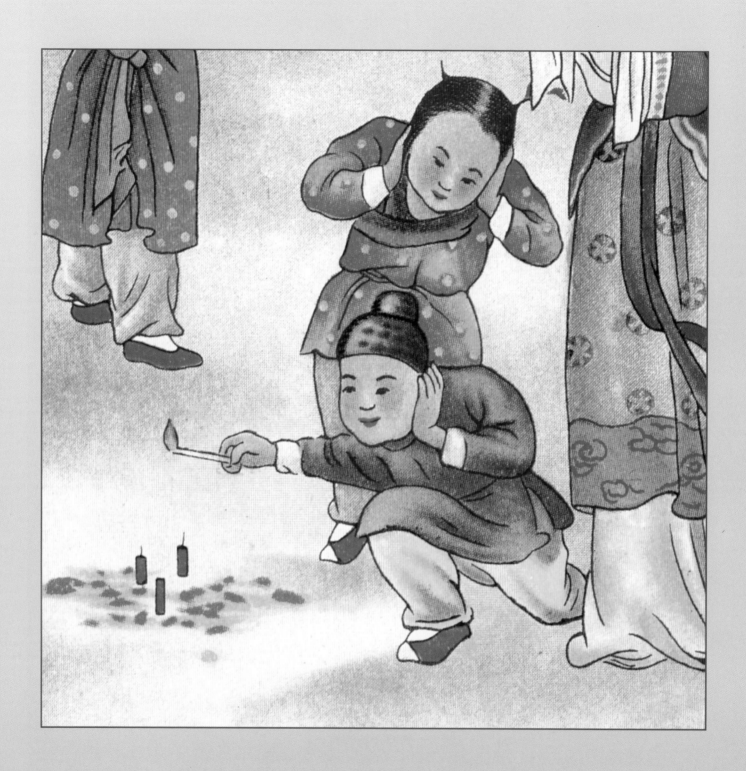

FIRECRACKERS

**Warren Dotz,
Jack Mingo, and George Moyer**

~The Art & History~

Ten Speed Press
Berkeley Toronto

Ten Speed Press
PO Box 7123
Berkeley, California 94707
www.tenspeed.com

Distributed in Australia by Simon and Schuster Australia, in Canada
by Ten Speed Press Canada, in New Zealand by Southern Publish-
ers Group, in South Africa by Real Books, in Southeast Asia by
Berkeley Books, and in the United Kingdom and Europe by Airlift
Book Company.

Text Design by Nancy Austin and Warren Dotz
Front cover: Double Dragon, Old Yuen Kee, Made in China, Class 1
Back cover: Noi-Zee Boy, Kwong Man Lung Firecracker Factory,
 Made in Macau, Class 3
 Rocket, Nam Yang Firecracker Factory, Made in Macau, Class 3
 Cowboy, Made for Lidell Fireworks Company, Made in Macau,
 Class 5
Front flap: Pelican [detail], Made for Wilfong Fireworks,
 Made in China, Class 1
Back flap: Roger (No Cha) [detail], Kwong Hing Tai Firecracker
 Manufacturing Company, Made in Macau, Class 2

Library of Congress Cataloging-in-Publication Data

Dotz, Warren.
Firecrackers : the art and history / Warren Dotz, Jack Mingo, and
 George Moyer.
 p. cm.
 Includes index.
 ISBN 1-58008-151-7 (pbk.)
1. Firecrackers. I. Mingo, Jack, 1952– II. Moyer, George, 1948–
III. Title.
 TP300 .D68 2000
 662'.1—dc21 99-089043

First printing, 2000
Printed in Hong Kong

2 3 4 5 6 7 8 9 10 — 03 02 01 00

CONTENTS

Chinese Child Lighting a Firecracker by Esther Hunt, San Francisco, Chinatown, 1910: Best remembered for her colorful watercolors, oil paintings, and statuettes of Chinese children, Hunt spent much time sketching in San Francisco's Chinatown.

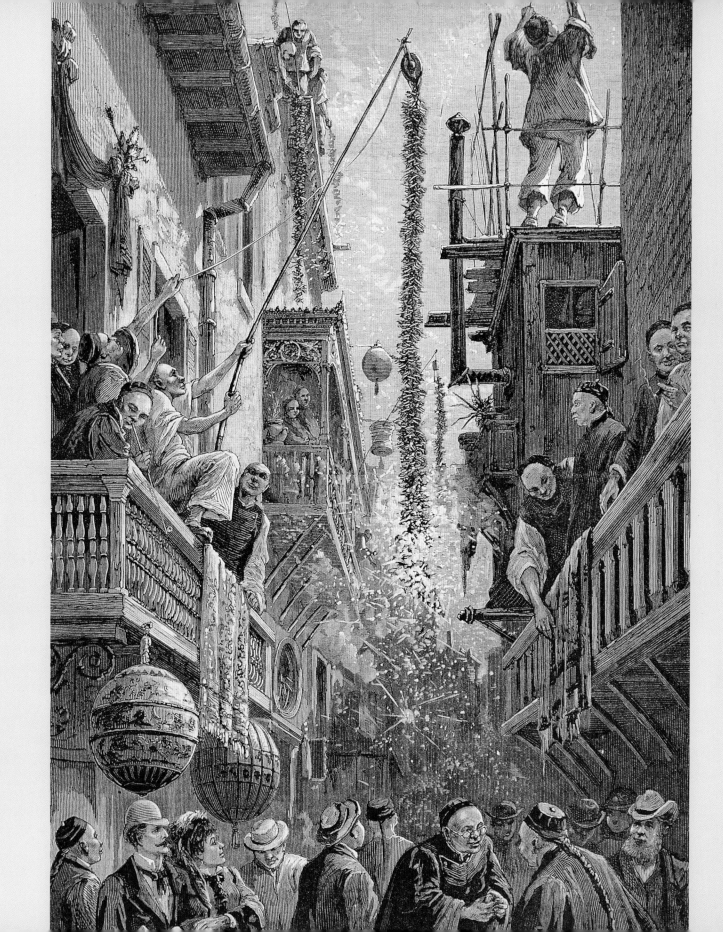

INTRODUCTION

FIRECRACKERS! The word alone conjures up rich, visceral images: sudden ear-splitting pop-pop-pop-popping, sparks flashing, acrid smoke drifting, kids running and laughing, hearts wildly beating. Who hasn't jumped out of his or her skin when a firecracker has unexpectedly (or sometimes even expectedly) gone off?

The allure of firecrackers is centuries old. Called the "fire drug" by the early Chinese (for the gunpowder inside firecrackers), firecrackers jolt hearts and addict spirits, especially of preteen boys. Although for some the allure wanes with adulthood, for others the magic of firecrackers never dies.

What makes firecrackers so appealing? It's their instant effect—not only on those lighting them but also on one's peers and (most hopefully!) on the stodgy adults nearby. The addictive quality of firecrackers comes with their explosive release and their intense power—the power to make Aunt Matilda shriek, the power to kick a can high into the air, the power of having contraband riches to hoard, trade, sell, and show off.

Despite the wonder of firecrackers, they are, for the most part, all alike. It's one of the truisms of marketing that the more similar your product is to its competitors, the more you have to differentiate with superficial things like packaging. Because there were few or no reasons to go with one brand over another, firecracker sellers had to engender brand loyalty

Skipper
Made for Consigned Sales
 Company, Inc.
Made in Macau, Class 3

Opposite: Holiday in Chinatown, San Francisco by Paul Frenzeny: Paul Frenzeny's wood engravings appeared in *Harper's Weekly* between 1872 and 1882. His sketches were made on cross-country expeditions that took him from New York City to San Francisco's Chinatown. *Harper's Weekly*, March 20, 1880.

another way. They couldn't easily compete on price, because the standard price was already absurdly low, so firecracker sellers built brand loyalty by using colorful pack labels to attract the hard-earned nickels and dimes of kids and teens. In bright comic-book hues, the illustrations, designed mostly by anonymous Chinese artists, were meant as a hook for impulse purchases, not as art for the ages. It's ironic, then, that these throwaway pack illustrations are now selling in auctions for dollar figures once reserved for fine art prints.

Ad for Gulf Motor Oil.
The Saturday Evening Post,
July 3, 1948.

Because firecrackers have become an icon of American popular culture, we often forget that firecrackers are a thousand-year-old ceremonial item that originated in Asia. Firecrackers have traveled a long, long distance from their original home and are now ingrained in cultural traditions around the world. It is this cultural and historical phenomenon that we will explore here.

When we teamed up to make this book, we hoped for a synergy of talents: A book publisher renowned for the quality of its products, a collector with reputedly the largest firecracker label collection on the planet, a researcher with a proven talent for tracking down great images, and a writer of a dozen popular culture books. We hope that you find that we've met the challenge.

But enough introduction—the fuse is lit. Our story begins . . . ✳✳✳

FIRECRACKERS

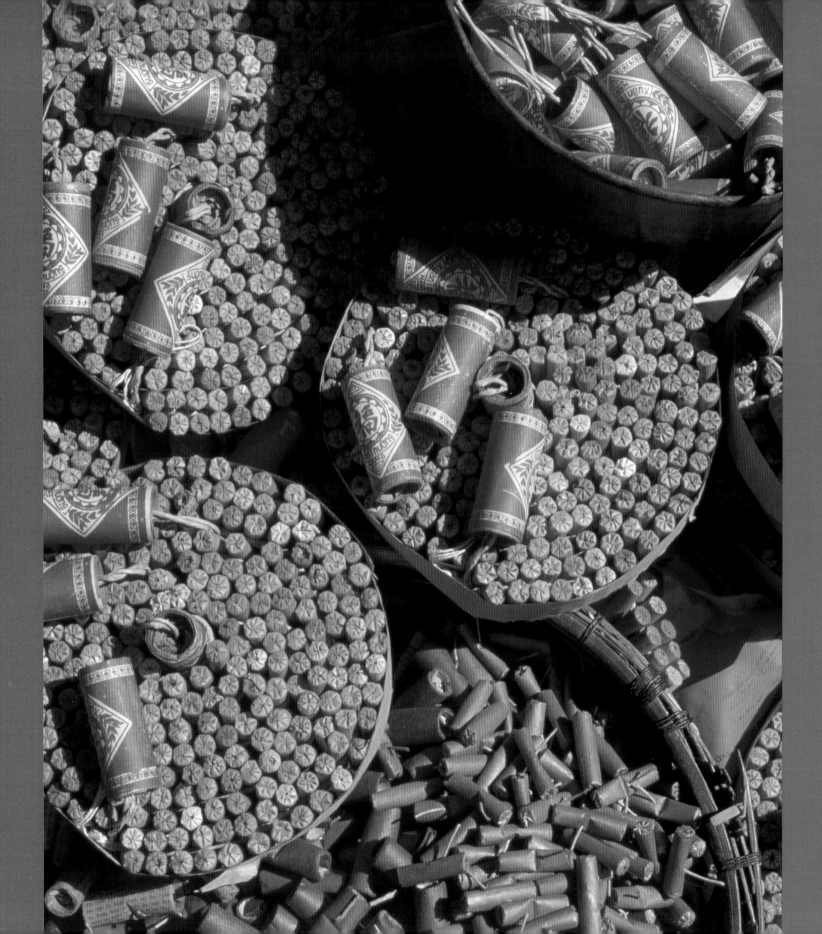

The Origin and Evolution of Firecrackers

Inside the palace, the firecrackers made a glorious noise, which could be heard in the streets outside. . . . All the boats on the lake were letting off fireworks and firecrackers, the rumbling and banging of which was really like thunder."

—Wu Tze-Mu, *"Dreaming of the Capital while the Rice Is Cooking"* (1275 C.E.)

IT TOOK GUNPOWDER to make the modern firecracker, but long before there was gunpowder, there were firecrackers. The first were completely organic and probably accidental: bamboo. Most likely, someone tending a fire ran short of fuel and decided to throw in a few lengths of green bamboo. The knobby round reeds blackened, smoldered, and hissed, and then did something completely unexpected: they exploded. Trapped inside the segments of the fast-growing reed are pockets of air and sap that will expand and eventually burst through the fire-weakened woody walls. The result is a sharp reverberating *blam!* which, back then, was something alarming that had never been heard before.

Exploding bamboo made the timid cower, babies cry, and animals run away. Someone somewhere along the line must have figured that if it worked with mortals, it may well work to scare away immortals. The ancient Chinese believed in Nian, a particularly nasty evil spirit who liked to eat crops and sometimes people. Sometime long before history records the event, the Lunar New Year became a ceremonial occasion to throw bamboo into bonfires in order to scare Nian far away, thus ensuring a year of health, peace, prosperity, and happiness. Over the years, the Chinese added the popping of bamboo to other ceremonial occasions: didn't evil spirits *also* need to be dispersed for weddings and funerals, for births and even shop openings?

Above: "Bursting Bamboo": Turn-of-the-twentieth-century Chinese firecrackers bore descriptive label designations based on their size and sound. These included "whip-guns," "double noises," and "hemp thunderers."

Opposite: Firecrackers. Da Nang, Vietnam, 1990.

3

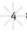

Green bamboo: The first firecracker.

Bamboo did the trick for a millennium or two. It did the trick for so long, in fact, that the name lives on centuries after bamboo was rendered obsolete by the discovery of paper and gunpowder. Chinese still call modern firecrackers *pao chuk*, or "burst bamboo."

The invention of gunpowder was likely an accident. Here's what historians surmise happened: A Chinese alchemist (or, some think, a cook) living a thousand years ago started mixing up sulfurous mixtures, stirring unbearably pungent compounds over a fire. As one dried into a fine black powder, something unexpected happened. *"Wah! Dui lei . . . !"* With a sputtering hiss and roar, the entire mixture went up in a white-hot flame.

Chinese Taoist alchemists eventually began experimenting with the first crude gunpowder, perhaps as early as the seventh century C.E. A mid-ninth century book, *The Classified Essentials of the Mysterious Tao of the True Origin of Things*, cautioned against its danger. In a list of thirty-five "wrong or dangerous" formulations, including lead medicines and mercury poultices, was one saying never to mix sulfur, arsenic disulfide, saltpeter (potassium nitrate), and honey: "Smoke and flames result, so that their hands and faces have been burnt, and even the whole house where they were working burned down. These things only bring Taoism into discredit, and alchemists should not do them."

Of course, the best way to make sure someone will do something is to tell them *not* to, especially when promising dramatic results like sudden flames. It wasn't long before backyard Taoists tinkered with the formula enough to make it more predictable—and also more powerful.

These early versions of gunpowder burned bright and hot, but didn't detonate instantaneously like modern gunpowder. However, this gunpowder was still a great step forward in bamboo firecracker technology. Somebody figured out that if they filled bamboo with the new powder, they'd no longer have to wait for several minutes for the air and water to expand enough to burst the bamboo. Instead, the flaming powder inside the bamboo released a tremendous quantity of hot gasses, cutting the wait time and dramatically increasing the noise.

One of the myths of the Western world is that the peace-loving Chinese never thought to use firecracker technology in war, and that it took the venal craftiness of Europeans to corrupt what was once pure and good. Not true, of course. The Chinese had as many wars as anybody. What military strategist could notice how easy it is to accidentally burn people with gunpowder and not try to figure out how to do it on purpose? Not long after the discovery of a crude gunpowder in the ninth century, *huo yao*, the "fire chemical," was being used in fire arrows, incendiary bombs, and poison-smoke bombs.

But that wasn't the end. Over time, chemists discovered that saltpeter releases its own oxygen as it burns. They also discovered that adding more saltpeter to the mix made it not just fast burning but truly explosive, detonating with a huge amount of energy, even when enclosed inside airtight chambers and under water. Sometime before the middle of the eleventh century, the proportion of saltpeter was raised to about 75 percent of the total mixture, about the same as modern gunpowder, with 15 percent charcoal and 10 percent sulfur.

Big Bang
Kwong Hing Tai Firecracker Manufacturing Company
Made in Macau, Class 4

The Origin and Evolution of Firecrackers

5

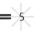

Foor Horsemen
Tai Hing Hong
Made in China, Class 1

A playful variation was the "ground rat," likely inspired by a dud bamboo firecracker. Designed like a firecracker, but with a hole in the end of the bamboo tube, a ground rat wouldn't explode but would skitter unpredictably along the ground, scattering crowds in gleeful terror. An incident in the official Chinese chronicles of 1264 C.E. described a ground rat chasing the emperor's mother around a courtyard during a celebration. Although frightened, she had the good humor to laugh about it the next day, probably sparing the lives of the officials who had been in charge of the display. Despite their civilian origins, ground rats were quickly adapted by the Chinese military for their effects on enemy horses and soldiers, especially when outfitted with hooks to catch on the soldiers' clothing and the horses' shanks.

The ground rats would sometimes even take flight for a moment or two. It didn't take long for a military designer to add fins for guidance, leading to

With that bang-up formula, the bursting bamboo got much louder. Unfortunately, bombs weren't far behind. The first of these were designed more for psychological warfare than actual damage: ground-shaking, mind-shattering explosions were set off during battles to terrify the other side into running away. (This psyche-warfare technique was still effective as recently as 1840, when the American sailing vessel *Independence*, transporting fireworks from China, managed to repel a band of Malay pirates using little more than a barrage of firecrackers, pinwheels, and Roman candles.) Over time, though, the aim became less to frighten enemy soldiers and more to simply kill them.

Meanwhile, firecrackers took their next evolutionary step. Instead of using bamboo, firecracker makers tried filling strong, stiff tubes of paper with gunpowder and adding a fuse. This was the beginning of the firecrackers as we know them, and this basic firecracker would remain essentially unchanged for many centuries.

Chinese Flaming Arrow and Flaming Wheel: Not long after the discovery of crude gunpowder, *huo yao*, the fire chemical, was being used in fire arrows and other incendiary weapons. Pirate brand cigarette cards, London, 1910.

the first rockets in the form of self-propelling arrows. Civilian fireworks designers converted the idea from the military and created rockets with explosive charges on the top, and then topped the missiles with color-burning minerals, creating fireworks.

> Certain inventions disturb the hearing to such degree that, if they are set off suddenly at night with sufficient skill, neither city nor army can endure them. . . . We have an example of this in that toy of children which is made in many parts of the world, namely an instrument as large as the human thumb. From the force of the salt called saltpeter so horrible a sound is produced at the bursting of so small a thing, namely a small piece of parchment, that we perceive it exceeds the roar of sharp thunder, and the flash exceeds the greatest brilliancy of the lightning accompanying the thunder.
>
> —Roger Bacon

In the middle of the thirteenth century, word of this new war matériel starting leaking into Europe by way of Dominican and Franciscan friars who had been traveling east to the Mongol court at Karakoram. The Chinese had been making cast-iron bombs for over a century and the Europeans were understandably anxious to learn the secret of making things blow up. One friar apparently delivered a stash of firecrackers to Roger Bacon

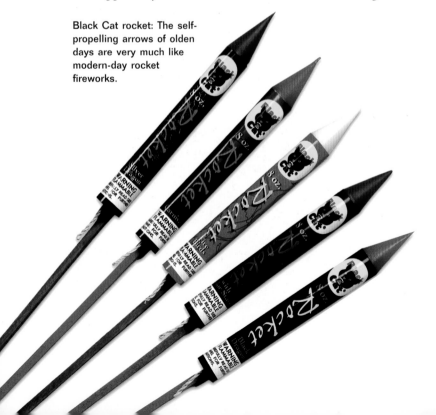

Black Cat rocket: The self-propelling arrows of olden days are very much like modern-day rocket fireworks.

Firecracker with black gunpowder.

at Oxford University, along with the secret of high-powered gunpowder. Bacon, a Franciscan monk, philosopher, and scientist, was impressed with these "children's toys" and their implications for modern warfare in the ancient alliances and blood feuds of European politics—so much so that when he wrote up his experiments to defend himself against accusations of witchcraft, he did so in a code in the hopes the information wouldn't fall into the wrong hands.

According to John Conkling in the July 1990 issue of *Scientific American*:

> The basic formula for black powder has persisted essentially unchanged throughout the centuries. . . . It may in fact be the only chemical product that is produced today using the same ingredients, the same proportions and the same manufacturing process as were used in the time of Columbus. This constancy reflects the fact that black powder is a nearly ideal pyrotechnic substance. It consists of abundant, inexpensive chemicals that are relatively non-toxic and environmentally safe. The mixture is so stable that it can be stored for decades without deteriorating, if kept dry. It is easily ignited by means of a moderate jolt of energy, such as a spark or a small burning fuse.

How do firecrackers explode? It's the saltpeter that does the bulk of the work. Saltpeter will burn brightly by itself, even in a vacuum, because it contains a large quantity of its own oxygen. Unfortunately, it takes a lot of heat to get it going. Luckily, sulfur will ignite at 250 degrees Celsius, which liquefies the mixture and raises its temperature to 335 degrees Celsius, saltpeter's fusion temperature. The saltpeter releases its own oxygen, so no oxygen needs to be sucked from the surrounding air, and rapidly oxidizes the charcoal and sulfur at temperatures of 3880 degrees Celsius.

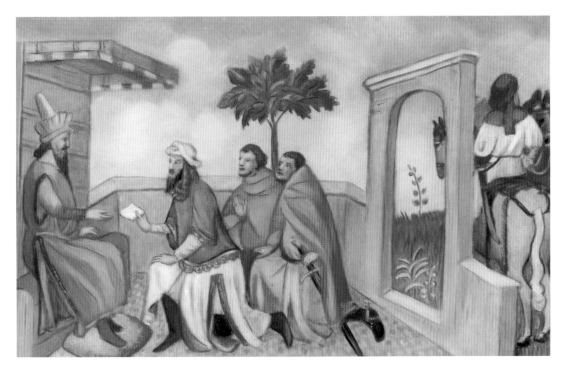

those of the Chinese, the Europeans' biggest technological contribution was learning how to propel pieces of metal in guns and cannons. Ironically, that discovery would later be used devastatingly against the Chinese, as we'll see in the following chapters. ✳✳✳

Left: Marco Polo before Kubla Khan: Italy first saw firecrackers in 1294 when world traveler Marco Polo brought them back from the Mongol court.

Below: "The Powder Monk": German monk and alchemist Berthold Schwarz, at work in the production of gunpowder in the early fourteenth century. Schwarz is credited by some historians with inventing the first gun and cannon. Sixteenth-century woodcut.

The sudden conflagration releases carbon dioxide and sulfur dioxide gases at a rate of 3,000 times the gunpowder's bulk. The paper walls of the firecracker can't hold it in, and they explode with a powerful bang.

Italy first saw firecrackers in 1292 when world-traveler Marco Polo sent a large stash of them home with this overblown description: "They burn with such a dreadful noise they can be heard for ten miles at night. Anyone who is not used to it could die, hence the ears are stuffed with cotton and clothes drawn over the head and the horses are tied on all four feet with their ears and eyes covered for it is the most terrible thing in the world to hear for the first time."

In Germany, another monk named Berthold Schwarz also did experiments with gunpowder and (in Germany, anyway) he is credited with inventing the first gun and cannon. Some scholars claim that he probably wasn't the first; in fact, there's only a little evidence that he even existed. Still, it's highly likely that people in other countries independently came up with the same inventions at about the same time.

Europeans did a lot once they got their hands on the formula for gunpowder. While their artisans made elaborate fireworks displays for the royal courts that may have even surpassed

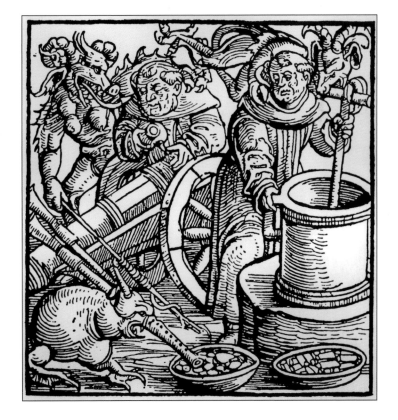

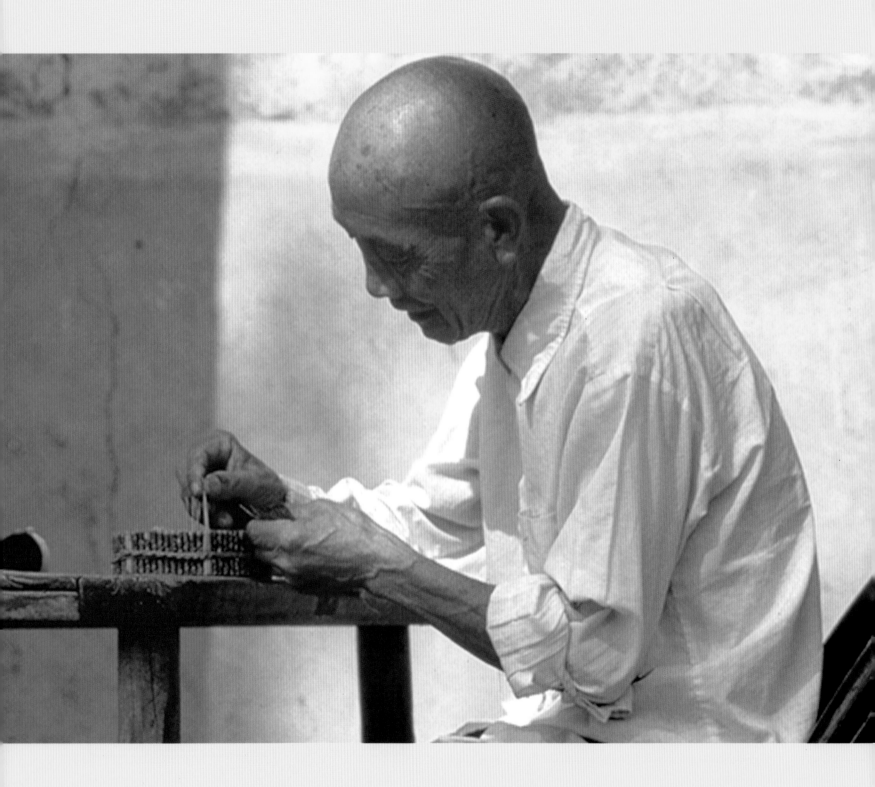

Firecracker Manufacturing

I T COULD HAVE BEEN 1910, 1410, or even 1010: Wind catching the sails, water lapping against wood, and polemen grunting and cursing as they move sampan boats along the winding rivers of China. Whether fighting the currents of the Pearl River in the south or the Yellow River in the northeast, the boats have made endless circles of commerce over centuries. They have carried minerals, paper, and supplies up the rivers to the little shops and factories of the firecracker makers, then carried the finished product back down to the ports and cities of the far-flung nation.

For countless years, perhaps as long as a millennium, there has been little reason to change the alchemic process that has turned powdered stones, ashes, and paper into firecrackers. And, for that matter, the process may not be that different a hundred years from now. But for this process to work, the materials to make firecrackers had to be assembled. Ironically, for about a century, Americans played a crucial role in providing one of the necessary materials.

Opposite: Adding fuses to Black Cat firecrackers. Hunan, China, ca. 1995.
Right: Map of the Pearl River Delta.

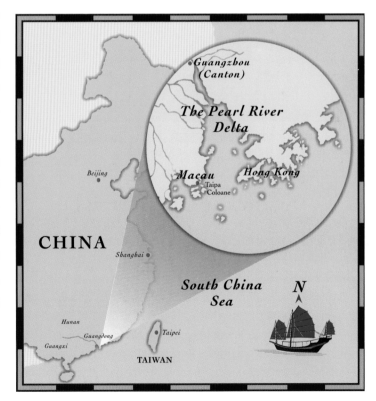

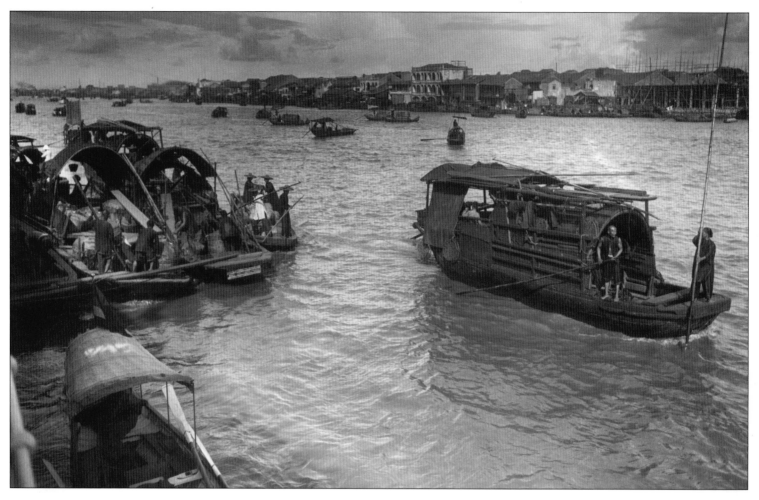

Scene on the Pearl River with boats: Sampan boats and junks along the winding and muddy Pearl River carried minerals, paper, and supplies into Canton and firecrackers out for export. Canton, China, 1916.

Assembling the Materials

If you're old enough, you may remember community paper drives, when roving bands of church members or uniformed Cub Scouts came to your door to ask for your old newspapers. Few people know the part that firecracker manufacturers had in creating that American institution.

While the *active* ingredient in firecracker and fuse is the powder, by bulk and weight the *principal* ingredient is paper. Chinese manufacturers have long used whatever paper was available. In much earlier times, it could be paper from pulped bamboo, straw, and whatever was left of mulberry branches after silkworms had fed on them. Despite that resourceful recycling, manufacturers continuously struggled to find enough paper to make billions of firecrackers each year.

Finally, in the late 1800s, some Canton firecracker manufacturers had an idea. They knew that America discarded scrap paper by the ton. They also knew that China had strongly resisted the importation of finished goods from other countries, and so many Chinese freighters were all but empty on the return trip from the United States. What more could they want than cheap materials and cheap freight charges? The Chinese began recycling newspapers in huge quantities from America.

William E. Priestley, a British-born Seattle businessman

who ran Chinese firecracker factories during the 1920s and '30s, wrote of visiting a paper recycler in Canton and being greeted in English by the proprietor who had spent several years in the United States: "Your hometown paper?"

Priestley, puzzled, asked what he meant by that.

"Well, I've got a big room of old newspapers that have been shipped from San Francisco, and I can give you a copy of almost any paper published on the Pacific Coast."

The increased demand for what once had been a throwaway item created a market for old newspapers and inadvertently founded the community paper drive, an American institution that lasted into the 1970s. In those days before municipal newspaper recycling, your doorbell would ring and a few polite members of a church group, charity, or the Boy Scouts would ask if you have any stacks of old newspapers. They'd throw your neatly tied bundles into the back of an old truck. The mountains of newsprint they collected would eventually net them a few dollars per ton from a used-paper merchant.

Where did a large proportion of these papers go? Many ended up on freighters steaming toward the harbor of Hong Kong. Then the papers were carried up the Pearl River to be pulped into a coarse brown paper for fireworks and firecracker tubes. Sometimes it wasn't even pulped but was used as is. Carefully take apart an old firecracker, and you might find a bit of news, comics, society columns, or even an old paperback novel from a half-century ago.

Inside the paper tubes, firecrackers contain explosive powder. Fuses contain the same powder, wrapped in tightly twisted paper. Until the twentieth century saw a gradual change to flash powder, firecrackers contained gunpowder, made from carbon, sulfur, and saltpeter (potassium nitrate). Carbon can come from burning any of a number of things from wood to coal; sulfur and saltpeter are plentiful in China and are inexpensively mined from the rocks and soil. Explosive powder is too dangerous to transport or even store in quantity, so the ingredients are shipped separately and mixed as needed at the factory.

American Curiosity about Firecrackers Grows

As firecrackers became more and more embedded into American Fourth of July celebrations in the 1800s, the circumstances of their production became an object of curiosity in America. Despite the fact that most firecracker makers were reluctant to let outsiders into their back rooms, we have a handful of published accounts from the late 1800s until World War II about the making of firecrackers in China: The reminiscences of William Priestley, already mentioned, appeared in the July 1931 issue of *Asia Magazine*. Another, quoted in an 1897 issue of *Scientific American*, is a report by John Goodnow, a consul general of the United States, who visited plants in the Canton area. Still another is an article by writer Erich Pomeroy, who visited a firecracker manufacturer in northern China for *St. Nicholas Magazine* in July 1910. Later in the 1900s came accounts published in pyrotechnic textbooks by Tenny L. Davis, Ph.D., and George W. Weingart who, although working from secondhand accounts, added some details that had not already been revealed earlier.

All of the articles and chapters suffer some maddening omissions and cross-cultural misunderstandings. For example,

An unrolled firecracker reveals newspaper from 1957.

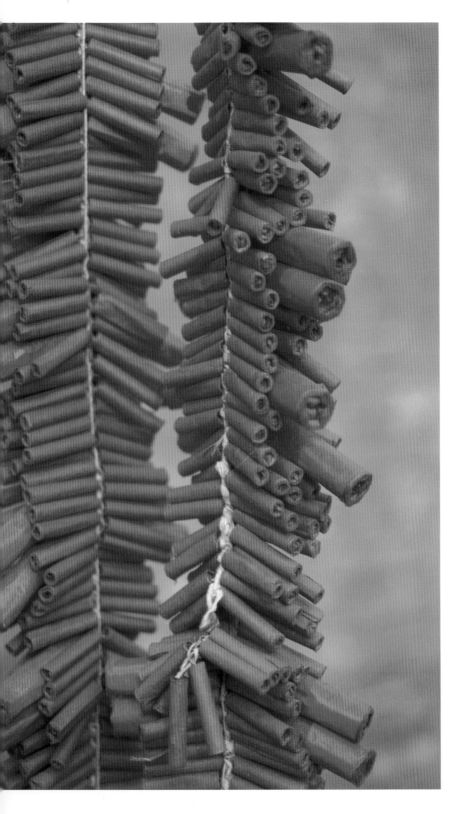

Strings of firecrackers at the A-Ma Temple. Macau, 1995.

several of the accounts quoted workers as saying they were making "a thousand" firecrackers at a time without apparently being aware that the Chinese often use the term to simply mean "many." But even if the numbers are suspect, the accounts offer several variations on traditional firecracker manufacturing methods as practiced for many centuries. Because they offer a glimpse into the time from the 1930s to 1970s that collectors consider the "golden age" of firecrackers (and because many of those same traditions have not changed significantly in the time since then), their impressions warrant recounting here.

The Steps of Manufacturing

According to Goodnow, there were no big factories in 1897 in China (although this would change soon after): "The crackers are made in small houses and in the shops where they are sold," he reported. "In the latter places the proprietor of the shop, his wife (or wives) and children do the work. No record is made of the number made and sold."

The process began by a worker making the firecracker tubes. He or she (women and children made up much of the work force in firecracker manufacturing) took stacks of coarse paper and fanned them out on a workbench so that one-third inch of each was exposed, "just like steps" on a staircase, as Pomeroy put it. "The workman . . . then slides down the stairs, as it were, with a brush of paste," essentially adding a strip of glue to one edge of the sheets so each can be rolled and glued like rolling a cigarette paper.

Starting at the unglued end, the worker rolled the top piece of paper tightly around a small iron rod four to six times, using a board with a handle like a carpenter's plane to securely glue the paper tube, which was usually twice as long as a finished firecracker would be. "He gives it an extra roll or two down the bench for good measure, slides it off the nail into a basket, and has another already started before you realize what he is about," wrote Pomeroy. (Today, the process has been mechanized—somewhat. According to Ralph Apel of Golden Gate Fireworks, rudimentary rolling machines, hand or foot operated, now exist. Apel has also seen one or two fully mechanized machines for rolling firecracker-

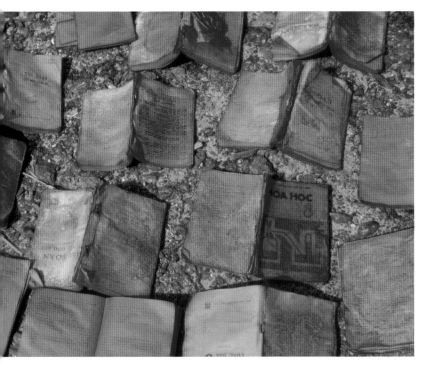

Dyed books used to make firecracker shell wrappers. Da Nang, Vietnam, 1994.

century. From designs to brand-name logos, these patterns inadvertently mimicked changes in Chinese culture after the fall of the emperor.

After the colorful paper shell wraps were rolled onto the tube, a child apprentice rebundled the tubes into a hatbox shape, with one change: instead of *one* rope around the middle, he tied *two* ropes around it, positioned one-third and two-thirds of the way along the length of the tubes, leaving the middle free. The reason for this became apparent quickly after drying: a worker with a huge knife sliced the bundle neatly through the middle, cutting all of the double-length tubes neatly in half and making two identical bundles of firecracker casings.

Now came the steps of sealing the bottoms. Historically, there were many ways of sealing the ends of firecrackers. One early way was to tie them with silk thread. Another was to seal them with a plug of clay. Weingart reported a fairly ingenious of doing this. Dry powdered clay was poured into the tube before and after the gunpowder was added. Both ends of the tube were then wet to solidify the clay.

There were two problems with the mud method, however.

tubes.) Also, some manufacturers dye the paper red before using it, especially in firecrackers for domestic use, in order to add more of the red fragments so beloved in ceremonial explosions.

One of the apprentices in the shop then arranged hundreds of empty tubes together in a six-sided bundle and tied them with a rope. The bundles, in size and shape resembling hat boxes, were set outside in the sun to dry.

The next step added decorative and colorful "shell wrap" around the little tubes. Before the twentieth century, firecrackers for domestic use followed a specific pattern within each braided-together string: many red firecrackers representing the common people, and one or two green and yellow crackers representing the government and emperor, respectively. Every string of firecrackers created a representative microcosm of Chinese society at the time. (These strings are call "emperor packs" by collectors.) Early in the twentieth century, usually just red firecrackers were exported. Red was, and is, considered a very lucky color in Chinese culture. A variety of shell-wrap patterns emerged in the twentieth

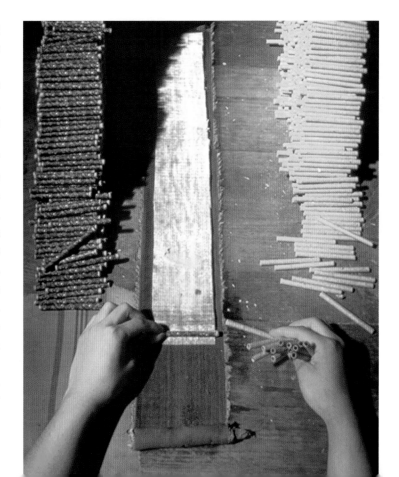

Black Cat shell wrappers rolled onto uncut firecracker tubes. Hunan, China, ca. 1995.

One was that the clay would blow up when the firecrackers exploded, creating choking clouds of dust during celebrations. Another was that the weight of the clay added costs to exporters, not just for freight but also because American tariff fees were based on total weight.

Early in the twentieth century, the Li & Fung exporting company began using paper-crimped fireworks to get around the weight problem. In this method, a worker first placed a paper disk at the end of the paper tube. Then he tapped around the end of the tube with a stick or blunt nail to bend its edges around the disc.

This innovation was adopted by other companies as well, and the crimped firecracker ruled for half a century. (Some companies even reportedly crimped the ends without a paper disk.) However, that changed dramatically near the end of the twentieth century when tariff laws changed. Suddenly the fees on firecrackers were based on *worth* instead of *weight*. Also, the extra labor of crimping became too costly in China as firecracker workers under communism began working fewer hours for higher wages.

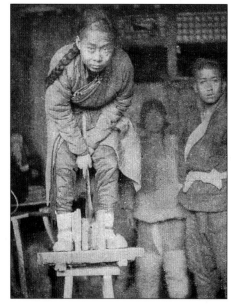

Cutting through a bundle of firecracker tubes with a heavy knife. *St. Nicholas Magazine*, July 1910.

Nowadays virtually all firecrackers are sealed with a coarse form of plaster of paris that is slopped onto the ends of the bundles. These gypsum plugs harden faster and don't disintegrate into dust when the firecrackers explode. Instead, they stay stuck inside the tubes or fall out of the cardboard and onto the ground.

Next came the mixing of the explosive powders; it was too dangerous to mix before it was needed. Metal is now forbidden from the mixing process—workers stir the mixture of powders with wood tools inside wood barrels to avoid accidentally making sparks. In huts far from the center of activity, on days where temperature and humidity are deemed less likely to create an unstable mix of volatility and static electricity, workers blend only as much powder as needed for immediate use. It's a time-tested safety procedure that unfortunately has been seared brightly into consciousness by horribly memorable explosions and conflagrations.

Now back to the tubes. Regardless of which method was used to seal the bottom, the next step varies depending on the author of the account. Some say that after turning the bundle right side up, a sheet of paper was glued to the top and holes, corresponding to the tubes, were punched in it. (Sometimes a drilled board was used instead.) Then a small measure of explosive powder ("the cheapest grade," sniffed Goodnow in his report) was sprinkled into the tiny openings, with the worker shaking the bundle or using a soft brush to spread the powder evenly into all the tubes.

Clay-sealed firecrackers: Paper-sealed, crimped-end firecrackers replaced the traditional, heavier, clay-sealed ones. This breakthrough lowered import duties and eliminated the problem of excessive dust produced during the discharge.

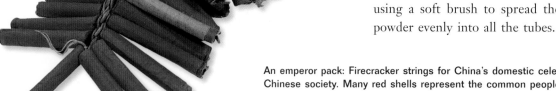

An emperor pack: Firecracker strings for China's domestic celebratory use symbolically represented Chinese society. Many red shells represent the common people, and one or two green and yellow crackers represent the government and emperor, respectively.

When powder was safely inside, the worker, using a mallet and blunt nail, tamped the powder down to the bottom of each tube.

Then came the fuses. "For the fuse, a paper is employed made from the inner lining of the bamboo," reported Goodnow. "In other places a fine rice paper is used, generally stiffened with buckwheat flour paste which, the Chinese say, adds to its flammability. A strip of this paper, one-third of an inch wide by fourteen inches (a Chinese foot) long, is laid on a table and very little powder put down the middle of it with a hollow bamboo stick." Using moistened hands to form the tissue paper into a string, the worker gives quick twists to the paper. Since this is a difficult step and because the fuse is the part of the firecracker that's most likely to fail, a skilled fusemaker is still considered very valuable to a firecracker manufacturer. After the fuses dried, workers cut the fuse into short pieces, stuck one into each tube, and then sealed the ends of the firecrackers.

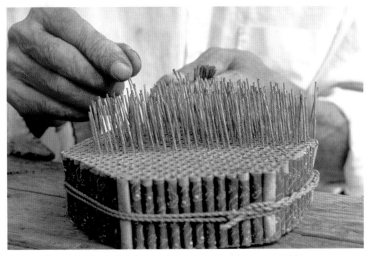

Adding fuses to Black Cat firecrackers. Hunan, China, ca. 1995.

"Completed and still crowded together in the bundles," waxed Pomeroy excitedly, "the little 'redskins,' with the fuses sticking out of their caps, seem to wear a festive, promising look that clearly says: 'You give us a light, and we'll do the rest. And what a high old time it will be!'"

Before that "high time" can occur, though, the firecrackers still needed to be strung together and packaged. For domestic Chinese use a century ago, the fuses were braided together (with hemp rope for strength) into strings fifteen to fifty feet long with, as Pomeroy put it, "bigger fellows, four or five times the size of the little fellows" plaited in at regular intervals to add a percussive backbeat when hung from a pole and lit. The strings were then neatly wrapped in long packages, covered with red or white paper. On the front of the package was a red paper label printed with the shop's name in gilt characters. The completed package was then ready to be shipped.

The packs destined for export to the United States were almost always much smaller than the long strings made for local consumption. In an 1874 article in *St. Nicholas Magazine* (which gave more attention to the details of firecrackers than any other mainstream magazine—not surprisingly since, like firecrackers themselves, the magazine was of particular interest to children and young adults), William Rideing described how the fire-

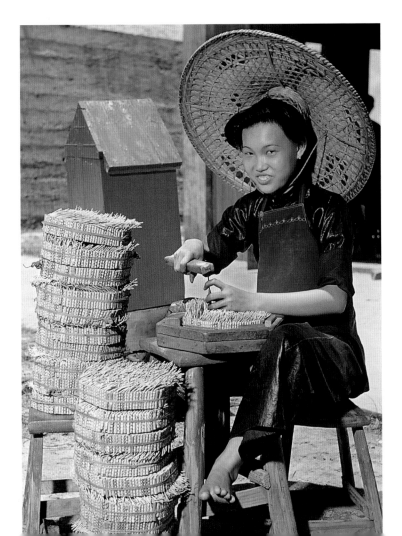

Tamping fuses at the Kwong Hing Tai factory: Each hexagonal bundle holds a thousand firecrackers. Macau, 1953.

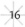

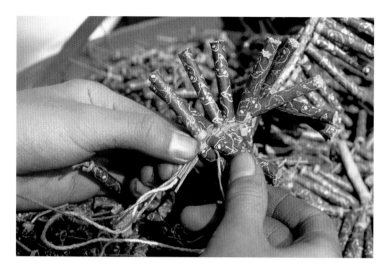

Braiding Black Cat firecrackers. Hunan, China, ca. 1995.

At least when it comes to advertising, some things don't seem to change.

Nowadays the firecrackers for export are generally arranged in flat packs of sixteen and fifty for Fourth of July use, or in long braided strings of 1,500 to 5,000 that are mostly used in Asian-American ceremonial use. They are no longer ten for a penny as in 1874, yet after a century and a quarter of inflation, they continue to be amazingly inexpensive: "However you buy them, they're roughly a penny per firecracker retail," says firecracker-wholesaler Ralph Apel. Considering the amount of material and labor that goes into each, it's hard to imagine a better bang for your buck.

crackers were packaged and his disappointment at what he first thought would be of great significance:

> The other day, I bought three packages of firecrackers, all manu-
> factured in China, and paid eight cents each for them. In each of
> the packs there were eighty crackers, so that I obtained 240 in all,
> for twenty-four cents. Could anything be cheaper? You know how
> they are packed—in white straw paper with a crimson label bear-
> ing an inscription printed in gilt letters. When I got home, I began
> to wonder what the inscription on the margin meant. I am not a
> learned person, so I asked a Japanese student who understands
> Chinese to translate it for me. The wonderful-looking characters
> proved to be no more than an advertisement of the dealers, read-
> ing, when translated, as follows: "Our office is in Ou-Sen, and we
> make the best kind of firecrackers. Please copy down this infor-
> mation and we hope there will be no mistake." The second pack
> shows the figures of two Chinamen, and the following inscription
> in Chinese: "The original store is now at the Square of Kau Chin,
> and we set before the public beautiful articles, including firecrack-
> ers, made by ourselves. We hope our customer will write down
> this information and remember." I was a little disappointed in find-
> ing that the outlandish characters had not something to say more
> significant than these things.

Firecracker merchant. Gouache, China, ca. 1820.

Working Conditions

Making firecrackers was not a dream job. The work was long, the conditions abysmal and dangerous, and the pay unbelievably low. "Free" workers worked seventeen hours a day seven days a week for about seven cents a day. Prisoners were also often hired and paid even less than that.

Author Erich Pomeroy asked a firecracker manufacturer how many firecrackers each worker was expected to make in a day: "The good-natured master of the shop said that one man is counted on to make twenty bundles up to the point where the powder is put in, when the crackers are passed on to others to finish and weave into strings."

Before opening his own factory, William Priestley had occasion to visit most of the other factories in the Guangdong Province and found working conditions to be disturbing-although not disturbing enough to change them significantly when he opened his own plant:

> The only bright thing in a firecracker factory is the smile on the face of the proprietor. . . . One worker told me that his family had been engaged in the firecracker business for at least four hundred years, and yet, I suppose, he did not earn more than twenty cents (gold) a day. With a background of four hundred years he had improved neither the methods of his ancestors nor his standard of living.

> There are no factory laws or regulations in a Chinese firecracker factory. A five-year-old child may be working alongside a withered old woman who might be the child's great-grandmother. The men in these factories look like slaves: one cannot imagine them suddenly breaking off in their work to tell a story to a neighbor. The young girls are full of chatter, which suddenly ceases when a stranger approaches. . . . All day the women sit at long benches pouring in the powder, inserting the fuse and packing the finished product ready for the market.

Consul General Goodnow also wrote about the working conditions and economies of the firecracker trade in China:

> The hours of labor are from 6 A.M. to 11 P.M. and there are seven working days in each week. Four-fifths of the crackers consumed

in China are made by the families of those who sell them, these people, of course, receiving no wages. Of the paid work, a very large proportion is done by women and children who are paid by the piece. It is estimated that thirty women and ten men can make 100,000 crackers per day, for which work the women will receive 5 cents each and the men about 7 cents each. An

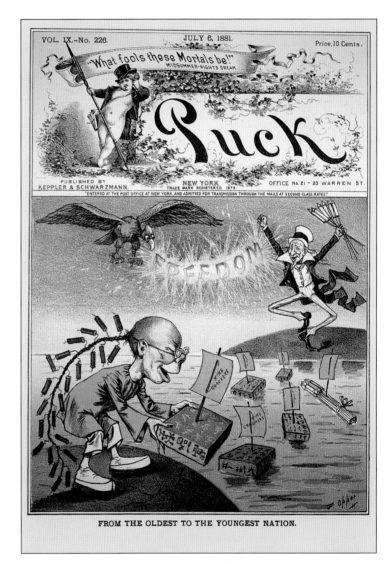

"From the Oldest to the Youngest Nation": This July 1881 *Puck* magazine cover portrays the Chinese in a condescending, stereotypical caricature. Issued one year before the Chinese Exclusion Act, which banned the immigration of Chinese laborers to the U.S., the cartoon reflects the anti-Chinese hysteria of the time. The act was championed by American white labor fearful of cheap foreign labor, unemployment, and economic depression.

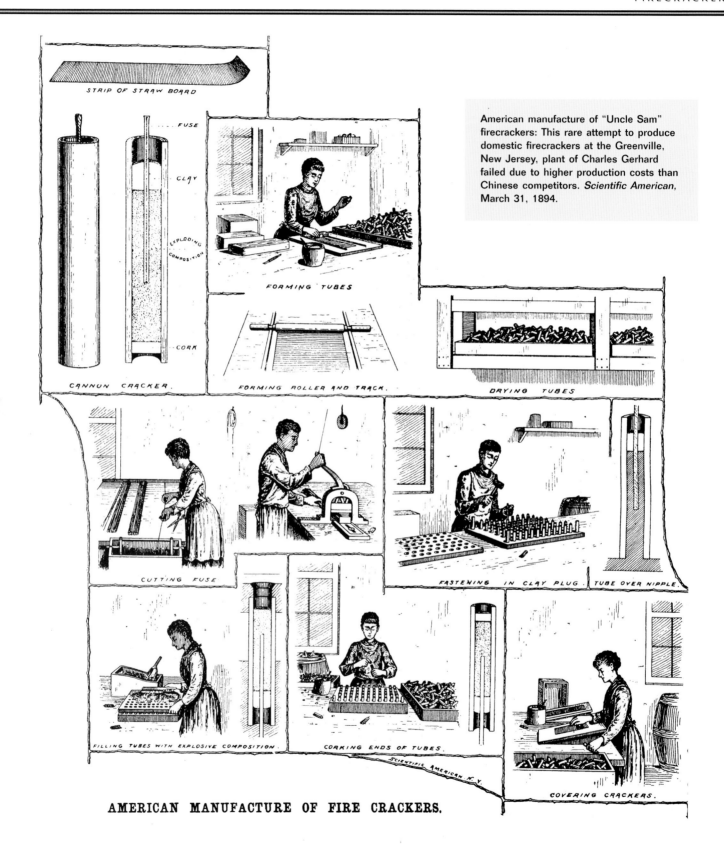

American manufacture of "Uncle Sam" firecrackers: This rare attempt to produce domestic firecrackers at the Greenville, New Jersey, plant of Charles Gerhard failed due to higher production costs than Chinese competitors. *Scientific American,* March 31, 1894.

STRIP OF STRAW BOARD

FUSE

CLAY

EXPLODING COMPOSITION

CORK

CANNON CRACKER.

FORMING TUBES

FORMING ROLLER AND TRACK.

DRYING TUBES

CUTTING FUSE

FASTENING IN CLAY PLUG. TUBE OVER NIPPLE.

FILLING TUBES WITH EXPLOSIVE COMPOSITION.

CORKING ENDS OF TUBES.

SCIENTIFIC AMERICAN N.Y.

COVERING CRACKERS.

AMERICAN MANUFACTURE OF FIRE CRACKERS.

apprentice is bound for four years, and during that time receives only his board. . . . Workmen at this trade receive about the average rate of wages paid here for common labor. The trade is considered unhealthy and dangerous, and therefore not desirable.

American companies might manufacture their own specialty fireworks, but they didn't bother making firecrackers because they found that it just wasn't profitable to try to compete with these labor costs, not even after the U.S. government slapped a 200 percent tariff on imported firecrackers in the late 1800s. Given this situation, when an American, Charles Gerhard, opened a firecracker plant in Greenville, New Jersey in 1894, the event was considered by the editors of *Scientific American* as newsworthy; the respected journal filled most of a page with details and diagrams of the plant. Unfortunately, the plant quickly folded. Not only were wages much more expensive, but the plant did not have anywhere near the productivity of its Chinese counterparts. Instead of forty workers turning out 100,000 crackers a day, the American plant had sixty workers turning out 50,000 crackers a day.

There's still no way for industrialized nations to beat the eighty cents to a dollar a day that Chinese firecracker plants currently pay their workers. To be fair, however, this is considered a decent wage in China. In their socialized system, workers are provided room, board, and medical attention on top of that pay.

Evolution and Revolution: The Firecracker Industry in Modern Times

The business of firecrackers changed more in the last century than it had in the previous nine. The businesses went from feudal shops and cottages to factories using modern marketing techniques; the powder charge changed from gunpowder to a more powerful flash powder; and finally, political revolutions in China created upheavals in the business that took decades to settle down.

Advances in Technology and Marketing

The first change was the result of a shift in firecracker science, technology, and business as the American market moved from being passive recipients of whatever the Chinese made to demanding consumers.

While there was no way to make a profit from manufacturing firecrackers in America, the same was not true of fireworks. The profit margin for fire*works* was much higher. Furthermore, while firecrackers merely had to make the same satisfying noise over the years, success in the fireworks industry required ever changing novelty, artistry, craftsmanship, marketing, and advancements in technology, all of which were hallmarks of America in the late 1800s. As a result, dozens of American fireworks companies emerged, competing with extravagant new colors and sparkles, names and packaging.

One of the technological advances the American fireworks makers adopted came from the nascent photographic industry: flash powder. Photographers ignited this new flash powder on top of a pallet to take indoor photos with light-hungry film. The result was a blindingly brilliant light, which was the result of adding ground-up metals and better oxidants to gunpowder to make it ignite faster and brighter than ever before.

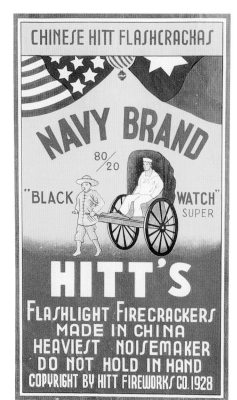

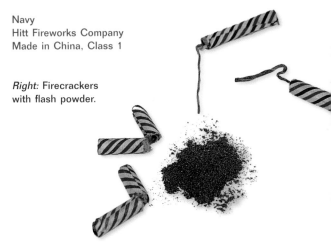

Left: Hitt Fireworks Company is credited with the innovation of adding flash powder to firecrackers. These newer "flashlight" firecrackers explode with a brilliant flash and louder sound.

Navy
Hitt Fireworks Company
Made in China, Class 1

Right: Firecrackers with flash powder.

In 1899, American fireworks manufacturers began hearing about Germans adding aluminum and magnesium to gunpowder for brilliance, color, and explosiveness. That year a chemist, Dr. Alfone Bujard, published his *Art of Fireworks* in Stuttgart, which revealed the new formulations. American fireworks manufacturers took to the new powders with a vengeance, experimenting with additional metals for new and more brilliant colors.

As fireworks got bigger, better, and brighter, firecrackers began seeming tired and old-fashioned. On the shelves and in the bins of fireworks retailers, the stenciled dragons and incomprehensible Chinese lettering on their red paper wrappings was easily outshone by the multicolored lithography of Vesuvius Cones and Roman Candles nearby.

In 1916, a pyrotechnic expert at Hitt Fireworks Company in Seattle had a literally brilliant idea: Why not brighten up firecrackers by using flash powder instead of gunpowder? For that matter, why not update the packaging, make it colorful, and aim it more at an American audience?

A representative from Hitt went over to China to demonstrate the new colors in fireworks, which seemed a little strange to him, "like bringing coals to Newcastle," he said. But he was also there to find a manufacturer that would make firecrackers with a new formulation: flash powder. That man was William E. Priestley, the man already quoted above.

"I take no particular credit," wrote Priestley with perhaps undue modesty years later, "for the fact that I stepped on the tail of firecracker tradition by suggesting to one of the manufacturers that he might improve the product by substituting for black powder a composition containing aluminum, which would give not only a sharper report but at the same time a brilliant flash. It was a formula that had been in use in America for some years but was entirely new to the Chinese. My suggestion was viewed with suspicion: What was good enough for the Han Dynasty was good enough for the Republic."

Priestley, not finding interest among the small shops that supplied his employer, conferred with some Cantonese associates about establishing a factory to make crackers with the new formulation. It was a decision that others would quickly follow over the next few years. Instead of making firecrackers in homes and little shops, he decided that the factory product might be both better and cheaper.

While in Hong Kong, Priestley determined that the best firecrackers were made in southern China and thus he could get "a dependable supply of cheap labor" there. He eventually set up a far-flung supply system for his factory: The tubes were made up the Pearl River several miles above Canton, and the fuses came from Shklung, a town about twenty miles below Canton. The powder, however, was made at the factory.

The new flash powder firecrackers worked like a charm. However, the new composition made what had always been a dangerous occupation even more deadly. In Priestley's case, his

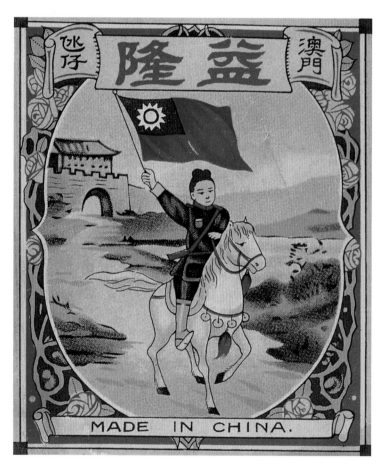

Sun Yat-sen, Chinese Nationalist revolutionary leader and founder of the Chinese Republic: Political unrest in the 1910s and 1920s saw many firecracker manufacturers leave China for the safer harbors of Portuguese Macau and British-held Hong Kong.

Sun Yat-sen
Unknown
Made in China, Class 1

factory blew up, killing thirty of his "girls" and making his operation no longer welcome in Hong Kong. After paying a settlement of thirty dollars to the family of each dead worker, Priestley started a new plant not far up the Pearl River, on an island across the river from Canton. For the plant, he used a design based on what he'd learned the hard way in Hong Kong. Instead of a heavy brick building, his factory consisted of smaller sheds far removed from each other, made out of bamboo and palm leaves. The sheds kept out the sun and rain but were not as dangerous as heavy brick and stone buildings in the case of fire or explosion. "The factory," Priestley noted, "was large enough to accommodate seven hundred workers. I arranged to have one door for each six girls, and all doors were to swing out instead of in. This is the only way to hang doors in a factory where there is danger of fire."

To advertise the new composition of these firecrackers, Hitt came up with a new name to differentiate these new louder, brighter firecrackers from the old black-powder kind: "flashlight firecrackers." As other manufacturers followed Priestley's lead, exporters in China began modernizing their labels to give to their products whatever competitive advantage that could come from bright illustrations and a memorable brand name. Local artists designed colorful labels using lithography presses that had newly arrived in south China from the west. They used images they believed would attract the nickels and dimes of American kids: cowboys, that game with the sticks and balls, and that jolly fat American white-haired winter holiday man.

Revolution

While developments were occurring in the firecracker industry, changes were also taking place on the political front as a revolution shook China in the 1920s. A breakdown of the country's political system bred a civil war among nationalists, socialists, communists, reactionaries, and warlords, all of whom were trying to grab power.

The owners and managers of the new firecracker factories, many of them Americans and Europeans, became targets of antiforeigner sentiment in China as the civil war threatened to erupt around them. Canton, the center of firecracker manufacturing, also became a hotbed of political intrigue and violence.

Ironically, much of the turmoil was a direct result of the gunpowder that Chinese had invented but that had been turned against them by the colonizing powers. To better understand this, let's take a brief step back in history. While the Chinese had used the "fire drug" as a modest way to augment their way of doing battle—as a flame thrower, for example, or as grenades when an enemy was within throwing distance—it took the Europeans to figure out that gunpowder could also be used to revolutionize war making. By using gunpowder to fire projectiles, they realized that they could destroy people, ships, and fortifications without ever coming close to them.

Back in 1757, Emperor Qianlong had successfully closed all trading ports to foreigners except the Pearl River Delta. However, when European navies appeared in China a century later with guns and cannons, there was no firepower strong enough to resist them. The foreigners began biting off pieces of that delta for themselves: Hong Kong quickly fell to the British, Macau to Portugal.

That was bad, but China lost even more face and power during the Opium War from 1839 to 1842. The Chinese had demanded that the notorious East India Tea Company stop dumping opium from India into its ports and into its people. The objection was not just because of antidrug feelings: having millions of its citizens addicted to an expensive foreign drug was draining the country of its silver. In the war that followed, the British government managed to enforce the dictum that China couldn't stop "free enterprise" or its spiritual and financial impoverishment of the land and its people.

Republica Portuguesa Macau: This former Portuguese territory is composed of the Macau peninsula, contiguous with mainland China, and the islands of Taipa and Coloane.

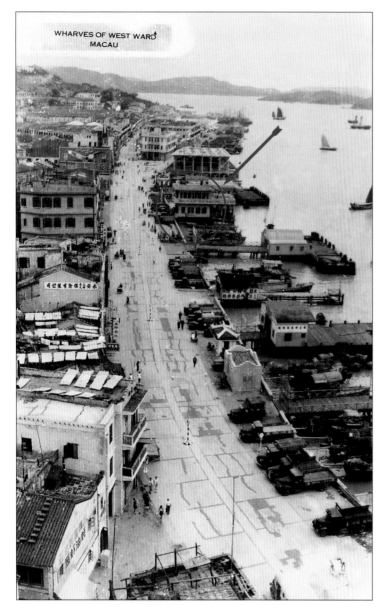

"Wharves of West Ward, Macau": Firecracker manufacturers such as the Kwong Hing Tai Firecracker Manufacturing Company (arrow) and Li & Fung, Ltd. dotted the wharves of Canton, Macau, and Hong Kong. Manufacturing was done at island and inland factories.

Finally, in response to other imperial powers trying to monopolize all the good ports, the U.S. Navy enforced a new demand of its own in 1899: an "Open Door Policy" requiring that China open up trade to American merchants and all other Western nations as well.

Failures at stopping this unwanted foreign intervention demoralized the leadership of China, enraged its people, and destabilized the country's already shaky political situation. In 1912, the central government in Beijing collapsed and the reign of emperors ended after thousands of years. Nationalists like Sun Yat-sen attempted to create a republic where a feudal society had

FIRECRACKER PILGRIMAGE TO MACAU

Like religious pilgrims to Mecca or Jerusalem, hardcore firecracker enthusiasts have been known to make the pilgrimage to Macau in order to commune with the golden age of the firecracker arts, most of which took place when the major firecracker manufacturers had relocated their operations on the Portuguese colony during civil unrest on the mainland.

Nowadays, Macau is no longer a colony, and the firecracker factories there are no longer operational. Yet, the lure of Macau still sings its explosive siren song to people who, in their youth, got "MADE IN MACAU" subliminally imprinted into their memories because of firecracker labels. Firecracker enthusiasts going to Macau have described finding ghost buildings of now-departed giants like Kwan Yick, Yick Loong, Po Sing, and Kwong Hing Tai. They bring back photos of themselves in front of rotting gates and faded signs.

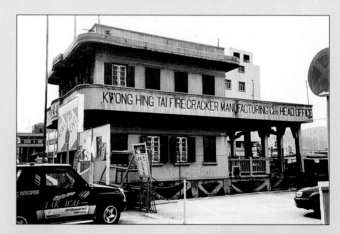

Above: Kwong Hing Tai Firecracker Manufacturing Company: This once prosperous manufacturer, makers of Yan Kee Boy brand among others, had its main office on the Macau wharf overlooking the South China Sea. Its gunpowder and manufacturing factory was located on the nearby island of Taipa. In disrepair, the empty building still stands despite the company's demise in the 1970s.

long been ingrained; other revolutionaries had their own political blueprints.

Most of China was not a safe place to be doing business, and Canton more so than most. After his plant manager was kidnapped for ransom by pirates and part of his plant accidentally blown up by some soldiers who had been sent over to "protect" it, Priestley decided to relocate his firecracker factory in a less tumultuous place. That sense of insecurity even affected firecracker exporting companies that were run by native Chinese. For example, Li & Fung, a Chinese exporter of firecrackers and other goods, moved their headquarters to the relative safety of British-run Hong Kong.

Unfortunately, the earlier factory blast left Priestley feeling like he didn't have the same option. As a result, in the summer of 1925 he removed whatever he could salvage from his factory in Canton and relocated in Portuguese-run Macau. Also, to hedge his bets, Priestley also opened a plant in Japanese-held Taiwan (known then as Formosa).

Macau, in fact, became the major capital of firecracker business. Some business owners found additional comfort in the offshore safety of one of its islands, Taipa. Just across the river from the international port of Hong Kong, just down the river from raw materials, Macau became the source of nearly all of firecrackers coming to America starting in the mid-1920s. It remained that way through half a century of significant unrest on the mainland. Except for an interruption during World War II, the factories remained successfully humming along until they ran headlong into a great wall called rapprochement in the 1970s. But we'll get to that in a few minutes.

Adoption of Modern Business Practices

Along with politics and technology, contact with Europeans brought a change in the way business was conducted. At the turn of the twentieth century in Canton, businessmen would meet in singsong houses—the Chinese equivalent of geisha houses in Japan—to negotiate deals. They'd wear long *cheongsam* gowns with extended sleeves that they'd roll over their hands and negotiate prices and quantities by pressing their fingers against the fingers of the other negotiator as if they were the beads of an abacus. "No documents were signed, no contracts exchanged, and no one knew what the deal was except the two concerned. Yet,

the agreement was binding on both parties and invariably was scrupulously honored," wrote Robin Hutcheon in a company biography of the firecracker exporter Li & Fung. It was a tradition that the company eschewed, following the lead of its Western counterparts that preferred a paper trail of documents and signatures. It foreshadowed much of what was to come as two different cultures collided and intertwined.

Meanwhile, however, some of the spirit of the Chinese singsong house extended to the United States in the 1920s and '30s. During that time, the thirteen largest firecracker importers would put aside their rivalry and territorial disputes and meet every year in San Francisco. Of the firecrackers that came into America, two-thirds passed through their hands on their way to firecracker stores and fireworks stands around the country.

The group met in their least busy time—the lull after the

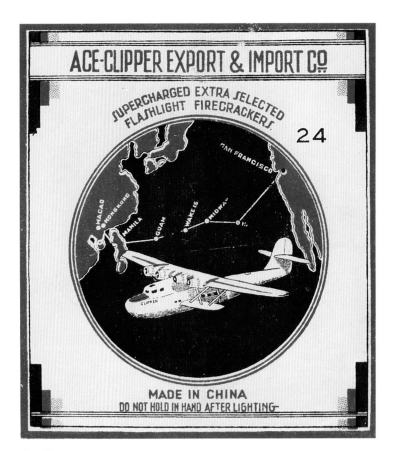

Ace-Clipper
Ace-Clipper Export & Import Company
Made in China, Class 1

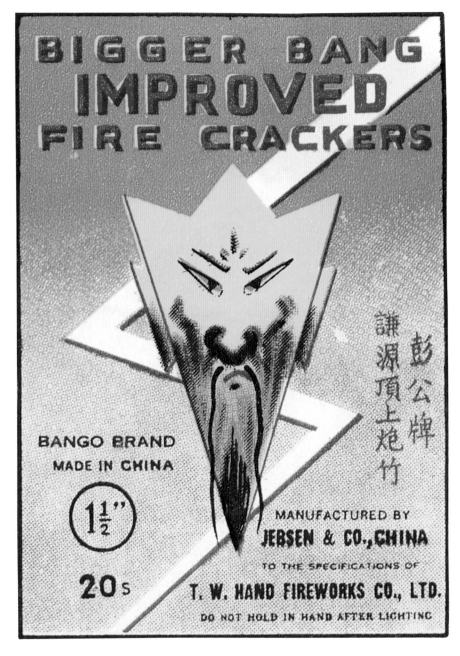

Fourth of July season but before the Christmas/New Year's/Chinese New Year season. Represented were importing and distribution companies like Hitt out of Seattle, M. Backes & Sons (Connecticut), Consolidated Fireworks (New York), Triumph (Maryland), Pensick & Gordon (Los Angeles), J. M. Da Rocha and Pekin Fireworks (San Francisco), Wallace Clark (Chicago), and T. W. Hand of

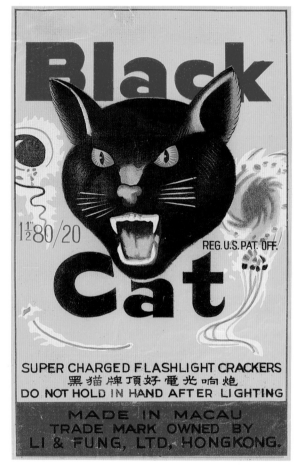

Bango Brand: This label illustrates the manufacturing and distribution path of this firecracker pack. Made in Kwangtung, China, for the Hong Kong–based exporter, Jebsen & Company, this pack was imported by the Ontario-based T. W. Hand Fireworks Company, Ltd. After arriving in Toronto, it was sold in border fireworks stands to Michiganders and upstate New Yorkers for the Fourth of July.

Bango
Jebsen & Company
Made in China for use in Canada

Li & Fung, Ltd.: Founded in 1906, Li & Fung relocated to the deepwater port of Hong Kong after the Japanese occupation of Canton in 1937. Exporting fragile products such as porcelain ware and ceramics along with explosive Black Cat, Giraffe, and Zebra firecrackers, Li & Fung established a reputation for its care and reliability in packaging.

Black Cat
Li & Fung, Ltd.
Made in Macau, Class 3

Toronto. The owners and purchasing agents came to socialize a little and spend some of the year's receipts, but they came mostly to do business.

Representatives of firecracker exporters from China also came to show off their colorfully packaged wares, negotiate prices, and make sales under the pressure of knowing that if they blow it here, they've lost most of the American market for a year or more. After all the presentations and negotiations were done, the American importers and distributors made their deals, and the manufacturers and exporters went back to Asia either empty-handed or with fistfuls of orders for the coming year.

Li & Fung

One of those exporters was the Li & Fung, Ltd., perhaps the most significant of them all, which paradoxically specialized in both firecrackers and fine china. When political situations calmed down in China during the 1930s, the company reopened business on the mainland with a firecracker plant. The company created its own brands, two of which are still famous, Giraffe and Black Cat. Unfortunately, just as the company got going, a new political firestorm hit: the Japanese army occupied the factory in the early days of World War II.

Five years after the war ended and the company was again on the road to prosperity, another blow struck. In response to China's intervention in the Korean War, the United Nations imposed a trade embargo against it.

To continue business without interruption, Li & Fung opened its own factory on Macau, one of six licensed by Americans to export firecrackers to the U.S.

The company eventually took over managing and representing the other five factories as well. But since mainland plants couldn't sell to the

world, their production wasn't enough to keep up with the post-war demand for firecrackers. Li & Fung saw the opportunity and opened a new plant in Taiwan called the President Firecrackers and Fireworks Company, Ltd. For the five years from 1967 through 1971, their firecracker factories did very well. Little did they know that the bottom was about to fall out from under them once again.

What happened? In 1972, President Richard Nixon and Secretary of State Henry Kissinger visited China in a dramatically unexpected reversal of U.S. policy. As a part of the good feelings, Nixon lifted the U.S. trade embargo against China. This was great news for world peace and the economy of the main-land, but it was the death knell for the firecracker makers of Hong Kong, Taiwan, and Macau.

Chinese mainland factories had better access to raw mate-rials and plenty of government-subsidized labor. Within two years, the cheaper Chinese firecrackers took over the market and drove the plants in Macau completely out of business. The golden age of firecrackers was over, and all that was left were the rotting buildings from which a billion packs of firecrackers once were rolled, powdered, fused, and packaged. ✳✳✳

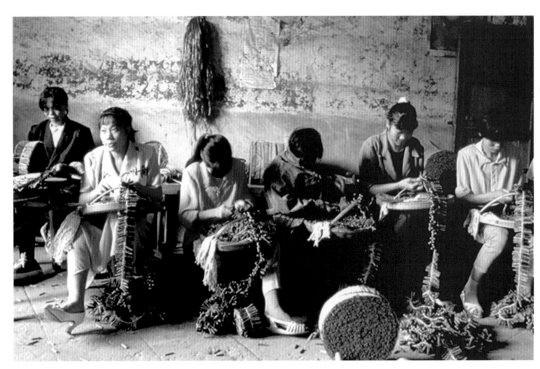

Workers braid firecrackers at the Black Cat firecracker factory. Hunan, China, ca. 1995.

Chinese Celebrations

Amidst the sound of firecrackers a year is out,

With a spring breeze instilling warmth into the tusu wine.

As the morning sun shines over the gates of every household,

The old Door God pictures are sure to be replaced by new peachwood charms.

—Wang Anshi of the Song Dynasty (960–1279 C.E.)

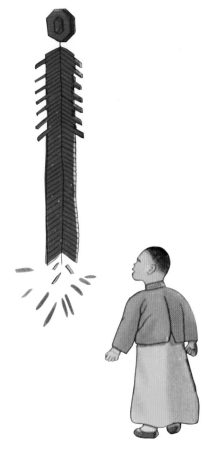

Firecrackers have been part of nearly every Chinese celebration for more than a millennium. From weddings to dragon dances, from funerals to store openings, firecrackers have been there. Let's look at a few of the particularly firecracker-intense Chinese ceremonies in detail.

Chinese New Year

"In the deep mountain of the West, there was a fierce demon that caused people to fall ill. The sound of firecrackers will drive this demon away." The ancient chronicler who wrote that was describing Nian. According to legend, Nian is a horrible creature who may have looked like a human (or a dragonlike unicorn, depending on the legend). Nian lives in remote mountains and comes out at the end of each year to kill people and livestock in the most savage ways possible. Villagers had tried fighting Nian, but the creature came back year after year, ravaging, killing, and laying waste. (Since "Nian" is also the word for "year," it's easy to wonder if Nian may actually be just an unconscious metaphor for the effects of time.)

Opposite and detail above:
China Bride
Li Toming & Company
Made in China, Class 1

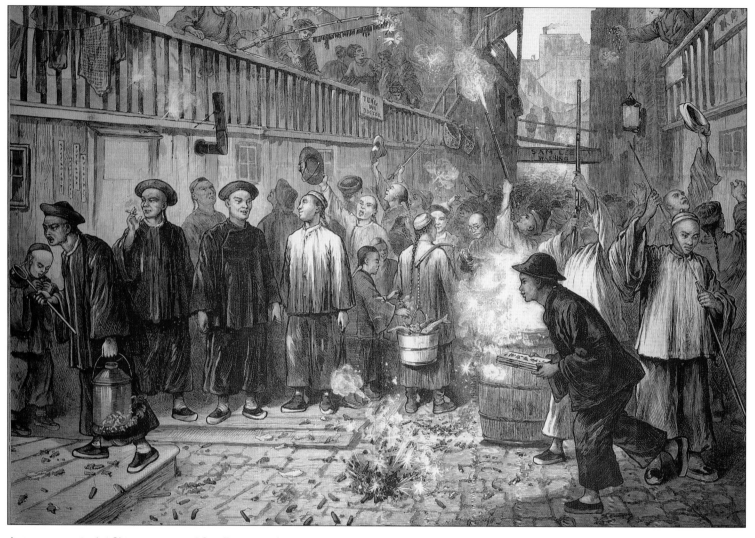

A street scene in the Chinese quarter of San Francisco, California, during the celebration of Chinese New Year's.
Frank Leslie's Illustrated Newspaper, March 6, 1875.

After many unsuccessful encounters, however, the villagers learned through trial and mayhem that the monster was afraid of three things: noise, sunshine, and the color red. As a result, New Year's celebrators began lighting bonfires, setting off thousands of firecrackers, and painting their doors bright red to keep the ravages of Nian away from their households.

Traditions in modern times continue on in the same vein. Celebrations of Chinese New Year can last for more than two weeks, although many modern celebrants cut down their observances to a few days or less.

Chinese New Year, which can be a mix of both festiveness and sadness, is based on the lunar calendar, meaning that it doesn't occur on the same day every year. It is celebrated on the first new moon that occurs between January 21 and February 19.

Traditionally, the festivities run for fifteen days, starting the night before the New Year and ending with the brilliant lights of the Lantern Festival on the full moon. Each day in between is imbued with symbolism for what we all long for: good health, happiness, and riches.

It's a time for the positive "yang" energies to muster their

forces and become dominant, sweeping away negative "yin" influences for a short while. Part of the process is to make things new around the house, finish off business, pay debts, and put up colorful New Year charms and posters.

Part of the traditional celebration involves painting door gods and couplets about the new year on the doors of the household. The door guards are the fierce warriors Shentu and Yulu, guardians of the underworld, who protect families from demons, and therefore are always depicted armed to the teeth. The demons know that if they venture too close, the door gods will bind them with reed ropes and throw them to their pet tigers as a New Year's treat.

The couplets represent a different impulse completely—a chance for the family to demonstrate its elegance and eloquence. Hand-painted with powerful, clean strokes, the couplets are written about good fortune, long life, and (in the past, anyway) the good fortune of having many male offspring—the idea being to bring these things forth by writing about them, as well as demonstrating the wit and education of those who live within. The inspiration for the couplets is said to be an inscription attributed to the Emperor Meng Zhang in the tenth century that hung on his bedchamber's door:

The New Year brings in overflowing good fortune,
The great festival is named Everlasting Spring.

In the present time, merely tacking up pictures of the gods and preprinted mass-produced couplets is considered sufficient.

Here is how New Year's Eve is celebrated in traditional Chinese households: On the eve of the new year, when all members of a household have arrived home, the family explodes a string of firecrackers outside the door before closing it for the last time that year. The idea is to scare the bad spirits away from the door long enough to get the door closed and thus shut them all outside. This ceremony is known as "door closing with firecracker protection."

Once the door is safely closed, family members will

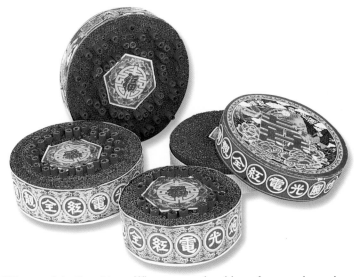

Chinese celebration strings: When unwound and hung from a pole, each celebration string is topped by a hexagonal bundle of firecrackers, called the Po Goi, or hex-head. The dangling, two-layer string of firecrackers will blaze upward and finally ignite the Po Goi in a climax of conflagration.

not open it again that night. They seal the door with a red paper cutout of the Chinese character meaning "wealth." Then, while lighting up every corner of the house in the hope of scaring away anything that may bring bad luck in the coming year, the family celebrates inside with food and drink into the wee hours of the morning. It's a night when children are allowed to stay up until long after midnight if they can; the adults try to stay up even longer in the belief that the longer they can go without sleeping that night, the longer the family elders will live in good health.

The next morning before the dawn, a string of firecrackers is lit immediately after opening the door (called "door opening with firecracker protection"), and then up to six additional strings can be lit for happiness, fortune, and longevity.

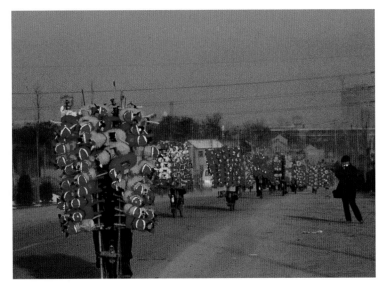

Bicyclers transporting firecrackers and fireworks to celebration. Beijing, China.

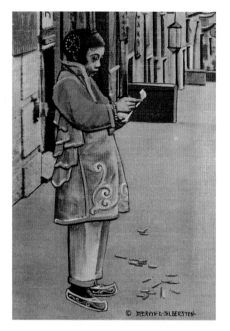

Left: Girl lighting firecracker, Chinese New Year. Chinatown, San Francisco.

Lantern Festival

The Lantern Festival is what non-Asians have come to know in the United States as "Chinese New Year." Dancers perform inside paper dragons and lions; there are plays, feasts, drumming contests, and a procession of fancy illuminated paper lanterns. And, where permitted by law (and in many cases, even where prohibited) a constant pop of firecrackers.

The origin of the holiday is unclear, but it seems to date back more than a thousand years. Originally it was a time to focus on praying for warm weather, spring rains, and fertility. As early as the sixth century C.E., public display of oil lamps inside elaborate lacquered lanterns was a hallmark of a three-day festival at the full moon. During the Song dynasty (960–1279), the festival was extended to five days and featured "rice-sprouting songs" (*yangge*), ghost exorcisms, "dry boat" pantomimes (with men dressed as women sitting in boats), and dances of

For the next fourteen days, there is a continual series of ceremonies and activities honoring gods, elders, and ancestors. For example, on the third day, people sweep their houses to clean them of any poverty in the coming year. All rubbish and waste paper is taken to an open field to burn. When that's accomplished, they burn candles and incense and light firecrackers in order to clear away the old and bring in wealth and happiness.

On the fourth day, married women make a ritual visit to see their parents and their childhood homes. On the fifth day, businesses reopen for the first time in the new year, setting off a barrage of firecrackers again to add protection from bad luck. Over the next days there are open houses, visitations, and the prediction of fortunes by astrologers in the temples. Day seven is celebrated as the birthday of humanity; other days are considered birthdays of animals and even fruits, rice, and vegetables. Finally, the full moon on day fifteen brings the climactic part of the New Year holiday: parades, lights, and firecrackers in celebration of the Lantern Festival.

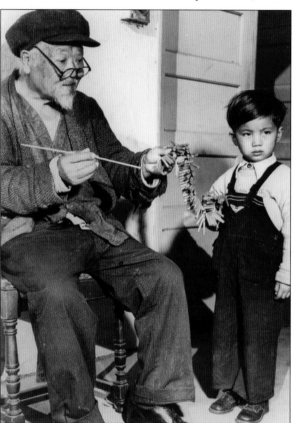

Above: Chinese elder with Chinese-American boy. Santa Cruz, California, ca. 1950.

Right: Charming girls of Chinatown, San Francisco.

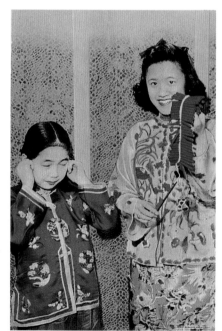

the lion and dragon-lantern. In the latter, dozens of people inhabit a cloth and papier-mâché dragon.

Like all long-celebrated festivals, the Lantern Festival has evolved over the years and continues to evolve. Now, for instance, in Yen-shui, Taiwan, braving a barrage of exploding bottle rockets during the Lantern Festival is considered a way to attain extraordinary good luck. In 1999, as has been typical in previous years, thirty people were injured severely enough to require medical attention.

Evolution of another sort is seen in the Lantern Festival in San Francisco. Although the dragon dance is still an integral part of the celebration—with a dragon that stretches as long as 160 feet, no less—the celebration now reaches out far beyond the Chinese community. In fact, in the United States, and particularly in San Francisco, what had been primarily a rural festival in China has become a multicultural extravaganza, mixing Chinese and American parade themes from the god of wealth to a drum and bugle corps to a gay chorus. "Although the dragon dance and promenade of immortal celebrities are adopted from the Chinese festival, the parade itself is a purely Chinese-American invention," write Carol Stepanchuk and Charles Wong in the book *Mooncakes and Hungry Ghosts* (China Books). "We have seen the birth of a new custom in the festival tradition, with a change in the ritual occurring just as other changes have through the millennia. In all likelihood, such a widely recognized and publicized event (more than one million television viewers and some 400,000 spectators) is here to stay."

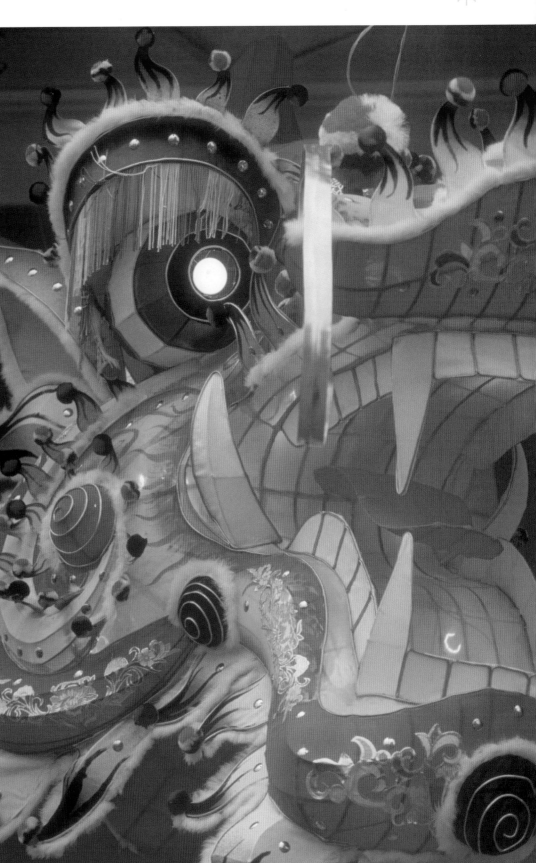

A dragon lantern glows at a festival for the Chinese New Year. Chiang Kai-shek Memorial, Taipei, Taiwan.

Right: Lion Dance. Chinatown, San Francisco.

Below: A dragon dance is performed through the smoke of firecrackers. Shenzhen, China, 1996.

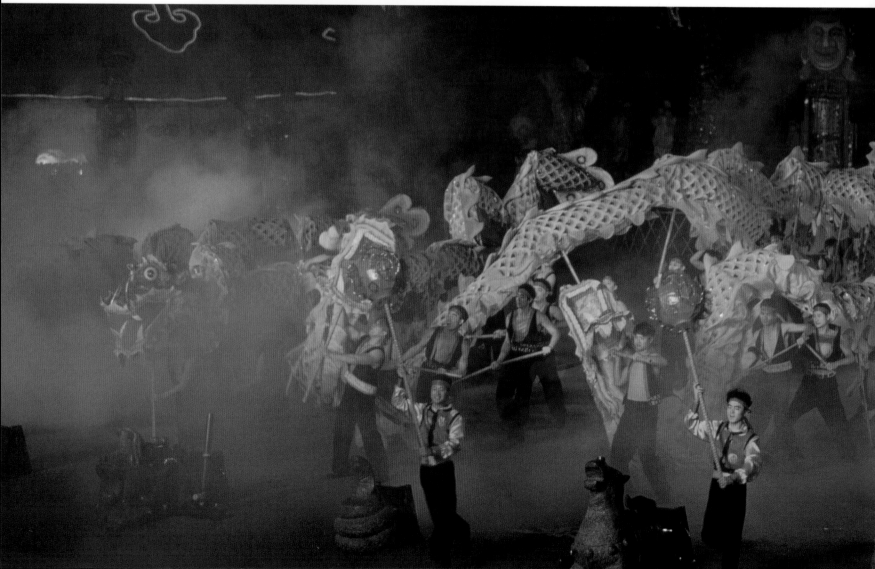

Dragon Boat Races

Duanwu Jie ("double fifth") is the summer festival held on the fifth day of the fifth month. The festival day goes back to prehistory, a remnant of the culture of the Baiyue tribe, who considered the dragon to be their tribal totem. The Baiyue cut their hair short, tattooed themselves so that they'd look like dragons, and actually considered themselves to be descendants of dragons.

Eventually, about 2,300 years ago, the day became an occasion to celebrate poet and politician Qu Yuan (born 340 B.C.E.), who is credited with writing patriotic odes while setting up a legal system and civil service that employed people of great competence and integrity. When a warlord's troops captured his city, Yuan jumped into the Mi-Luo River in Hunan, grasping a heavy rock with both arms. When the news of his death came to the

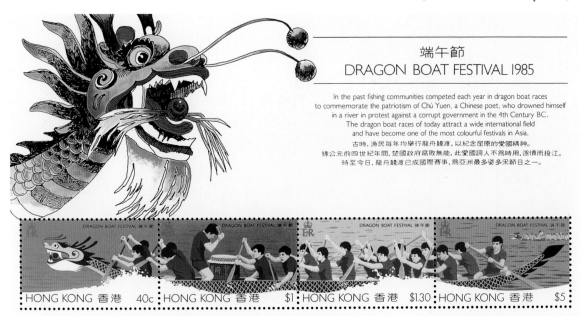

端午節
DRAGON BOAT FESTIVAL 1985

In the past fishing communities competed each year in dragon boat races to commemorate the patriotism of Chú Yuen, a Chinese poet, who drowned himself in a river in protest against a corrupt government in the 4th Century BC. The dragon boat races of today attract a wide international field and have become one of the most colourful festivals in Asia.

古時, 漁民每年均舉行龍舟競渡, 以紀念屈原的愛國精神。
緣公元前四世紀年間, 楚國政府腐敗無能, 此愛國詞人不爲國用, 遂憤而投江。
時至今日, 龍舟競渡已成國際賽事, 爲亞洲最多姿多采節日之一。

HONG KONG 香港 40c HONG KONG 香港 $1 HONG KONG 香港 $1.30 HONG KONG 香港 $5

The Hong Kong Dragon Boat Festival.

city, the citizens rushed to boats and rowed desperately to find his remains. Unfortunately, his body had apparently drifted down the river to the sea and was never recovered.

The citizens' boat search for Qu Yuan is, by tradition, the beginning of the Dragon Boat Races. Here rowers, to the percussive beat of drums and a background barrage of firecrackers, race hand-carved canoes bearing dragon heads. The boats ranged in size from forty to a hundred feet long. Each boat can hold as many as eighty rowers, who now mostly just race. In the past, however, the race also degenerated into small naval battles as crews taunted, rammed, and even sometimes assaulted the rowers in the other boats. As one observer put it, the impression one got from a distance was of witnessing "a race of drunken galloping centipedes." One of the most famous contemporary races is the annual Hong Kong Dragon Boat Festival.

Bomb Day

In California's Gold Rush era, many Chinese people ended up settling in rural regions of the state, working in mines, on railroads, and on farms. Marysville, forty-two miles north of Sacramento, had a fairly large Chinese population in 1854, second only to San Francisco. (Its Chinatown is among America's oldest still in existence.) The oldest Chinese mine workers erected a temple there to honor Bok Kai, "God of Water and the Dark North," the first (and quite possibly only) Bok Kai temple in North America.

Bok Kai's festival of tribute, Yee Yeit Yee, takes place on the second day of the second month of the lunar year, and (except for a few missed years because of world wars and things) Marysville has celebrated it with a bang every year since 1880, attracting participants and tourists from around the country and world. Not surprisingly, the celebration involves firecrackers. However, a holiday, which when translated means "Bomb Day," requires special custom firecrackers, which include prized rings. The bomb-making job has been passed along through generations. The bombs are made

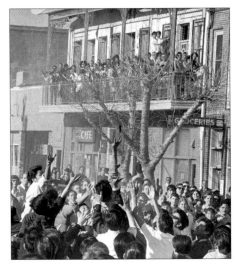

Left: Bomb Day: Spectators try to catch the lucky ring in the annual Marysville, California, festival.

Below: "California—The Chinese in San Francisco—On the Way to a Festival." *Frank Leslie's Illustrated Newspaper,* April 15, 1882.

with magazine paper rolled tightly around a stalk of bamboo, dirt, gunpowder, tape, satin cloth, a sealing-wax-like resin, and twine. The rings are made of a fine wire covered with satin ribbon. The finished firecracker bombs are covered with gold leaf, and, for safety, the fuses are inserted just prior to the ceremony.

Although the celebration includes a colorful parade and other celebratory stuff, the highlight is the firing of 101 of the handmade bombs. Within each extra-large firecracker is a numbered "fortune ring" that flies into the air; young people (and a few not-so-young) scramble to collect them. The rings are kept for a year's worth of good luck, or sometimes sold to onlookers. The number four ring is considered the luckiest and so commands the highest price, which reportedly has ranged in recent years from a few hundred dollars to a high of $2,000.

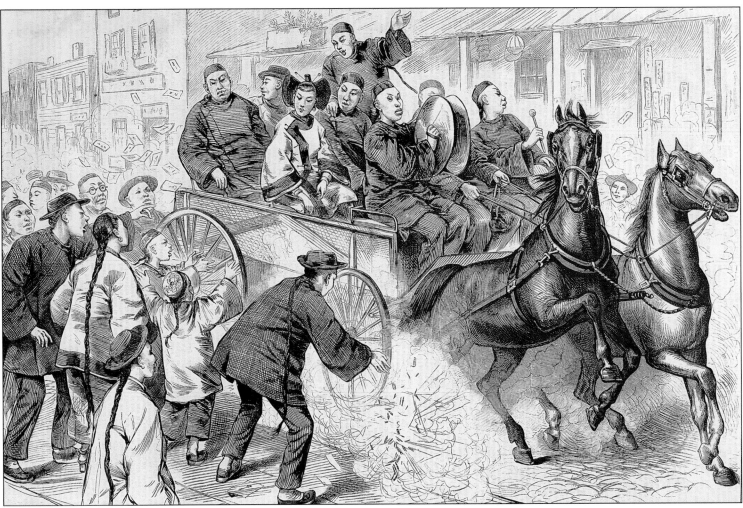

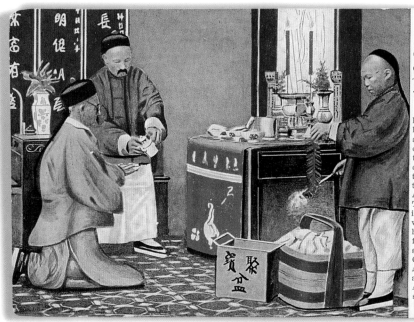

5.—THE CEREMONY OF ANCESTRAL WORSHIP.
—
A Chinese believes that he has three souls, and when he dies one goes to the other world, one into the tomb, and the third into the Ancestral Tablet which is treasured and worshipped by his surviving family. It is said that the Chinese spend £24,000,000 per annum on Ancestral worship.

Left: The ceremony of ancestral worship, Chinese Missionary Society. Hong Kong, ca. 1912.

Below: Farewell, a brand of ceremonial firecrackers that was used for Chinese funerals.

Farewell
Unknown
Made in China, Class 1

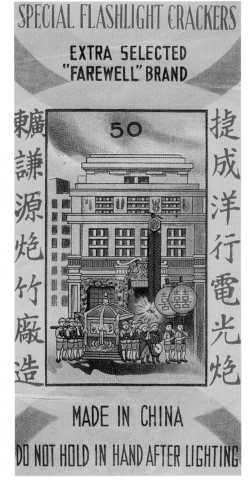

Other Practical and Ceremonial Uses of Firecrackers

Although firecrackers are a key part of many large festivals and celebrations, they also play a role in the more ordinary, everyday events of life. (Only rarely is the use of firecrackers prohibited. Firecrackers were banned by nervous authorities in Hong Kong during the Cultural Revolution in China in the 1960s, for example. Hong Kong residents had to make due with plastic replicas and recorded sounds of firecracker reports, but they continued to celebrate, albeit in altered fashion, in traditional ways.)

In China, firecrackers are used for almost everything ceremonial, from grand openings of stores to funerals to religious worship. (Firecrackers are, in fact, sold in stores that specialize in religious supplies.) By blasting away the negativity from the area, the bad spirits are sent away, leaving room for the good ones to join whatever ceremony is going on.

In weddings, for example, the explosions of firecrackers are depended upon to clear out "negative *chi*" (*chi* means energy) and "jealous *chi*." It is believed that if the spirits of jealousy attack during the ceremony, the bride may begin menstruating. Such a harbinger of bad luck, traditional Chinese believe, means that the marriage will not last long and will end in either death or divorce.

Just as weddings take place every day, so too do changes in employment and business ownership. It has long been customary to shoot off a string of firecrackers when someone moves into a new job or office. And when a new shop opens, it's traditional to keep the front boarded up until the last minute. Then enough boards are removed to let the owner squeeze through to light off a string of firecrackers and while they pop, the rest of the boards are removed and the store is opened for business.

Firecrackers, as we have seen earlier, are not only used in ceremonies for businesses but also as a part of home life. Many people, even non-Asians, swear by *feng shui*, the ancient Chinese art of arranging the interior spaces of homes and other buildings

to bring harmony, health, and good luck to the inhabitants thereof. Firecrackers hung around your household are believed to promote a change in energy and bring new beginnings, harmony, balance, fame, wealth, awareness, energizing of the lazy, comfort for all, and protection of the household from harm.

And as we saw earlier with the Lantern Festival, traditions evolve. Firecrackers are sometimes part of those evolutions. Chinese people who have converted to Christianity, for example, use firecrackers to celebrate Christmas. They blow them off while waiting for the arrival of Dun Che Lao Ren" ("Christmas Old Man"), a jolly fat man dressed in red who delivers toys to children. Here we see the Christian celebration of Christmas joined with its secular American counterpart in Santa Claus/Dun Che Lao Ren, and both are then spiced up with Chinese firecrackers.

For the Chinese, firecrackers are a part of nearly every aspect of life—work and play, sacred and secular, celebration and sadness. Although other cultures may not have integrated firecrackers into daily life as fully as the Chinese have, firecrackers have made their way into the hearts, homes, and celebrations of people around the world. Whether supplied with crackers from China or from their own indigenous firecracker factories, firecrackers are a part of celebrations from Vietnam to France, from England to Thailand—and, of course, in America, as we'll see in the following chapter. ✳✳✳

FIRECRACKERS IN EVERYDAY LIFE

One occasion in Chinese culture that has made liberal use of firecrackers was the celebration when Japan surrendered in World War II (August 15, 1945), as reflected in this account ("Crackers Pop & Dragon Dances in Chinatown") from the *Chicago Daily Tribune*:

Chinatown celebrated Japan's surrender last night with firecrackers in joyful disregard of the city's anti-fireworks ordinance. The firecracker stock-pile, which appeared sufficient to last through the night, was brought from China before the Japanese invasion and stored against the day of victory, said Gerald Moye, head of the On Leong Merchants' Association and esteemed as the mayor of Chinatown. "Shooting firecrackers is a way of saying, 'Thank God,'" said Moye.

Wentworth Avenue for a block south of 22nd Street was given over to the setting off of fireworks. Men, women, and children filled the roadway. They touched off small firecrackers a string at a time and now and then someone lighted one of the giant size.

Half a dozen dragon-shaped, twenty-foot clusters of firecrackers were suspended from the rooftops. Lighted from the bottom, the string exploded with deafening noise and showers of paper.

After an hour of firecracker shooting, in which everyone participated, the crowd fell back and

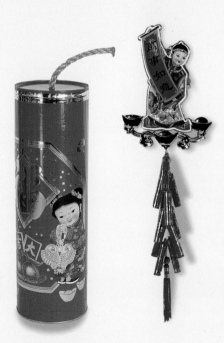

made room for a ceremonial dance of one dozen men filling the cloth form of the lion dragon. Formerly a religious rite, the dragon dance is for modern Chinese a means of celebration of any great national event. Tong members appeared with cymbals and drums. Street car traffic, which had been slowed, came to a stop.

One problem nowadays in the United States is the conflict between the exercise of religion and custom by Chinese-descent people and anti-firecracker laws in the cities and states where they live. In some cases, Chinese people have prevailed on religious freedom grounds; in others, bowing to the civil authorities and their own concerns about safety, they have used other means of simulating firecracker sounds, such as popping the bubbles in plastic bubble wrap or using recordings of firecrackers.

Left: San Francisco Chinatown New Year's ornaments include strings of plastic firecrackers and firecracker-shaped candy containers. Officially, genuine firecrackers are banned, but are still often used.

A-MA TEMPLE

Macau's name comes from "A-Ma-Gau," meaning "the place of A-Ma." A-Ma, a goddess disguised as a poor girl, once caught a ride with a poor fisherman when she was refused passage by wealthy junk owners. A storm blew up, destroying the boats of those who refused her, but the lowly fisherman was spared.

When the boat arrived safely in Macau, she vanished and reappeared in all her godly glory. On the spot where she is reputed to have been transformed, fishermen built a temple in the early sixteenth century. The A-Ma temple is built into a rocky hill and features prayer halls, pavilions, and courtyards, as well as firecrackers at regular intervals. Especially color-ful is the festival of A-Ma, which takes place on the twenty-third day of the third moon (April or May), during which members of tour groups jostle with worshippers to light "joss" sticks (a long-ago adaptation of the word "deus") and watch lion dances and the lighting of long strings of firecrackers.

Left: Illustration of the A-Ma Temple, Macau: The A-Ma Temple is the foremost religious shrine of Macau. Built into the side of a boulder-strewn hill, it consists of prayer halls, pavilions, gardens, and courtyards. Firecrackers to scare away evil spirits are exploded daily in the entrance courtyard.

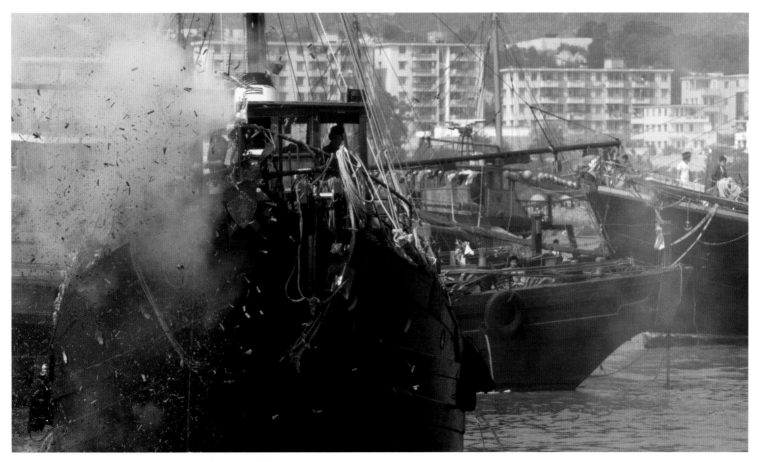

Firecrackers explode on a fishing boat in the port at Macau.

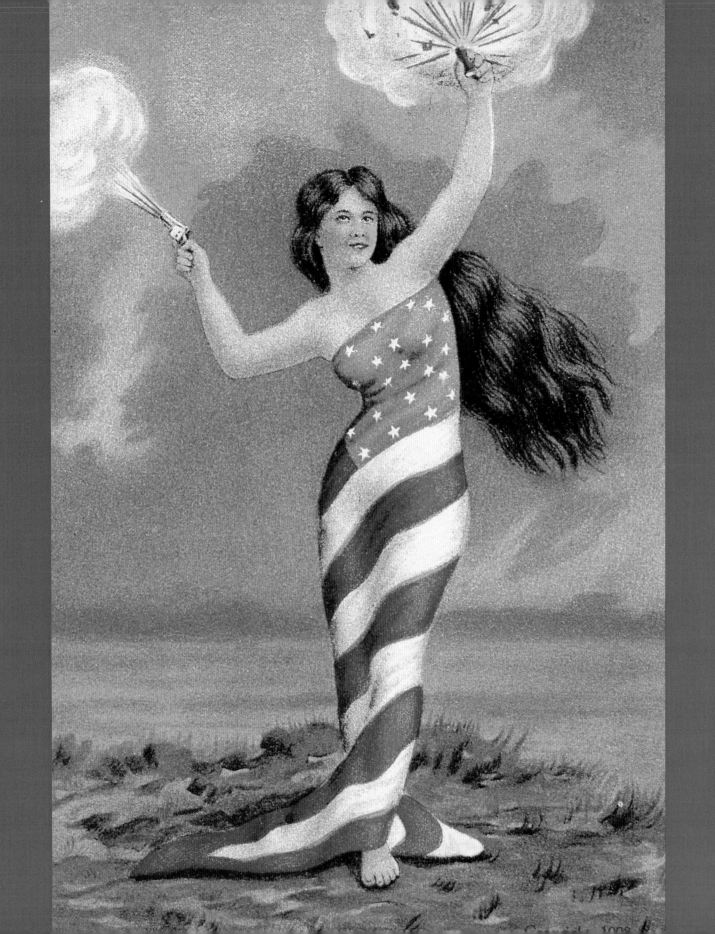

Firecrackers in America

Fireworks can provide a beneficial sense of mastery and power for youngsters.
The child is in complete control of what to him is something wonderful, and this in turn produces a sort of cathartic effect.

—Dr. William E. Schumacher, Maine Director of Mental Health, 1966

Above: "Hurrah for the Fourth of July": At the turn of the twentieth century, sending a Fourth of July postcard depicting Uncle Sam and firecrackers was a popular American tradition. ca. 1910.

Opposite: Miss Liberty, at Dawn's First Peep by Charles A. Beck, 1908.

THE SIGHT OF A GARISHLY PAINTED FIREWORKS STAND, the colors and crackle of a firecracker pack, the smell of burnt powder—for most Americans these things still bring back vivid memories of Fourths of July past. Americans have used (and sometimes abused) firecrackers in their ceremonies for more than two centuries—not much by the standards of Asian celebrations, but a long time nonetheless.

How the first firecrackers traveled from China to the New World isn't completely clear. Trade routes to Asia had made it possible that the Spanish introduced firecrackers to South America very early; some experts believe that the English and Dutch brought firecrackers to the northern colonies by the mid-1650s.

Still, we can surmise that firecrackers were not a common part of America's outdoor celebrations in 1776. Note their glaring omission in the 1776 letter John Adams wrote to his wife about what he hoped would happen in celebrations of Independence Day in future years: "pomp and parade, with shows, games, sports, bells, bonfires and illuminations." (Many people mistakenly assume that his use of the word "illuminations" refers to fireworks, but it actually describes a custom of placing candles in windows of houses on special occasions.) In fact, the earliest documentation of firecrackers coming to the United States happened eleven years later, as we'll see in this chapter.

Fourth of July

Even while the Revolutionary War raged, soldiers on the fourth day of July set a percussive tone that continued into all future Independence Day celebrations: they filled muskets and flintlocks with extra doses of gunpowder and fired them into the air—captured British guns were particularly treasured. After the British were routed (until 1812, anyway), the deafening tradition continued with pistols, cannons, and fireworks.

One ear-splitting form of revelry in rural areas was called "shooting the anvil." A blacksmith's anvil was placed on the ground and a bag of gunpowder with a fuse was placed on top of it. Finally, another anvil was placed upside down on top of the bag, the fuse was lit, and everybody scattered. This was to avoid being crushed like a cartoon character, because the top anvil was propelled into the air before returning heavily to ground. It was said you could hear the sound of a good anvil shoot for miles in all directions.

Finally, a decade after the American Revolution, firecrackers appeared. Elias Haskett Derby, a ship owner from Massachusetts, had commissioned the *Salem* as the first ever American-owned oceangoing vessel. On a 1787 voyage that took the ship to China and Calcutta, the captain heard firecrackers in the street and was reminded of Independence Day celebrations back home. He decided to fill some leftover cargo space with a few boxes of firecrackers, as much an item of curiosity as commerce.

Upon the ship's return to Massachusetts, the firecrackers sold so quickly that Derby wished there had been more cargo space available. "The firecracker's capabilities in aiding the uproar on the Fourth of July were quickly recognized," reported the *Wonder Book of Knowledge* in 1913. "Thereafter every ship that made the voyage from Massachusetts Bay to India or China brought back firecrackers with their shipments."

In densely packed larger cities, citizens quickly recognized that the practice of shooting pistols and anvils into the air was dangerous, especially in the hands of kids. Firecrackers were encouraged as a safer alternative. By the time of America's Civil War, Chinese firecrackers were making their

"Joined Together: Sam and John 'The Siamese Twins' of the Fourth of July" by L. M. Glackens. *Puck*, July 1913.

way deep into America's heartland as a Fourth of July tradition. But elsewhere in the country, firecrackers starred in another holiday—Christmas.

Beginning to Sound a Lot Like Christmas

Southern firecracker traditions developed differently from those of the North. From the 1830s until the 1930s, firecrackers were an intrinsic part of Christmas celebrations. Slaves before the Civil War, for example, were spared the labors of the field in the Christmas season. Some hoarded pennies in order to buy firecrackers and rockets; those who didn't even have that much to spend made their own firecrackers by blowing up hog bladders like balloons, tying them off tightly, and popping them in the flames of a bonfire.

The inclusion of firecrackers in southern Christmas celebrations may have been from factors relating to culture or climate, but some firecracker historians suggest darker motivations. The fact is, by the mid-1800s, there were good reasons for the Southerners to downplay Independence Day. First of all, the Fourth was about celebrating the birth of a nation that many of its citizens felt ambivalent about, a union from which the region would soon be forcibly prevented from leaving. Second, it must have given the South pause, with half of its population legally enslaved, to be celebrating a violent revolution against tyranny. Slave rebellion was a threat that gave slave holders pulse-pounding nightmares in the middle of the night—why give the slaves ideas about freedom, justice, and equality?

Given these circumstances, the big firecracker and fireworks celebration in the American South was Christmas. It fit their weather better than the North because, although fireworks over a snowy field is especially pretty, it gets hard to stand around in fields for very long in the cold, and it is especially hard to light fuses with mittens on. It also fit a basic fundamental religiosity. Finally, it fit the message they wanted to give their slaves: depend on Jesus, and you'll be free in the sweet by and by.

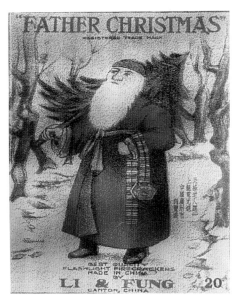

Top: Santa Claus
Him Shun Fireworks and Firecracker
 Manufacturing Company
Made in China, Class 1

Bottom: Father Christmas
Li & Fung, Ltd.
Made in China, Class 1

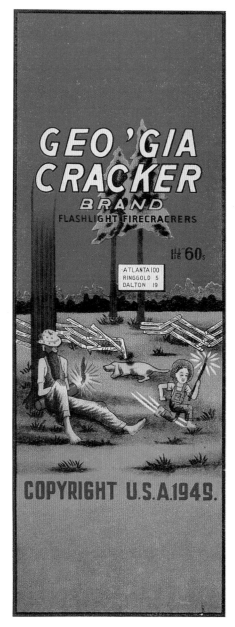

Geo 'Gia Cracker
Imported by D.S. Jones
Made in Macau, Class 2

Not that there weren't also isolated pockets in the North where guns and explosions marked the holy day. Pittsburgh, Pennsylvania, for example, was a northern city where the Prince of Peace's birth was celebrated with an ungodly racket: guns, noisemakers, and firecrackers. The *Pittsburgh Daily Commercial Journal* described the scene:

We are in the midst of the Holidays. . . . "Juvenile artillerists" shake the streets with small thunder; and firecrackers emulate the spluttering of musketry, while the screams of alarmed ladies, as some young rogue discharges his firecrackers at their feet, would prove annoying, were it not for the peals of merry laughter that invariably followed the fright.

In Philadelphia, a similar noisy custom was recorded annually from 1820 until it was banned in 1881: Christmas Eve marchers played horns, pennywhistles, spoons on pans, and handbells, and lit firecrackers to awaken the sleepy at midnight. Apparently, that wasn't as strange as it seems. Christmas noisemaking was a tradition brought from Europe, according to John A. Chapman writing about life in Dutch Fork, South Carolina, in 1832:

The young men of Dutch Fork retained many of the wild, frolicksome habits which their forefathers brought with them from the Fatherland. Perhaps the wildest of these customs was to ramble throughout the night on Christmas Eve, in companies of a dozen persons, from house to house, firing heavily charged guns. Having thus aroused the family, they would enter the domicile with stamping and scramble to the blazing fire, greedily eating the praetzilles and schneckilies, imbibe, with many a rugged joke and ringing peal of laughter, heavy draughts of a compound liquor made of rum and sugar, butter and alspice stewed together, and then with many a screetch and holler rush in to the night to visit the next neighbor.

Taking a small step back historically, the earliest known reference to Christmas fire-

Santa Claus [detail]
Woo Ping Fire Cracker
 Manufacturing Company
Made in China, Class 1

crackers appeared in a book published in 1821 called *The Children's Friend*. In the moralistic style that was fashionable for children's literature at the time, Santa Claus is quoted as saying:

To some I gave a pretty doll,
To some a peg top, or a ball;
No crackers, cannons, squibs or rockets,
To blow their eyes up or their pockets.

Despite this, in Mississippi in the 1850s it was traditional for Santa to bring both boys and girls "popping crackers," which were also called "babywakers" for obvious reasons. The crackers were lit with hot coals carried from the kitchen stove with a shovel.

There were some kids who would rather go without presents than firecrackers. Thomas A. Hord was six when his family was homesteading in a tent in Texas. Years later, he recalled the Christmas of 1844, when none of the kids in their settlement got gifts. They were determined, however, to have some traditional Christmas firecrackers. They stole some gunpowder from their fathers' supply tent, filled a hole in the ground, and set it off. A few of the kids were slightly singed from the explosion, but all of them felt the pain of spankings from their fathers that day.

Though for many people firecrackers were an essential part of Christmas celebrations, the custom of Christmas firecrackers was not universally beloved. An Englishman visiting Baltimore in 1866 wrote that he felt like he were in the middle of a war as "every ten minutes or oftener a gun or squib was fired off."

A reporter for the *New York Times* visited Washington, D.C., in culture a southern town, and complained in print that on Christmas Day, "the distracting reports of fire-arms and fire-works, an absurd southern custom, has at times been hideous."

By the 1930s, the "absurd Southern custom" had begun to disappear and Independence Day celebrations became the dominant firecracker celebration in the South just as they were in the North. However, there's a paradox: Even though

there are few reports of large-scale firecracker use around Christmas, the two weeks before Christmas is still a huge firecracker-selling time in the South according to fireworks stand operators. Is this an indication, as some have suggested, that firecrackers are being bought early for noisemaking on New Year's Eve? Or could it be that most of the buyers are Northerners loading up on contraband firecrackers on vacation trips to southern climes?

Childhood Memories

Though we all have collective memories of the big celebrations of the Fourth of July and Christmas that we share with our families, friends, and communities, we each also have our individual memories. This is especially true of memories involving firecrackers. Ask any adult male (and some females) of a certain age and they will likely tell you firecracker stories. "I placed my firecrackers safely in the front of my overalls to protect them from pranksters at the park," Dr. Harold William Wood reminisced, thinking back to 1917's Independence Day in Oklahoma when he was twelve years old. He'd spent his last nickel of the day on a pack of firecrackers. "I hid them because I'd heard about one boy who had his firecrackers in his hip pocket. A prankster lit a match to one of the exposed fuses which resulted in blowing the pocket off and giving the boy an unwanted 'hot seat.' Luckily, he was not burned or injured."

Ironically in this law-abiding nation, the most vivid memories seem to come from people who grew up in places where firecrackers were illegal. The smell of forbidden fruit—that is, gunpowder—made it much more exciting to buy, hoard, and blow off firecrackers than if

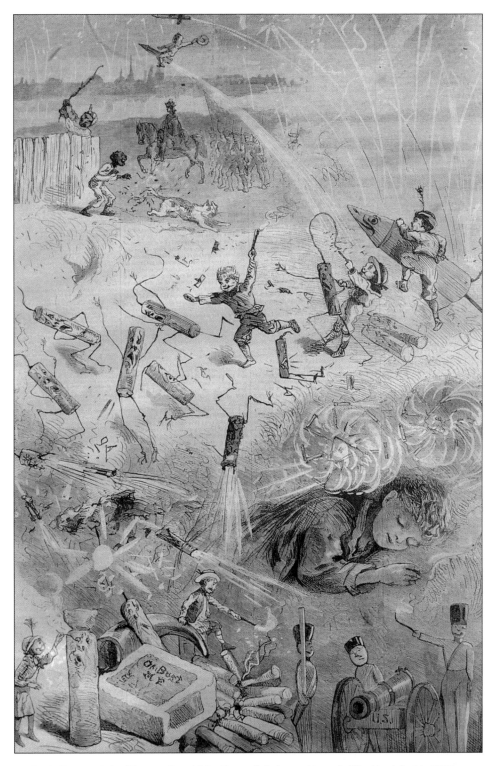

"A Boy's Dream of the Glorious Fourth" by Percival de Luce. *Harper's Weekly*, July 11, 1874.

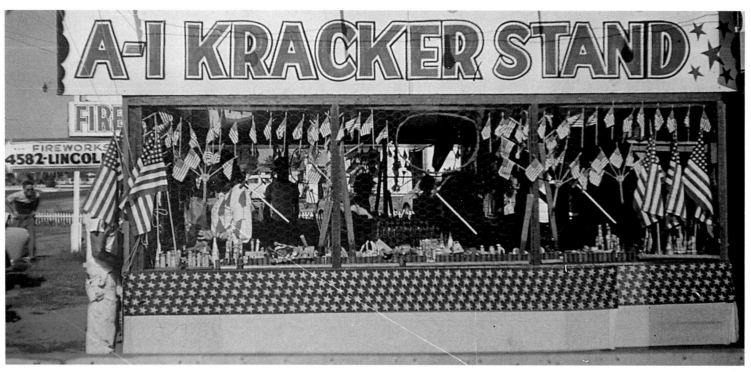

A-1 Kracker Stand

they were something you could buy in the local grocery store. *Pyro-Fax* magazine, a now-defunct "zine," once asked its subscribers to contribute first-person childhood firecracker stories. A disproportionate number were from places like Michigan, one of the first states to ban firecrackers back in the 1930s. The sto-

Boys on street corner with can and firecrackers. New York City, July 4, 1915.

ries had a certain consistency about them: The white-knuckle excitement of smuggling packs of Bango Brand firecrackers across the border from Canada. Borrowing Dad's car supposedly to go to a school dance and hightailing it to Ohio for a firecracker run. Trying to slip away from anti-fireworks parents while traveling through southern states, hoping to slip away during a gas stop to Silly Sally's fireworks stand. Or finding a shady older brother of a friend of a friend who'd sell a handful of loose firecrackers at outrageously high black-market rates.

When you're a kid who has blown his last pocket change on a pack of firecrackers, you're not likely to set them all off at once in a long string, Chinese-style. Instead, you're more likely to painstakingly unravel the braids of fuses and light them one at a time. One secret about firecrackers, however, is that unlike fountains or even sparklers, they are not intrinsically interesting after the novelty has worn off. A single explosion followed by another single explosion can become singularly dull, which is where the dubious creativity of youth kicks in. One of the *Pyro-Fax* recollections was a primer by someone named Pyro Jones about all the uses he found for a single firecracker—some relatively harmless, some not:

- "The Poor Boy's Firecracker Mortar": Putting a smaller empty can inside a larger can with a firecracker and firing the smaller one into the air.

- Knocking down milkweed plants by attaching firecrackers to the stems with masking tape.

- Setting up plastic toy soldiers into a battle scene on the ground and burying firecrackers among them to simulate explosions. "Flying plastic soldiers, craters in the soil, and some occasional sprays of dirt in our faces gave our playtime a more authentic feel," wrote Jones.

Every year in July, popular American magazines bring alive firecracker imagery on their covers.

- Using a steel pipe and a firecracker to launch corn cobs several feet. "A target was set up, or this device could also be used during battlefield maneuvers with the toy soldiers."

- Destroying model airplanes, boats, or cars that had outlived their interest.

- Tossing a snowball into the air with a lit firecracker inside. "On at least one occasion, a few of these 'cannonballs' were used during snowball fights, more or less to provide hits through fallout when getting a snowball into the enemy's fort was nearly impossible."

- "The exploding tomato held an even greater fascination," Jones wrote. However, he had to deal with angry parents

after one cousin, "a little overweight and not too fast on her feet" didn't clear the impact zone fast enough, splattering the back of her white blouse with tomato puree.

One of the recurring themes of childhood firecracker memories is that of looking for "duds" the day after celebrations. Some kids would cut them open and try to roll up a new firecracker; others would light the powder directly and let it sizzle; a few discovered that if you stamped on the powder as it burned, the pressure from your foot could sometimes get it to explode instead of just sizzle.

This magazine cover celebrating firecrackers and the Fourth of July was illustrated by the portrait artist James Montgomery Flagg. A decade later another of his works would become an American classic: "I Want You," the WWI recruiting poster of the pointing Uncle Sam. *Life*, July 5, 1906.

A coming together of icons: Just as Alfred E. Neuman is synonymous with *MAD* Magazine, so firecrackers are synonymous with the Fourth of July. *MAD* Magazine, July 1963.

Childhood memories of firecrackers also usually evoke memories of people—including adults who would inevitably try to place a damper on youthful enthusiasms and excesses. But the adults we remember most warmly are those who still had a bit of "kid" left in them, those who could play and celebrate with us, those who could have just as much fun setting off firecrackers as an adult as they did when they were children.

This kind of "play," we now know, has psychological benefits—though as kids we didn't think about "psychological benefits"; we just thought about fun. It's good to know that some adults—like Dr. William Schumacher, Maine's Director

of Mental Health—haven't forgotten about fun—and fireworks. In a July 1966 *Medicine at Work* article, Dr. Schumacher promoted a bill to legalize firecrackers, Roman candles, and sparklers in his state. He wrote:

> Fourth of July used to be a lot of fun, a day when we could celebrate not only our nation's independence, but also our personal independence. Fireworks are a wonderful way of getting rid of tensions. People ought to have a chance to blow off steam once in a while. . . . It is good for all of us to get an occasional superego release. Afterward we are all the better for it. Many cultures have blowoffs and whingdings, during which people can let their controls down a little. The Latin Americans have their carnivals, for example. What do we have? Our tension outlets are increasingly organized and controlled. New Year's Eve is about all, unless you want to count office Christmas parties. Injuries will occur, just as kids get hurt skating, cycling and playing football, but fireworks should no more be banned than bikes.

The Dr. Schumachers of this world help keep the brightness and sparkle of firecrackers alive in the memories of children—and adults as well. But even as Dr. Schumacher and others have argued for the preservation of firecrackers, many others have argued successfully against them. The main issue? Safety.

Firecracker Safety

On July 4, 1875, under a heading "Ninety-nine Fourth of July's," the *Chicago Tribune* editorial page railed:

> There have been really 100 of them—the original Fourth and ninety-nine cheap imitations. Ninety-nine times has the American eagle shrieked and the American orator roared. Ninety-nine times have we indulged in vocal pyrotechnics and Chinese firecrackers. Ninety-nine successive years have we set aside one whole day for killing small boys, putting out eyes, rending limbs, scaring horses, burning houses, and otherwise providing disaster, dismay, and disgust as a glorification and symbol of the American idea of freedom.
>
> But if we shall survive the hundredth repetition of unlimited license and folly, cannot some other and more sensible celebration of the

FIRECRACKER CANNON

The firecracker cannon was a novelty toy from the 1880s, designed to make shooting firecrackers a little less dangerous by putting the firecrackers inside an iron barrel and pointing them away from the shooter. The illusory safety became even less so when boys discovered that they could use the cannon to propel stones and metal ball bearings. A later cannon from the 1920s tried to channel this impulse by providing colorful but harmless foam-rubber projectiles to fire from the end of the barrel.

The cannons, with names like the Hotchkiss or the Home Guard, were either loaded from the muzzle, which put the loader right in the line of fire, or from the breech (the back) with a little hole for stringing the fuse through.

A variation of this that was introduced in 1937 was a little less safe, even though it was advertised as being "designed to take the firing of salutes out of the hands of children." The National Fireworks Company introduced the "Army Kraker Kit," which included a toy cannon, a box of firecrackers, and several paper targets. As described approvingly in *Nation's Business* (July 1937) in an article written by the company's vice president, each firecracker "is pressed against a spring inside the cannon and the fuse twisted into a patented notch at the cannon's mouth. The fuse burning away releases the spring which automatically hurls the salute 20 to 30 feet away, where it bursts. . . . Target-shooting appeals to nearly everyone and National feels that it has made the firing of salutes safe and more interesting. . . ."

Interesting, maybe, but safe? Not if it's your older brother doing the shooting. The ill-conceived firecracker launcher died quickly in the marketplace.

anniversary of American independence by invented? Can't we dispense with the crackers, and rockets, and pistols, and cannon, and gimcracks [a type of jumping firecrackers], and the whiz and bangs of the traditional Fourth?

FIRECRACKERS CAN SAVE YOUR LIFE

Firecrackers can have practical uses, even for adults. For example, consider this newspaper report from the early twentieth century:

Firecrackers Give Fire Alarm

Firecrackers served as an efficient fire alarm in the case of a house that caught fire in Minneapolis recently. Acting on the suggestion of a member of the fire department the owner when building his house had scattered firecrackers among the rafters, studding, flooring, and wall spaces. A test of this novel fire-alarm system occurred recently when fire broke out during the night. The popping of the firecrackers, set off by the flames, awoke the sleeping occupants of the house, who were able to put out the fire before it had got beyond control. Some firemen assert that this plan has no equal in giving an early alarm.

Above: Firecrackers scattered among the rafters, studding, and wall spaces of a private home have been reported to be an effective household fire alarm.

People have been warning of the dangers of pyrotechnics since a Chinese alchemist wrote a millennium ago that gunpowder can injure flesh and burn down houses. While the alchemist wrote in the hope of inspiring personal restraint, the anti-fireworks proponents wrote in the hope of inspiring prohibitions, often using statistically shaky data to bolster their appeal to emotions: "Only 10,048 soldiers were killed or wounded during the Revolutionary War which followed the first Independence Day, July 4, 1776. Since 1900, over 112,000 Americans have been killed or wounded celebrating that first day of independence," wrote the editor of the *Saturday Evening Post* on June 28, 1952, in an editorial titled "Must We Maim Children Just to Spite George III?" To understand the additional shrillness of the opposition to firecrackers, it is true that replacing gunpowder with flash powder increased the explosive impact of firecrackers, making them more dangerous to both make and use.

In response to editorials, injuries, and community concerns, firecrackers in the United States have been legislated nearly to the endangered species list. Some of the changes have probably been a good thing. For example, lowering the federal standard for the quantity of flash powder to 50 mg, the equivalent of one-sixth of an aspirin, has made it much harder to do permanent damage with firecrackers. Although eyes can still suffer injury from exploding firecrackers, holding a legal-strength firecracker too long nowadays would most likely result in little more than stinging fingers and ringing ears. Other steps taken by government and manufacturers include the following:

- Fuses are regulated so as not to ignite too quickly or slowly. Most packs have a thin lacquered "safety fuse." Located at the beginning of the braid of fuses, the safety fuse is difficult to light except at the very end, which makes it safer.

- Flash powder is now made with a more stable recipe. The oxidizer in the pyrotechnic flash powder can no longer contain potassium chlorate, which was much used in the past for its strength and loudness. Unfortunately, potassium chlorate also made the crackers much more sensitive to shock, so some thrill seekers enjoyed the jolt of detonating them by hitting them with a hammer on an anvil. Instead, the oxidizer is now potassium perchlorate. Sulfur is no longer used, making the crackers safer (although not as strong).

- Crackers are now braided in a way that makes them very difficult to unbraid, because the government feels single crackers are more likely to be blown off by unsupervised children than an entire pack.

Despite these safety precautions, most people live in places where it's illegal to own or use firecrackers. Eighteen states have banned firecrackers outright, and within the other thirty-two, many cities have enacted local ordinances making them illegal within city limits. So unless you live in a rural or semirural area of a laissez-faire state, you probably cannot legally own firecrackers.

Yet, even where illegal, the continuous drumroll of firecrackers is heard into the night as the Fourth of July approaches. The prohibiting has turned otherwise law-abiding citizens turn into smugglers and scofflaws, willing to defy the law in order to make a little noise. Like laws against alcohol in the 1920s or marijuana in our time, one effect is to engender a casual disrespect for law. Another is to reduce quality control as genuinely dangerous homemade explosives become the firecrackers most readily available, usually trying to replicate the cherry bombs and M-80 salutes of long ago. Those way-too-powerful big bangers were deemed felony "illegal explosive devices" by the federal government in 1967, saving fingers, hands, and school plumbing fixtures all over America.

As a black-market commodity, illegal firecrackers are manufactured in clandestine labs and basements, and so their reliability isn't very good. According to the Consumer Protection Safety Commission, "homemade firecrackers" are responsible for up to 40 percent of all fireworks injuries and for the vast majority of the ones resulting in serious injury and death. Bottle rockets, essentially unguided missiles with an explosive at the end, are responsible for half of the serious eye injuries.

Legal firecrackers can still put out a good bang, yet are reasonably safe if used as directed. For example, a study by the

FIRECRACKERS CAN SAVE YOUR CROPS

Using firecrackers in the field and garden? A *Reader's Digest* report from 1939 claimed that recycled gunpowder from firecrackers was good for vegetable gardens. An article from the March 1955 issue of *Farm Journal* has a more ambitious use of firecrackers: using them to scare marauding birds out of fields and fruit trees. Advised the *Journal*:

> Suspend a four-foot cotton rope, about $5/16$ inches in diameter, from a tripod of sticks or poles. Insert the fuses of firecrackers at intervals in the rope, and set fire to the bottom end. The rope will smolder away at the rate of about six inches per hour. The firecrackers explode as the rope burns, so that you can time the explosions by varying the distances between firecrackers. A set of firecrackers every 360 feet down the field does the job. Start bombing early, just as the birds fly in from their night roosts. (Better explain what's up to the neighbors and local police beforehand, though.)

American Academy of Pediatrics found that *legal* firecrackers result in only 16 percent of all reported fireworks-related injuries (that includes not just injuries from explosions but also things like toddlers eating firecrackers and having their stomachs pumped). This statistic compares favorably with even sparklers, normally considered relatively benign, which are the cause of 19 percent. Still, anything fun can cause injury and should be used with caution.

In one sense, the arguments for and against firecrackers and other fireworks in the U.S. revolve around the two poles of American democracy: individual freedom and community responsibility. The tension between those two poles helps make America what it is—with both its conflicts and communions. And chances are, this being America, the debate about firecrackers will continue—and will continue to evolve. ✳✳✳

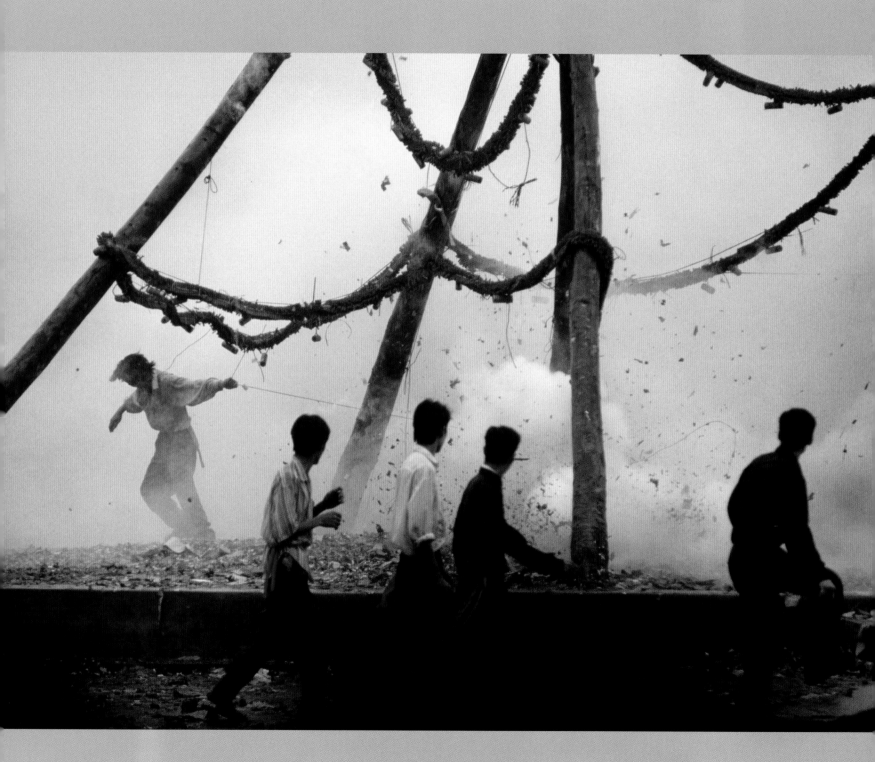

Firecracker Celebrations Around the World

It is a queer custom, this setting-off of fireworks, but it is observed in several countries:
among others, in England on the fifth of November (the anniversary of the Gunpowder Plot),
in China on New Year's Day, and in South America on all suitable and unsuitable occasions.

—William H. Rideing, 1874

BESIDES CHINA AND THE UNITED STATES, firecrackers play a role in celebrations around the world. In some countries, nearly any saint's day, celebration, or public revelry is sufficient reason to blow off some firecrackers. Let's look at some of the more interesting occasions where firecrackers have become an essential part of the celebration.

Guy Fawkes Day, England

In England, the Brits have celebrated Guy Fawkes Day on November fifth with firecrackers, revelry, effigies, chants, and songs for nearly five hundred years. Over the centuries, the celebrations have mellowed into a holiday similar to Halloween in the U.S., but that wasn't always the case. Back in the 1600s the celebration was a semisanctioned night of terror aimed at Catholics and their churches.

The holiday commemorates the thwarting of a plot by Guido "Guy" Fawkes and a small cadre of Catholics. After Henry VIII broke from Roman Catholicism and founded his own Church of England, the English government began confiscating Catholic church property, fining people who didn't attend Anglican services, and imprisoning, exiling, and killing priests.

Opposite: Tet firecracker celebration: Thousands of firecrackers are exploded during Vietnamese Tet New Year's celebrations. Sixteen local families near Hanoi spend the entire year making the firecrackers for this particular village. Dong Ky, Vietnam, 1994.

Below: Guy Fawkes and the "Gunpowder Plot" conspirators.

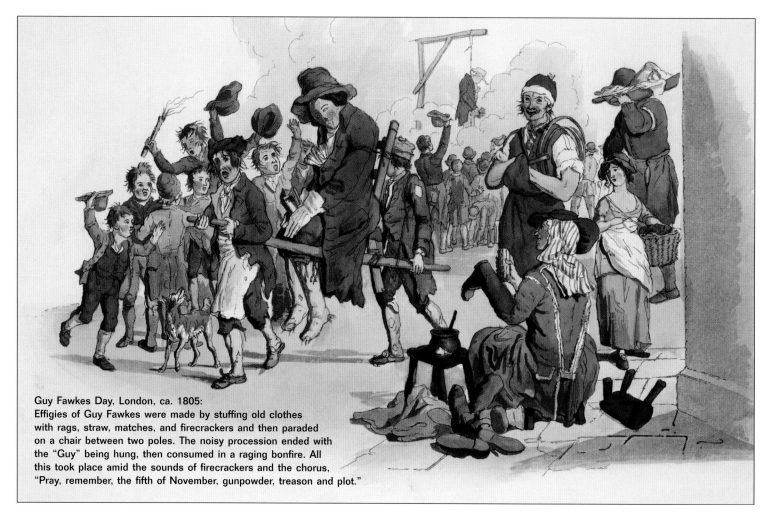

Guy Fawkes Day, London, ca. 1805:
Effigies of Guy Fawkes were made by stuffing old clothes
with rags, straw, matches, and firecrackers and then paraded
on a chair between two poles. The noisy procession ended with
the "Guy" being hung, then consumed in a raging bonfire. All
this took place amid the sounds of firecrackers and the chorus,
"Pray, remember, the fifth of November, gunpowder, treason and plot."

Five Roman Catholics, including the hapless Fawkes but led by Robert Catesby, decided that a radical solution was necessary. They decided to blow up Parliament on November 5, a day when James I, his ministers, his queen, and his oldest son would be attending. In the spring of 1605, they rented a storage cellar that happened to extend under the Parliament building. Over the next few months, they rolled in thirty-six barrels of gunpowder and then went their separate ways, waiting for November to roll around.

Catesby, meanwhile, made a fateful decision. He decided that a group of five people was not enough to take over the government and make England safe for Catholicism, even if they managed to wipe out the entire English political establishment

beforehand. Catesby recruited some more people into the plot. One of them, however, had a brother-in-law, Lord Monteagle, in the Parliament, and so he wrote an anonymous letter suggesting Monteagle not attend the November 5 session. Monteagle alerted the government and at about midnight on the night before, Guy Fawkes was discovered in the cellar with the thirty-six barrels of black powder and a pocket full of fuse material and kindling. Although he gave a phony name ("John Johnson"), he openly admitted that he intended to blow up the king and parliament.

While being tortured, he revealed his coconspirators. The thirteen conspirators were dragged through the city and condemned to death by drawing and quartering (along with some completely innocent priests) and their heads were put on public

Pray, remember, the fifth of November
Gunpowder, treason and plot.
I see no reason why gunpowder treason
Should ever be forgot.
Guy Fawkes, Guy Fawkes
'Twas his intent
To blow up the King and the Parliament
Three score barrels of powder below
Poor old England to overthrow
By God's providence he was catched
With a dark lantern and burning match....
A penny loaf to feed ol' Pope
A farthing cheese to choke him
A pint of beer to rinse it down
A faggot of sticks to burn him.
Burn him in a tub of tar
Burn him like a blazing star
Burn his body from his head
Then we'll say old Pope is dead.
God save the King!
Hip hip hooray
Hip hip hooray!

—"Bonfire Prayers," recited at the start and finish of
November fifth Guy Fawkes celebrations

spurting and squibbing fooleries in Lincoln's Inn Fields," and in 1660, tireless diarist Samuel Pepys noted "boys in the street fling[ing] their crackers" in celebrating the day.

The holiday evolved away from its strident anti-Catholicism as time went on. The night before became a time to do pranks of the soaped-window, treacle-on-the-doorknobs variety against friend and foe. It became a tradition to fill barrels with tar to be set on fire so that long plumes of flame emerged as the barrels were rolled down the street, presumably in imitation of the barrels of gunpowder. And in the eighteenth century, the effigies of the pope became "Guys" (after Fawkes). Children decorated the "Guys" with old clothes and grotesque faces and then went from house to house begging pennies in Guy's name in order to buy firecrackers. The firecrackers were hidden in the dummies so that when they were thrown into large community bonfires, they'd explode and make the effigy's burning even more dramatic. "I've seen a capital Guy Fawkes made with a broomstick, a ragged old coat, a battered old hat, and a penny paper mask," wrote William Rideing in 1874. "Boxes of matches, squibs and crackers were secreted about his ugly person, and then he was carried over the town in an old chair, with a chorus of noisy youngsters following after and singing: 'Gunpowder plot shall never be forgot / As long as old England stands upon a rock!'"

display on sharp poles. Needless to say, things got even worse for the Catholics living in England after that.

Guy Fawkes Day was part of that. From that year on, political figures and Anglican ministers determined that the "Papist treachery" should be remembered annually with inflammatory sermons, bonfires, bells, gun shooting, carrying seventeen crosses to commemorate the Protestants that Mary, Queen of Scots had burned at the stake when she was trying to move the United Kingdom back to Catholicism, burning effigies of the pope and Catholic saints, even smashing church stained-glass windows adjudged to have an "overly Catholic" theme. By 1647 the *Mercurius Elencticus* newspaper was reporting that firecrackers had entered the mix as well with "some

India's Firecracker Festivals

Firecrackers are associated with joyful Hindu festivals. In November, the five-day festival of Diwali honors a number of gods, but especially Lakshmi, the goddess of good luck. One of the last things done on Diwali is to drive out Alaksmi, the goddess of bad luck, poverty, and misfortune. This is done by sweeping, yelling, and making loud noises throughout the house. As in China, firecrackers are considered useful tools in this process.

Earlier in September, the explosions of firecrackers punctuate the ten-day festival of Ganapati Bappa Morya, celebrating the popular elephant-headed god, Ganesh. What makes him so popular is that he is the giver of fortune and prosperity, and he helps prevent natural catastrophes and obstacles to success.

Why does Ganesh have an elephant head? The most popular story is that his mother, the goddess Parvati, wanted to take a bath in Lord Shiva's house but needed someone to guard the door. So Parvati created her son from the dirt from her own body to stand watch. Shiva is the destroyer god whose meditation keeps the world in existence, so you can imagine that he'd have little patience with being barred from his own home. When he came home and found a stranger preventing him from entering his own door, he angrily chopped off the boy's head. However, upon seeing Parvati's grief, Shiva sent out troops to find a quick replacement for the boy's head. When they came back with an elephant, Shiva attached the head to the boy and revived him.

The Ganapati festival involves much music and uproar, many processions and thousands of clay statues—some standing as tall as a house—that are decorated with garlands of flowers, ornaments, and lights. Finally at the climax of the festival, celebrants immerse an image of Ganesh in a nearby river, lake, or ocean.

Oddly enough, the festival itself is not a very old one. Until about a hundred years ago, the days of Ganesh were celebrated quietly at home. An early Indian anticolonialist named Lokmanya Tilak saw the days as a chance of uniting Indians in a political celebration disguised as a religious one, with freedom of India being the goal. He figured that the British administrators, who were quick to quash mass political demonstrations, would be hesitant to crack down on a religious one. Still, while freedom from colonialism was still decades away, the festival took root and thrived.

India is one of the relatively few countries that has an indigenous firecracker industry, allowing it to avoid trading with China, with which it has had shaky and rivalrous relations for centuries.

"STANDARD" FIREWORKS, SIVAKASI.

Opposite: Lakshmi, the goddess of good luck.

Lakshmi
Standard Fireworks Ltd.
Made in India

Right: Ganesh, the god of fortune and prosperity.

Dipavali Crackers (Ganesh)
Excel Fireworks Industries
Made in India

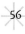

Vietnam Firecracker Day and the Tet Festival

Like India and Guatemala, Vietnam is a country that has a small indigenous firecracker industry. In the village of Dong Ky, they celebrate "Firecracker Day" on the third day of the third month of the Chinese lunar year. The festival goes back only a hundred years or so, created by local merchants to attract throngs of customers to soak up music, food, and crafts.

On Firecracker Day, families from villages around the area compete to create the biggest, best, and loudest firecracker. "The firecrackers give a big explosion, belching a lot of smoke and broken pieces of paper, amidst the sounds of drums and gongs and shouts from the crowd," says writer Do Phuong Quynh in *Traditional Festivals in Vietnam*.

As part of the festival, there's a ring game: A large firecracker shoots a small iron ring that people fight to retrieve after it hits the ground. If you catch it and keep it from the others trying to snatch it away from you, you will be guaranteed happiness and good fortune for the rest of the year, as well as win gifts of wine, meat, and eggs.

Vietnam's most important firecracker holiday is Tet, which

Celebrators carry a giant, decorated firecracker in the processional parade. Dong Ky, Vietnam, 1994.

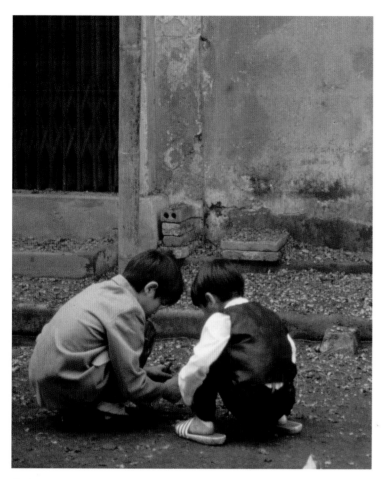

Children collect used firecrackers after the Tet New Year's celebration. Hanoi, Vietnam 1994.

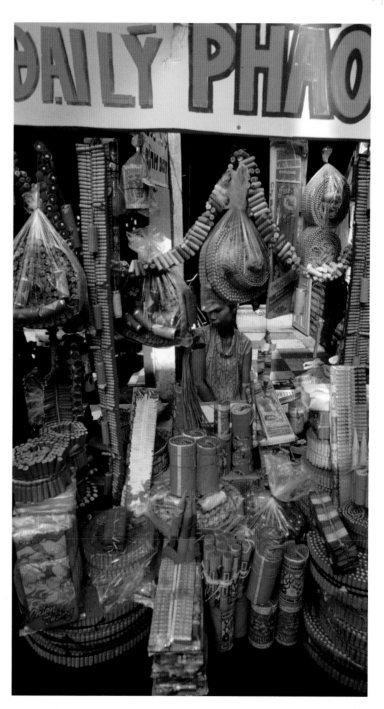

Firecracker stand in Phung Hiep Market. Mekong Delta, Vietnam, 1992.

means "the first day of the first month"—the Vietnamese New Year. Tet has borrowed a lot from the Chinese New Year, including its date, and many of the traditions are similar. Some interesting variations from the Chinese traditions, however, are worth mentioning. For three days, the people take extra care not to show anger or strife, because it's believed that Tet is an omen foretelling events for the rest of the year. Children are not allowed to cry or fight. People in mourning are not visited in the fear that doing so will foretell death. Houses are painted bright colors and people dress in new clothes, and at the stroke of midnight on New Year's Eve, loud noises usher out the old year and ring in the new. Tet is again being celebrated in Vietnam with firecrackers after a five-year ban by authorities that was put into place in 1994 after seventy-one people were killed by pyrotechnics.

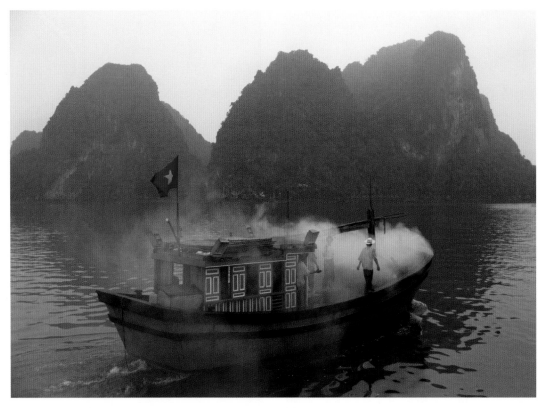

Fishermen set off firecrackers for good luck. Ha Long Bay, Vietnam, ca. 1990.

Thailand's Bun Bang Fai

Bun Bang Fai in late May is a two-day festival incorporating Buddhist, Brahman, and animist elements. It is also an excuse for grown-ups to play with huge and scary firecrackers.

Bun Bang Fai comes at the beginning of the arduous labors of the agriculture season. The biggest celebration is in the otherwise undistinguished town of Yasothon, where besides the gunpowder, the festival is a full-blown bacchanalia of drunkenness, cross-dressing, and women parading with large wooden phalluses. It's a two-day chance to drink, fight, curse, and act in sexually forbidden ways before returning to a culture where for 363 days of the year such things are tightly suppressed.

On the second day of the festival, villagers launch their homemade rocket bombs. The purpose is to shake up the skies, the clouds, and the rain gods in a region where drought is not uncommon.

Unfortunately, huge homemade rockets (some as long as several yards in length) are not the most dependable delivery system for the airborne firecrackers. In 1999, four people were killed and eleven seriously injured when a 480-pound rocket lifted about one hundred feet off the ground before plunging into a crowd of villagers. The villagers take that sort of thing in stride, however—five minutes later, the next round of megafireworks went up.

Winners of the rocket competition win a small official prize but a lot more in side bets among teams. Losers are wrestled into the mud.

France

On July 14 in France, Bastille Day is a big day for firecrackers, commemorating the storming of the notorious prison during the French Revolution. Ironically, there were no longer any prisoners there to save, but it's still a big holiday akin in spirit to America's Fourth of July.

South and Central America

As in China, much of South and Central America uses firecrackers during religious (and some secular) holidays. Indigenously made firecrackers from packs bearing names like The Hurricane and The Black Bull are used through December into Christmas and New Year's, as well as on significant saints' days.

Whether firecrackers really do prove devotion to God and country, or merely that people will use any excuse or occasion to make noise, they have achieved near universality as a way to celebrate just about anything. ✳✳✳

A papier-mâché Judas figure explodes in a burst of firecrackers during a Holy Week festival in Mexico City.

"In South American countries such as Chile and Peru, a friend of mine who lives there tells me that firecrackers are introduced at every festival and especially at those of the Church. The people derive a frantic pleasure from them and set them off in broad daylight and at all hours of the night. . . . Fireworks are also displayed during church services, so there is a perpetual Fourth of July."

—William Rideing, 1874

El Caballo
Unknown
Made in Macau for use in Mexico

The Art of the Firecracker Label

I N CHINA, BILLIONS OF FIRECRACKERS are set off annually for celebrations, so in the beginning, seeing a few hundred thousand being loaded into oceangoing schooners in the early 1800s was fairly insignificant. Even a century later, after the popularity of firecrackers had grown exponentially outside of China, Chinese manufacturers packaged them for export in the same way as for their domestic market: wrappers of cheap paper with Chinese lettering telling the name and location of the originating shop, shipped in wooden cases. The wooden cases, often also used as displays within the shop, were beautifully decorated with gold foil, which was embossed and hand painted in traditional Chinese themes of gods and dragons.

Their first, early bow to the American market around the turn of the twentieth century was to begin stenciling an eagle or other "American" animal on the labels to match the Chinese dragons and lions, and adding an English translation of the Chinese script.

Importers and retailers in the United States also treated firecrackers as an afterthought. Unlike Chinese luxury items like silks and fine ceramics, which could be sold for many times the wholesale price, firecrackers held the most appeal to kids for whom a small pack was a major expenditure. While it was true that the wholesale price in China was low (heartbreakingly so, considering how much handwork went into making a firecracker), the profit margin was slim enough that a shipment consisting solely of firecrackers wouldn't have been worth the freight charges, much less the tariffs at the other end.

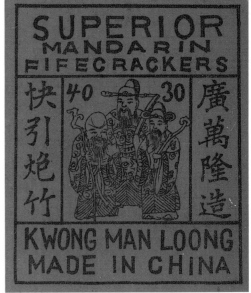

Above: Superior Mandarin
Kwong Man Loong
 Firecracker Factory
Made in China, Class 1

Opposite: Red Child
Unknown
Made in China, Class 1

Gold Labels

Gold labels were produced between 1850 and 1910 in the Canton region, particularly in Fat Shan (which is why they're sometimes generically called "Fat Shan labels" by collectors). Unlike much of firecracker art, the gold labels didn't come attached to the individual packs of firecrackers but were used to decorate wooden crates used for shipping the firecrackers.

Each label was gold leaf that was pressed against hand-carved wooden blocks. The embossed foil was glued to rice paper to keep its shape and then hand painted by up to twenty artists working assembly-line style. The gold labels depicted very traditional Chinese themes: gods and goddesses, Confucius, the eternal dance of yin and yang, dragons, flowers, bats, and unicorns. Because of the labels' fragility and because firecracker art was not much valued at the time, few of the gold labels have survived in good shape.

Left: Fat Shan Gold Label
Tong Tai
Made in China, Class 1

Above: The reverse side of this Fat Shan label reveals a rice paper address label of the Canton shop that made and sold it.

(The margin was low enough that when Chinese exporters Li & Fung began using paper instead of clay to close the ends of the firecrackers, they considered the few pounds of weight they saved as a competitive edge.) Through the nineteenth century and into the twentieth, firecrackers were considered less of a significant import item than ballast.

That changed. With the advent of color-printed national magazines and radio networks in the U.S. at the beginning of the twentieth century, manufacturers of everything from corn flakes to liver pills got a push toward mass marketing, colorful new packages, and bold new advertising slogans. American consumers and importers demanded more than cheap paper with stenciling on their products; they wanted bright new firecrackers in bright new packaging. With flash powder and a shipment of lithography machines to Hong Kong in 1910, Americans started getting what they expected: modern, full-color rice-paper labels affixed to glassine wrappers showing the firecrackers inside.

In a culture as old as China's, there are many stories going back into prehistory, and the first lithographed images on firecracker packages reflected those stories. As firecracker exporters became more attuned to the American market, Chinese artists also began portraying images that they believed would be better suited to America. Changing labels to American-themed designs was not hard for the Chinese. As manufacturers of goods for export to Europe and the United States, they easily adapted their designs to Western tastes—for example, their flawless rendering of Dutch windmill-and-wooden-shoe motifs on fine china.

Unfortunately, none of the actual label artists are known. Large exporters like Li & Fung may have had their own in-house designers; others may have used label experts like the Kwan family. The Kwans' patriarch, Kwan Chuck Lam, had been classically trained by the English artist G. Chinnery. His descendants became specialized in the fields of advertising, poster and label designs, and lithography. His great-grandson Kwan Wai Nung was the first to bring color lithography to Hong Kong. After founding the Asiatic Lithographic Printing Press, Ltd., Kwan Wai Nung became known as "the king of calendar art" and began producing labels en masse for a wide variety of products like tea, medicine, food products, and cosmetics. Firecracker manufacturers hired printers like the Kwan family to design and reproduce their labels, initially simply adapting many of the same designs

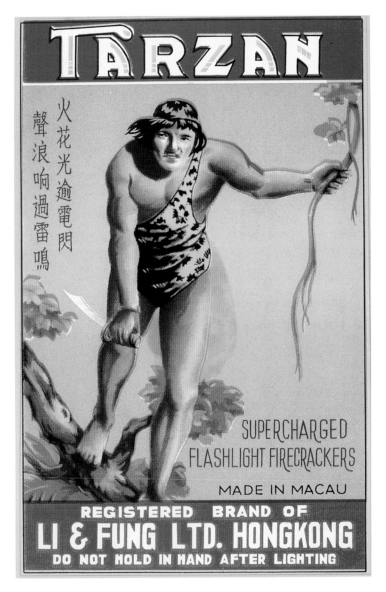

Tarzan
Li & Fung, Ltd.
Made in Macau, Class 2

and motifs that had already been successfully used to sell everything from soap to soup noodles.

As you'll see in coming pages, the artists borrowed images from sports, wildlife, American myths and legends, popular culture, and current events . . . sometimes successfully, sometimes with an occasionally jarring cross-cultural misfire.

Chinese Folklore and Mythology

To the people of China, each icon like a dragon or the golden-braceleted child No Cha implies an entire multilevel story in the place where history, legend, and religion intertwine. Most of the stories represent nobility, virtue, and wisdom: strength and goodness are represented by the dragon, the joy and sadness of eternal love by the cowherd and the weaving maiden, peace and prosperity by the phoenix, grandeur and felicity by the

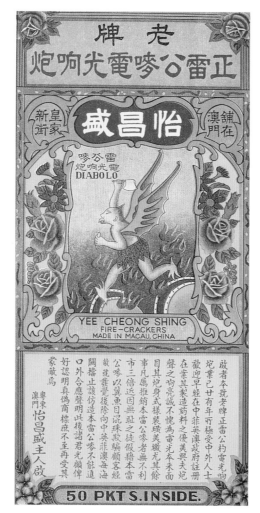

Diabolo
Yee Cheong Shing
Made in Macau, Class 2

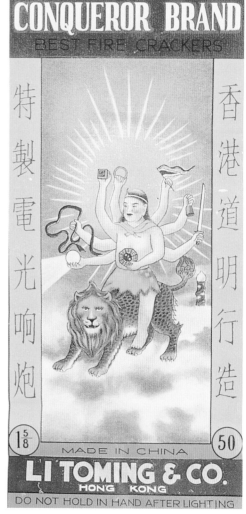

Conqueror
Li Toming & Company
Made in Hong Kong, Class 1

unicorn. Outside China, these mythology-based labels became inextricably associated with the country that invented the firecracker. They were loved for their exoticism and history. American firecracker buyers found these pictures fascinating, even though most had no clue to the stories behind them.

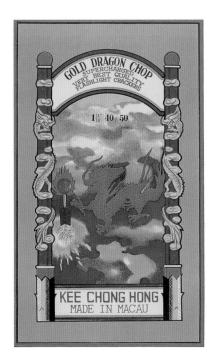

Above: Golden Dragon Chop
Kee Chong Hong
Made in Macau, Class 2

Right: Dragon
Nam Yang Firecracker Factory
Made in Macau, Class 2

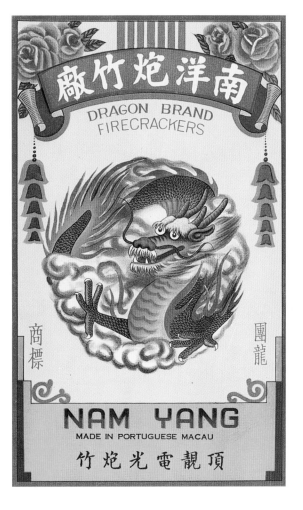

TIGERS

Tigers in China are considered as the kings of all wild beasts. They were common in ancient China. Marco Polo reported that they were so common in the northern parts of the land that traveling alone there was very dangerous. In mythology, however, tigers symbolize courage, military skills, and dignity and, like the dragon, they can drive off demons. As a result, tigers often adorn doorposts and even children's caps.

In a Chinese fable, Buddha invited every creature to spend New Year's with him. Only twelve appeared so he declared that a year would be named for each of the twelve faithful creatures. The tiger was made the third sign of the Chinese zodiac, a very auspicious number. Both the tiger and the dragon are usually depicted as solitary figures, so the firecracker label depicting the two together shows a rare meeting of two great forces of the universe.

DRAGONS

The dragon, one of China's most complex symbols, protects humanity from evil spirits. Unlike the Western species that are prone to firebreathing evil, Chinese dragons are good-natured and benign, yet powerful enough to shrink to the size of a silkworm or to expand to fill the space between earth and sky. Dragons hibernate underground in the winter and emerge exuberantly in the spring, and so they are a symbol of rebirth, fertility, joy, and health. When dragons play with a red, pearl-like thunder ball above the clouds, it causes the nurturing spring rains; it's not surprising, then, that their image is popular on the packs of thunderous firecrackers.

Right: Dragon and Tiger
Kwong Hing Tai Firecracker
Manufacturing Company
Made in Macau, Class 2

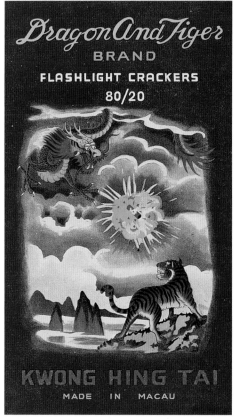

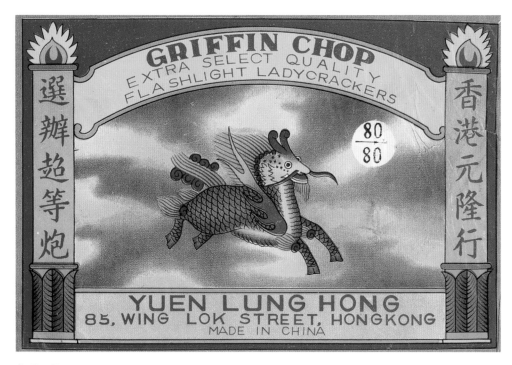

Griffin Chop
Yuen Lung Hong
Made in China, Class 1

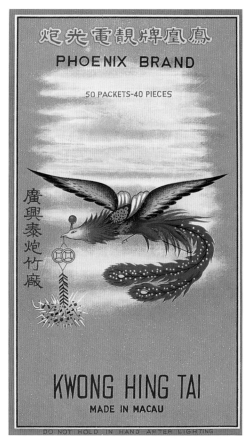

Phoenix
Kwong Hing Tai Firecracker
 Manufacturing Company
Made in Macau, Class 2

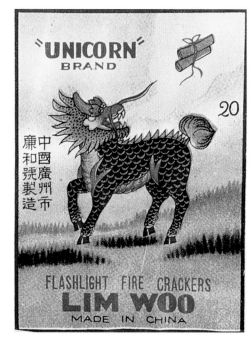

Unicorn
Lim Woo
Made in China, Class 1

THE UNICORN

The Chinese unicorn has little in common with its European counterpart. Called "Ky-lin," it has the body of a horse or deer, the scales of a fish, and one, two, or even three fleshy horns making it unsuitable for fighting. Ky-lins are good omens and are symbols of goodness, longevity, and wise and virtuous government. They can even walk on water and are kind to all living creatures. It is said that Confucius's mother became pregnant with him after stepping into a unicorn footprint; it's also said that a unicorn was last seen by humans shortly before Confucius died, and that they are hiding from us until humanity moves back from its state of brutality and corruption.

THE PHOENIX

In China the phoenix is the emperor of birds and has little in common with the phoenix of Western mythology. It represents unity through marriage and appears in many wedding accoutrements, including special packs of firecrackers perfectly suited for weddings.

The parts of a phoenix represent laudable human qualities: the head, virtue; its back, correct conformity with rituals; its breast, humaneness; its stomach, reliability; and its wings, duty—all of which apparently are believed to be particularly suited to unity through marriage.

NO CHA

No Cha, invariably depicted with his magic bracelet, is a very popular hero of Chinese mythology. He was born of the wife of Li Ching, the leader of a small kingdom before the unification of China. As she approached labor, she had a dream of a Taoist monk placing a bracelet to her bosom and incanting, "Receive the child of a unicorn." No Cha was born as a red glowing ball of flesh, and Li Ching decided that euthanasia was the right thing to do. But when he cut the ball open, a baby emerged surrounded by a red halo and wearing a golden bracelet and dazzling red trousers.

By the age of seven, No Cha had already grown to the height of six feet and had become a great warrior, traveling on two wheels of fire and using his magic bracelet and a flaming spear to vanquish the enemies of his father's kingdom. "No Cha," by the way, means "here is a loud cry."

Right: Roger (No Cha)
Kwong Hing Tai Firecracker Manufacturing Company
Made in Macau, Class 2

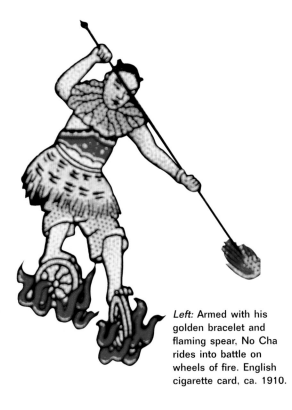

Left: Armed with his golden bracelet and flaming spear, No Cha rides into battle on wheels of fire. English cigarette card, ca. 1910.

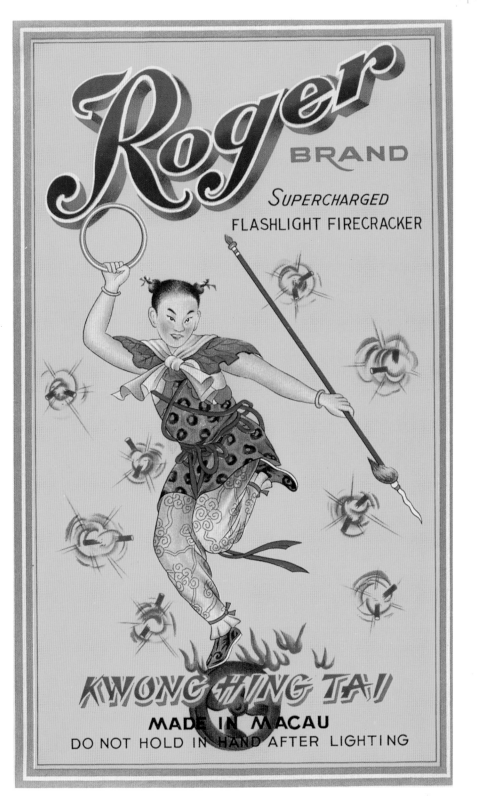

THE WEAVING MAIDEN AND THE COWHERD

The Weaving Maiden is considered a patron saint of woman's work, and the seventh day of the seventh month brings a festival in her honor. According to legend, she and her six sisters

The Weaving Maiden and the Cowherd
Kwong Hing Cheong
Made in China, Class 1

descended from heaven to bathe in a stream that ran through a cow pasture. There, she and a Cowherd fell so deeply in love that they stopped doing their labors. The Queen Mother of Heaven, upset at this state of affairs, summoned the goddess back into the sky. To the queen's chagrin, the Cowherd followed, so she took a golden hairpin and drew a great river, the Milky Way, to separate them from each other.

The Chinese can show you the constellations that they say are the two lovers separated in the sky. The Queen Mother eventually relented a little, allowing the two lovers a conjugal visit one day a year on the seventh day of the seventh moon. On this day, unmarried women on earth make offerings to the Weaving Maiden.

THE MOON MAIDEN

In Chinese mythology, the moon is populated by immortals. The goddess who rules them all from the Moon Palace is Cha'ng O, the Moon Maiden. Like the Weaving Maiden, the Moon Maiden is separated from her celestial lover. He lives on the sun and they can meet only once a month on the night of the full moon. Cha'ng O and her husband, Hou Yi, symbolize, respectively, the moon and sun, the feminine and masculine, the light and dark, and the yin and yang qualities that govern our world.

The Moon Maiden is often depicted rising to the moon after drinking a magic potion that had been given to her husband. Traditionally depicted sprinkling flower petals onto the earth as she floats heavenward, the label depicted on the facing page is unusual in that she is instead showering the earth with firecrackers.

Below: The Moon Maiden is a popular motif that can be found in a wide array of Chinese products such as kites, tea, incense, and, in this case, ornamental paper.

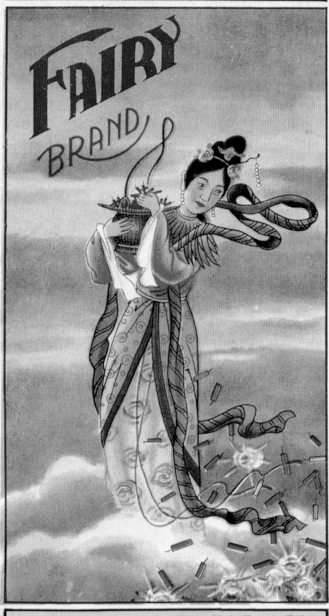

Fairy Brand
(Moon Maiden)
Ting Liu Factory for
 The Oregon Fireworks
 Company
Made in China, Class 1

Chinese Maidens

Firecrackers have a phallic, sexual component and these maidens play that up. Some are quite innocent-looking in traditional garb, but others show a less-than-innocent allure in lounging poses and sly glances.

Clockwise from right:
Maiden
Made for J. P. Vasunia & Company
Made in Macau, Class 2

Earth Brand Maiden Firecracker
Wong Kwong Hing Ho Kee Fire Works
Made in Macau

Maiden
Him Yuen Firecracker Company
Made in China, Class 2

Golden Bat Brand Maiden
Kwan Yick Fireworks Company
Made in China, Class 1

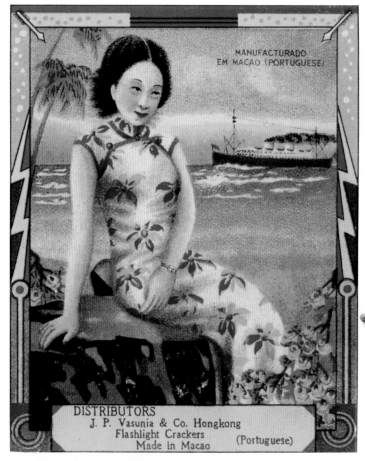

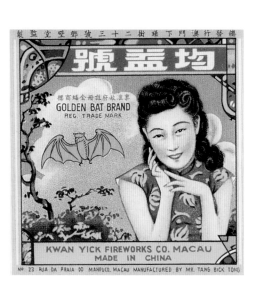

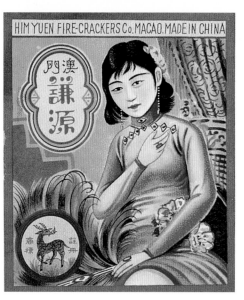

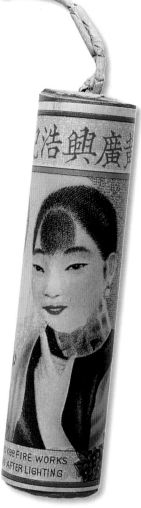

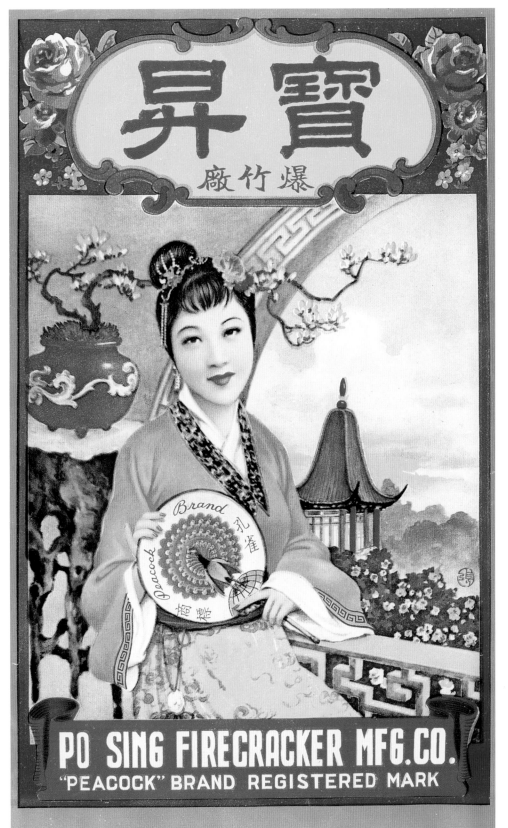

Peacock Brand Maiden
Po Sing Firecracker
 Manufacturing Company
Made in Macau, Class 2

Chinese Life

Who could resist scenes of beautiful places and children? Postcardlike labels show off the traditional, scenic side of China: a pagoda, the Great Wall of China, and a starry night on the Pearl River delta. The slice-of-life labels show Chinese kids doing kid things: setting off huge strings of firecrackers, sitting on sleds, and otherwise having an idyllic life. You have to wonder what the ten-year-olds working seventeen-hour days in the firecracker plants thought as they glued these labels on.

Clockwise from above left:
Big Boy
Tai Lee Hong
Made in China, Class 1

Star Light
Made for Balfour, Guthrie & Company, Ltd.
Made in China, Class 1

China Town
Ming-Hing Factory for Li & Fung, Ltd.
Made in China, Class 1

Golden Boys [detail]
Kwong Wah
Made in China, Class 1

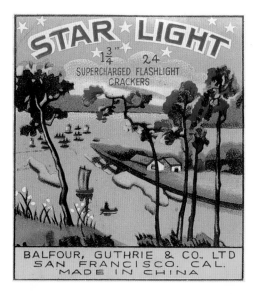

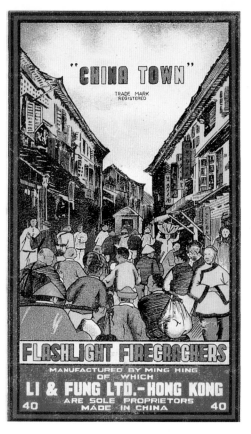

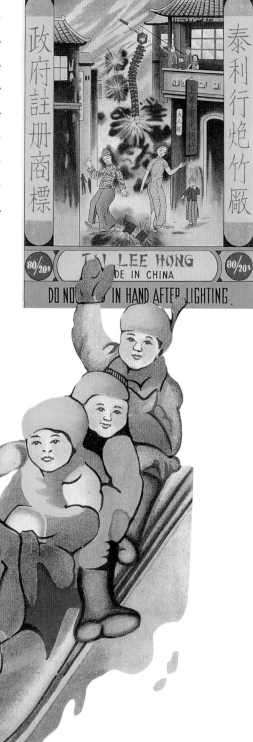

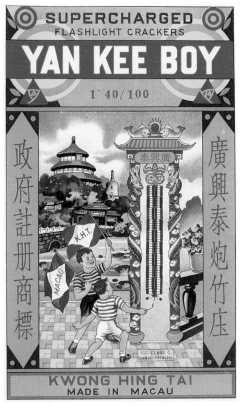

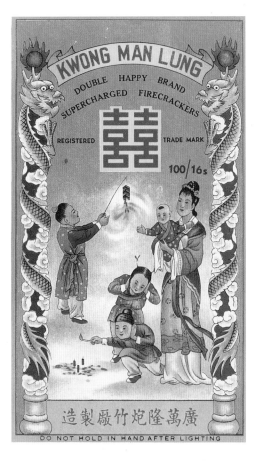

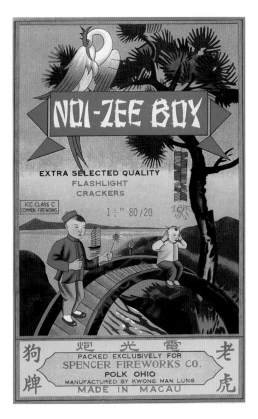

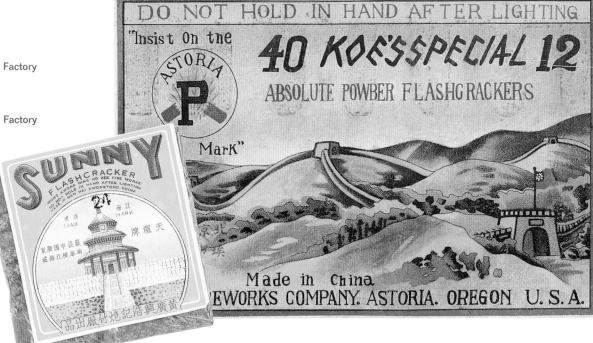

Clockwise from above:
Yan Kee Boy
Kwong Hing Tai Firecracker
 Manufacturing Company
Made in Macau, Class 2

Double Happy
Kwong Man Lung Firecracker Factory
Made in Macau, Class 2

Noi-Zee Boy
Kwong Man Lung Firecracker Factory
Made in Macau, Class 3

Koe's Special
Made for Pekin
 Fireworks Company
Made in China, Class 1

Sunny
Woo Kwong Hing Ho Kee
Made in China, Class 1

Warriors

The warrior has long been respected in Chinese culture. Warriors and gunpowder explosions go together, even if most of the firecracker soldiers look more like the hand-to-hand, spears-and-horses type.

Opposite, clockwise from upper left:
Chinese Warrior
Kee Chong Hong
Made in China, Class 1

Silver Knight
Made for Spencer Fireworks Company
Made in China, Class 1

Warrior
Kwong Yuen Hang Kee
 Firecracker Factory
Made in Macau, Class 4

Below: Warrior
Him Yuen Firecracker Company
Made in Macau, Class 2

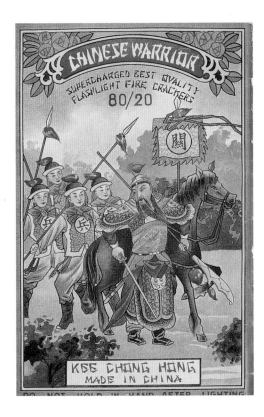

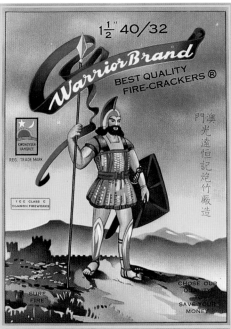

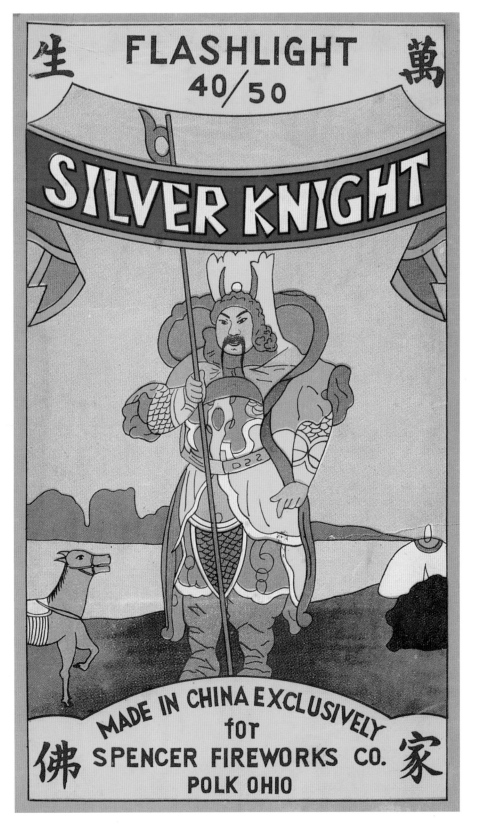

American Folklore and Pop Culture

The Chinese have their dragons and phoenixes, but Americans have their own mythology. Angels battle red devils, Tarzan swings with Daniel Boone and Robinson Crusoe, bats take flight with werewolves, and dinosaurs, King Kong, and baby giants live large—in our imaginations, at least.

Right: Angel
Kwong Man Lung Firecracker Factory
Made in Hong Kong, Class 2

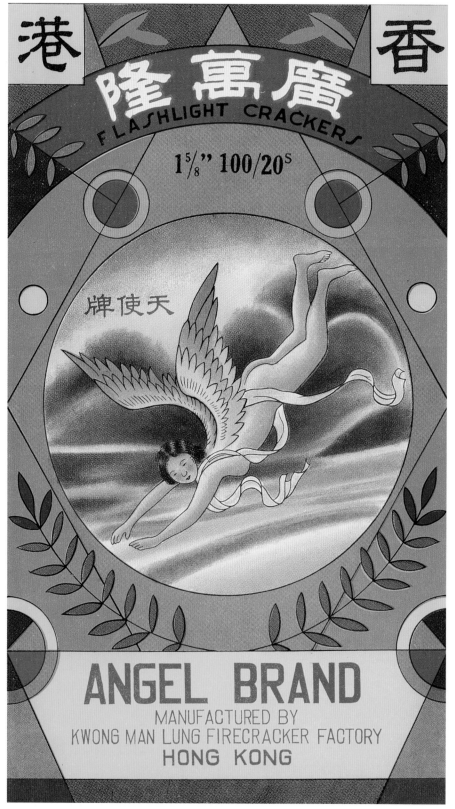

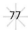

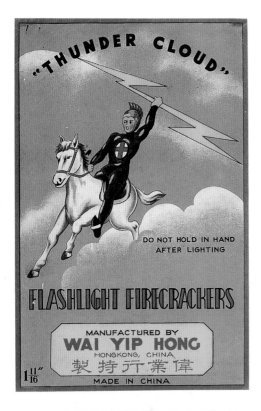

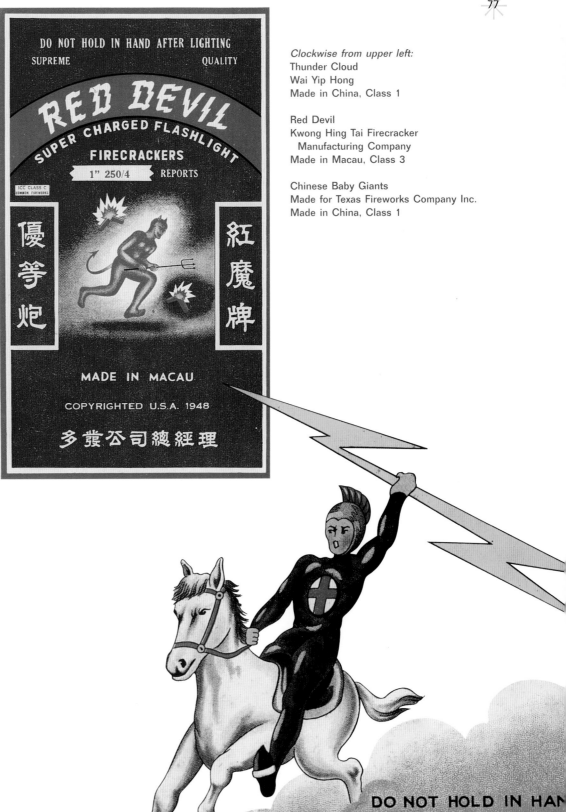

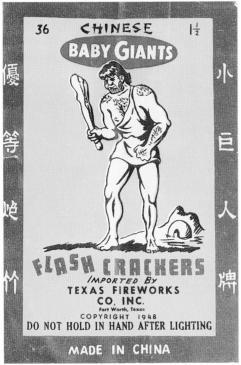

Clockwise from upper left:
Thunder Cloud
Wai Yip Hong
Made in China, Class 1

Red Devil
Kwong Hing Tai Firecracker
 Manufacturing Company
Made in Macau, Class 3

Chinese Baby Giants
Made for Texas Fireworks Company Inc.
Made in China, Class 1

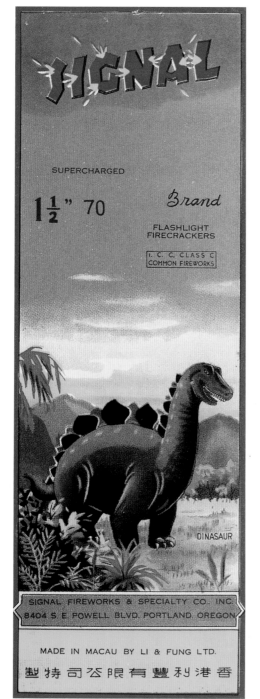

SUPERCHARGED

1½" 70 *Brand*

FLASHLIGHT
FIRECRACKERS

I. C. C. CLASS C
COMMON FIREWORKS

DINASAUR

SIGNAL FIREWORKS & SPECIALTY CO. INC.
8404 S. E. POWELL BLVD. PORTLAND, OREGON

MADE IN MACAU BY LI & FUNG LTD.

香港利豐有限公司特製

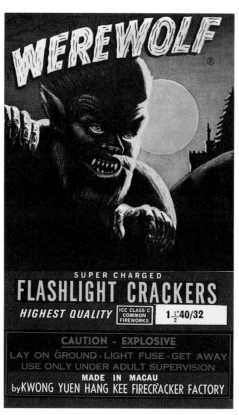

WEREWOLF ®

SUPER CHARGED
FLASHLIGHT CRACKERS
HIGHEST QUALITY | ICC CLASS C COMMON FIREWORKS | 1½"40/32

CAUTION - EXPLOSIVE
LAY ON GROUND - LIGHT FUSE - GET AWAY
USE ONLY UNDER ADULT SUPERVISION
MADE IN MACAU
by KWONG YUEN HANG KEE FIRECRACKER FACTORY

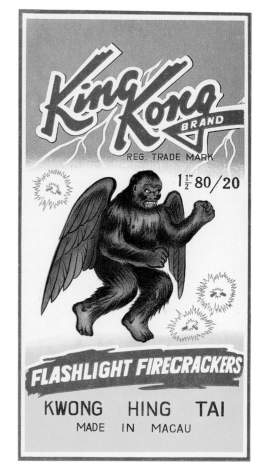

King Kong BRAND
REG. TRADE MARK

1½" 80/20

FLASHLIGHT FIRECRACKERS

KWONG HING TAI
MADE IN MACAU

Opposite, left to right:
Signal
Li & Fung, Ltd.
Made in Macau, Class 3

Werewolf
Kwong Yuen Hang Kee
 Firecracker Factory
Made in Macau, Class 4

King Kong
Kwong Hing Tai Firecracker
 Manufacturing Company
Made in Macau, Class 2

Below: Pioneer
Made for Dreyer
Made in Macau, Class 2

Below, center: Robinson Crusoe
Yue On Wing
Made in China, Class 1

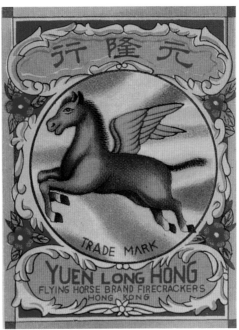

Left: Flying Horse (Pegasus)
Yuen Long Hong Firecrackers
Made in China, Class 1

Below: Captain Kidd
National
Made in China, Class 1

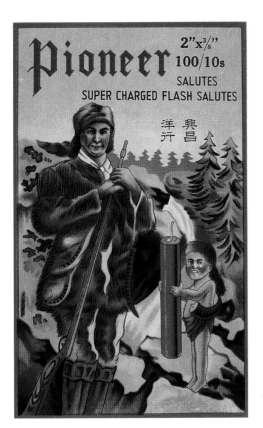

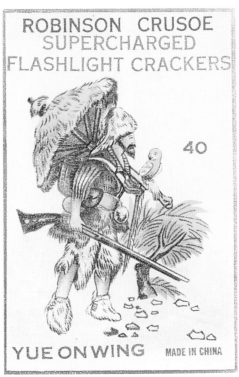

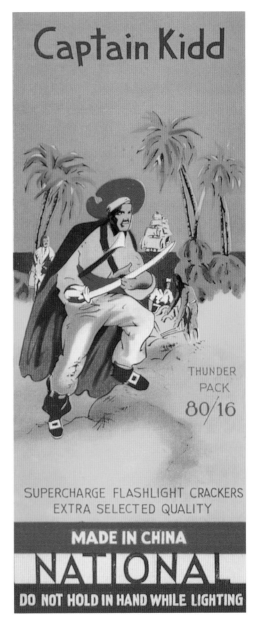

Cowboys and Indians

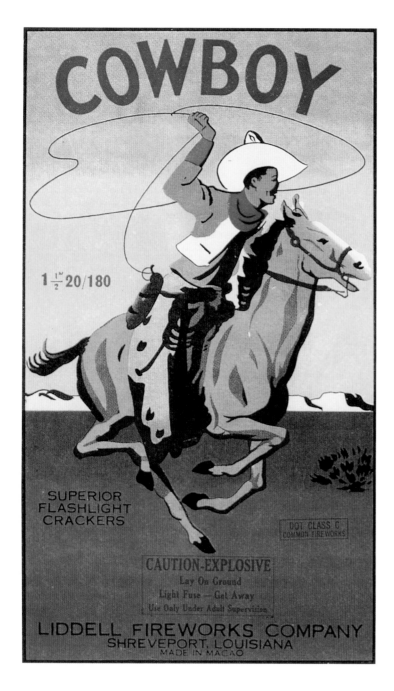

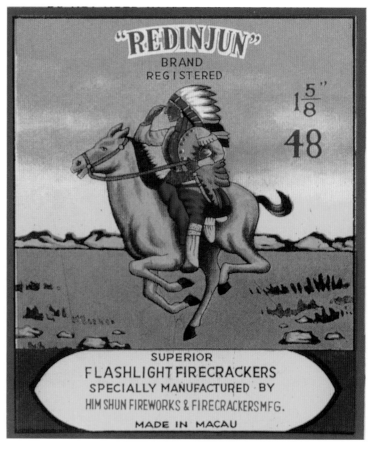

"Bang bang, you're dead!" Few who weren't there can imagine the impact of cowboys and Indians on the dreams and fantasies of boys before moms, reacting to the violence of the 1960s, took toy guns out of the hands of their children. During the years of cowboy movies and the early days of television, an Old West motif was likely to be very popular, as seen by these firecrackers aimed squarely at the heart of the American market.

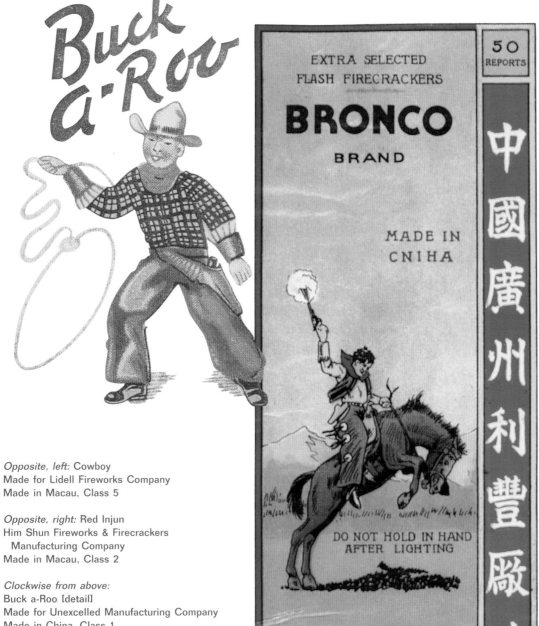

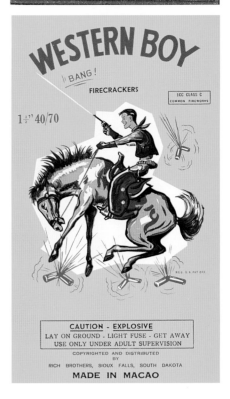

Opposite, left: Cowboy
Made for Lidell Fireworks Company
Made in Macau, Class 5

Opposite, right: Red Injun
Him Shun Fireworks & Firecrackers
 Manufacturing Company
Made in Macau, Class 2

Clockwise from above:
Buck a-Roo [detail]
Made for Unexcelled Manufacturing Company
Made in China, Class 1

Bronco
Made for M. Backes' Sons Inc.
Made in China, Class

Bobco Bill's Cowboy
Made for Bond Brothers & Company, Inc.
Made in China, Class 1

Western Boy
Made for Rich Brothers
Made in Macau, Class 4

Animals

Black cats are considered good luck in China, but bad luck in America. Somehow in that yin-yang dichotomy, the Black Cat label has lived out nine lives as probably the longest-surviving brand of all. Other popular brands like the Giraffe and Zebra also prove that firecracker manufacturers love animals.

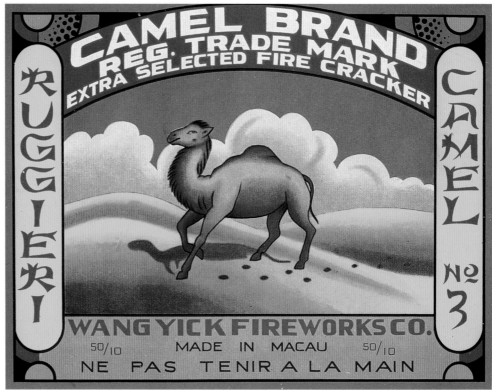

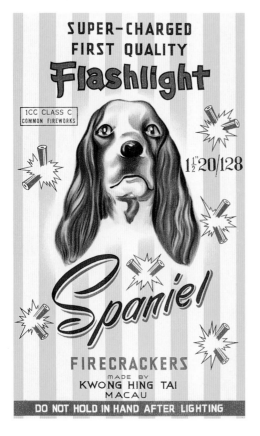

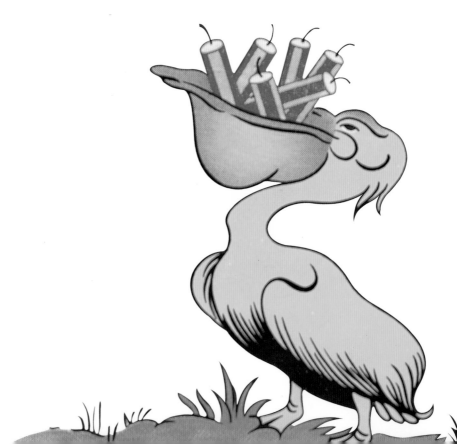

Opposite, left: Spaniel
Kwong Hing Tai Firecracker
 Manufacturing Company
Made in Macau, Class 3

Opposite, right: Camel
Wang Yick Fireworks Company
Made in Macau, Class 2

Below: Pelican
Made for Wilfong Fireworks
Made in China, Class 1

Right: Giraffe
Li & Fung, Ltd.
Made in Macau, Class 2

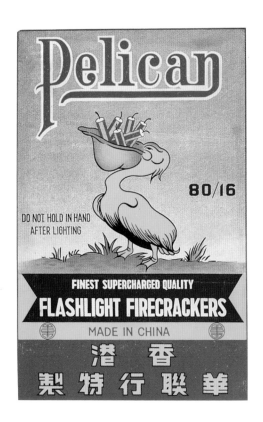

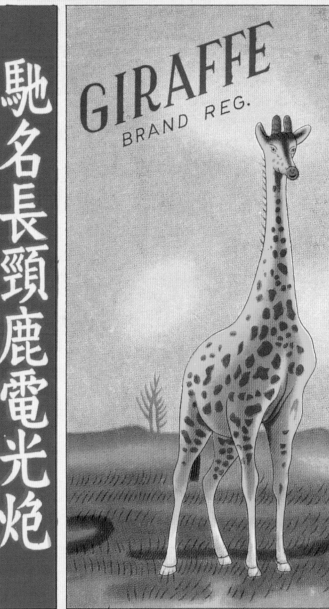

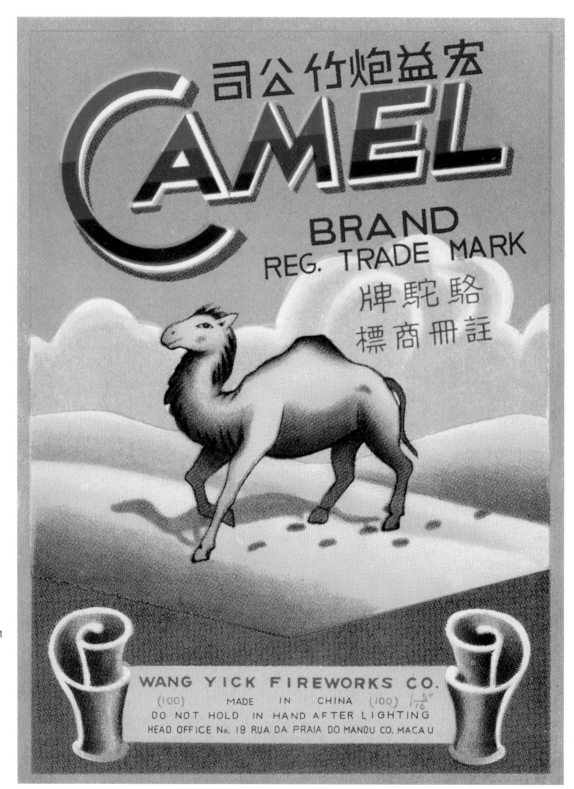

Camel
Wang Yick Fireworks
 Company
Made in China, Class 1

Clockwise from right:
Orientals (Monkeys)
Made for Unexcelled
 Manufacturing Company
Made in China, Class 1

Zebra
Li & Fung, Ltd.
Made in Macau, Class 3

Black Cat
Li & Fung, Ltd.
Made in Macau, Class 2

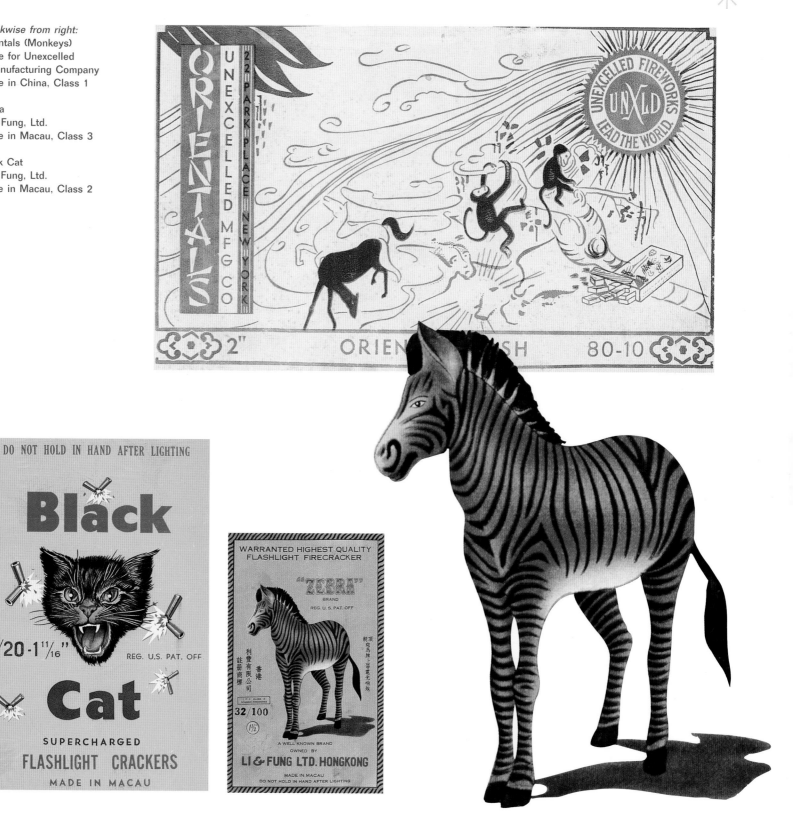

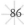

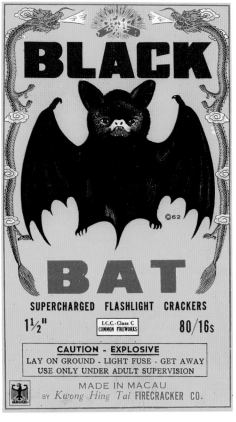

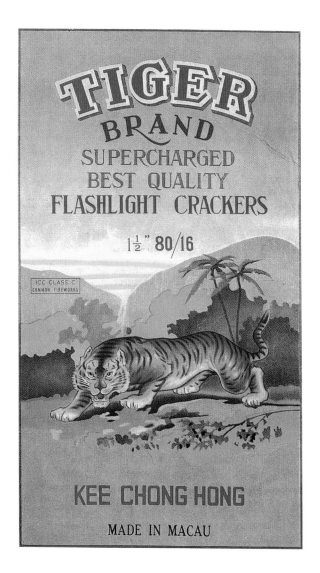

Clockwise from above:
Black Bat
Kwong Hing Tai Firecracker
 Manufacturing Company
Made in Macau, Class 4

Tiger
Kee Chong Hong
Made in Macau, Class 4

Leopard [detail]
Li & Fung, Ltd.
Made in Macau, Class 2

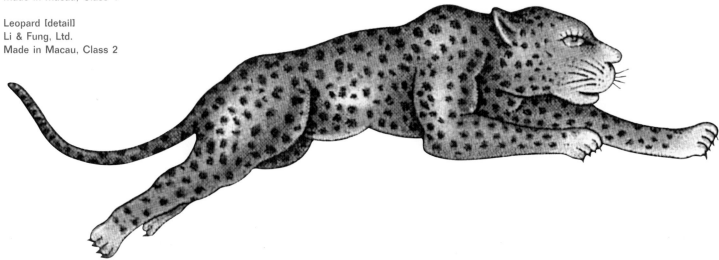

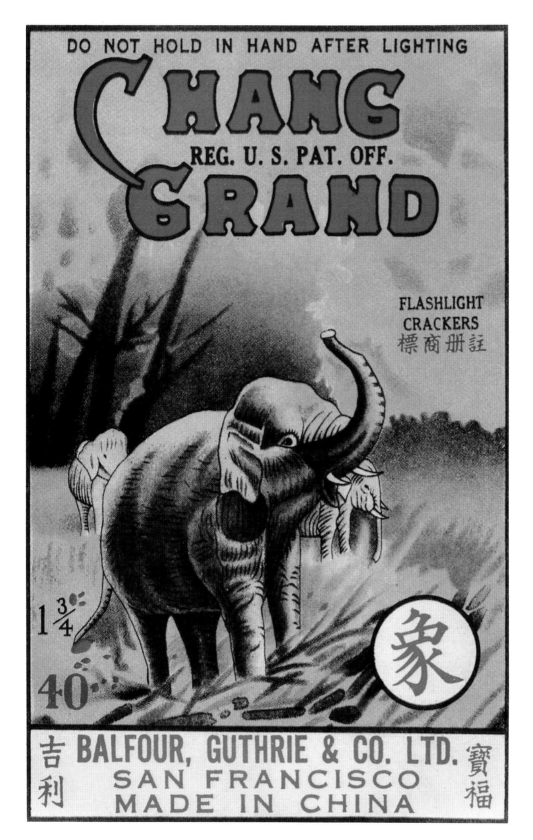

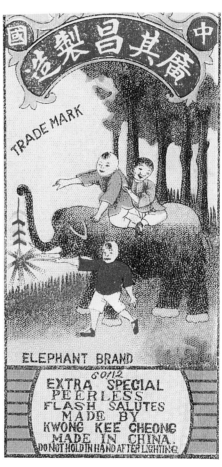

Left: Chang Grand
Balfour, Guthrie & Company, Ltd.
Made in China, Class 1

Below: Elephant
Kwong Kee Cheong
Made in China, Class 1

Aquatic

Under the sea live turtles, sea horses, and apparently Asian mermaids. Goldfish are considered lucky, especially in multiples of two or three, which explains the Double Goldfish.

Right: Mermaid
Made for Liebermann Waelchli & Company
Made in Hong Kong, Class 1

Below: Sea-Horse
Kwong Hing Tai Firecracker
 Manufacturing Company
Made in Macau, Class 3

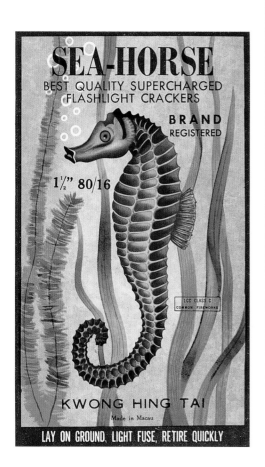

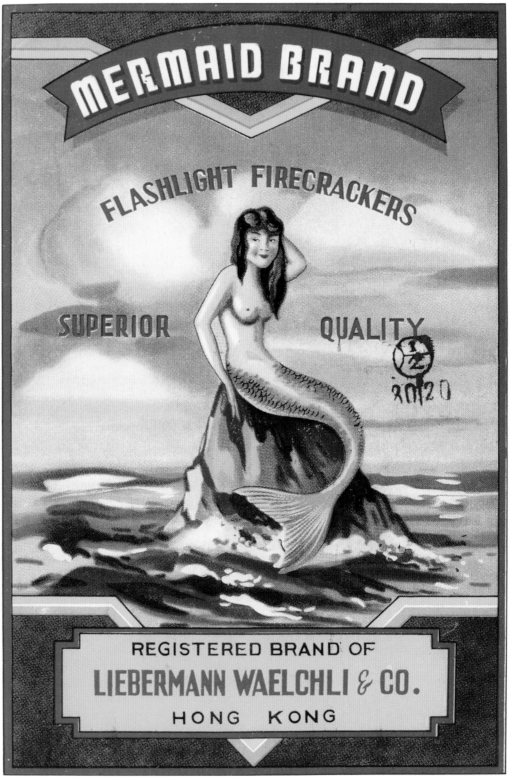

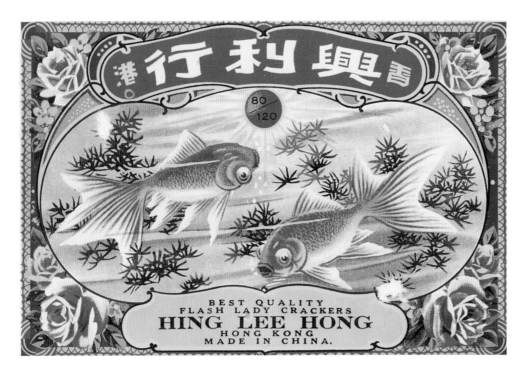

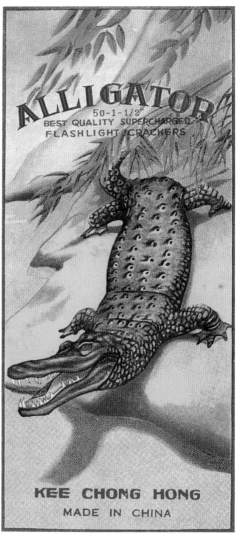

Left: Double Gold Fish
Hing Lee Hong
Made in China, Class 1

Below: Alligator
Kee Chong Hong
Made in China, Class 1

Whimsy

Firecracker labels abound with fanciful images and whimsical delights not often found in more traditional product advertising. By the way, the horse-riding girl on the Triumph pack is the daughter of Ben Decker, the president of the Triumph Fusee and Fireworks Company.

Right: Blazing Star
Made for Wallace Clark Company, Inc.
Made in China, Class 1

Below: Cats
Ming-Hing Factory for Li & Fung, Ltd.
Made in China, Class 1

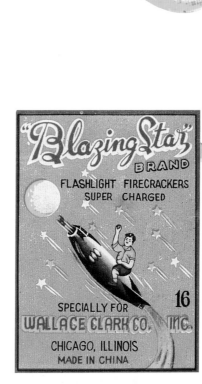

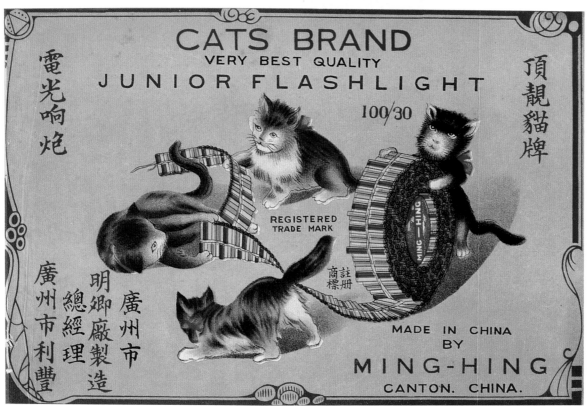

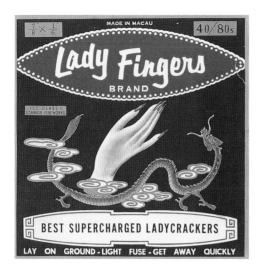

Clockwise from above:
Lady Fingers
Kwong Hing Tai Firecracker
 Manufacturing Company
Made in Macau, Class 3

China Goo Boy
National
Made in China, Class 1

Cracker Boy
Unknown
Made in Macau, Class 3

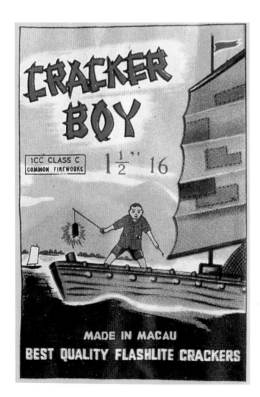

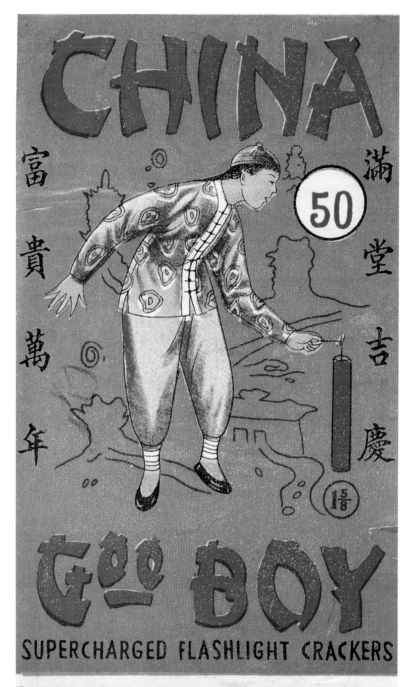

Right: Boomerang
Kwong Man Lung Firecracker Factory
Made in Macau, Class 2

Below: Mighty Mite
Kwong Hing Tai Firecracker
 Manufacturing Company
Made in Macau, Class 3

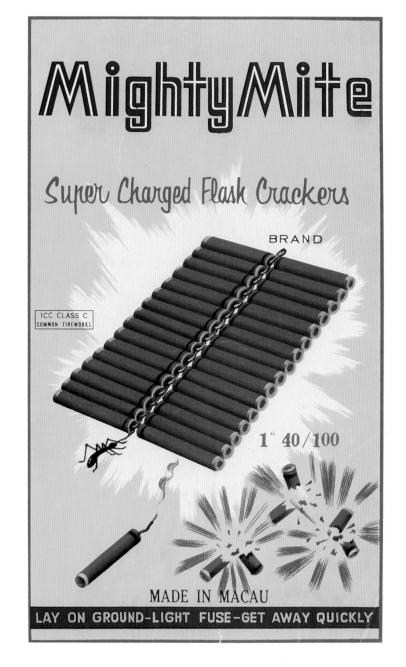

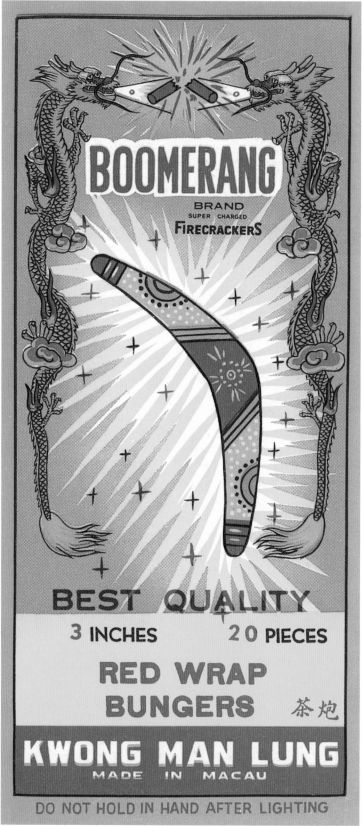

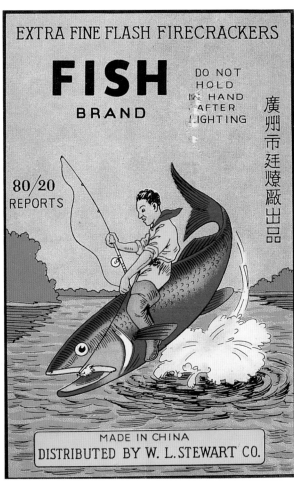

Clockwise from left:
Fish
Distributed by W. L. Stewart Company
Made in China, Class 1

Triumph
To-Yiu Factory for Triumph Fusee and
 Fireworks Company
Made in China, Class 1

Bango (Dragon)
Jebsen & Company
Made in China for use in Canada

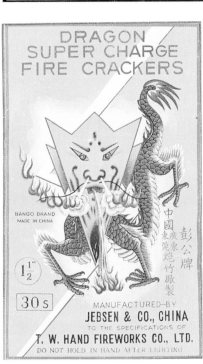

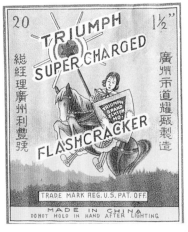

Astrospace and Explosives

The junior birdmen of yesteryear could think of little that would be more exciting than to go into outer space. The other side of rocket technology, however, was every kid's nightmare in the 1950s: intercontinental missiles and nuclear bombs.

Clockwise from upper left:
Space Missile
Hing Cheong Yeung Hong
Made in Macau, Class 3

Apollo
Po Sing Firecracker Factory
Made in Macau, Class 4

Rocket
Flying Fairy Brand
Made in China, Class 1

Martian
Jebsen & Company
Made in China for use in Canada

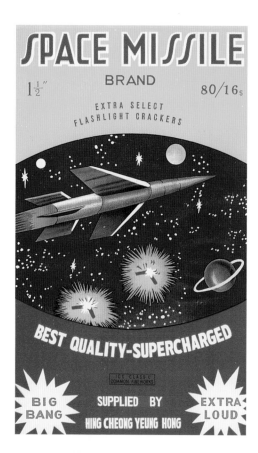

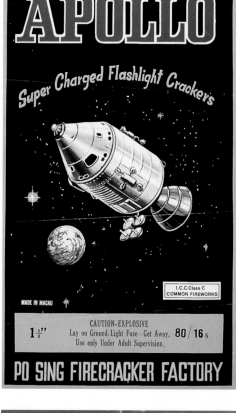

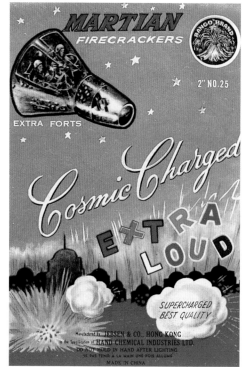

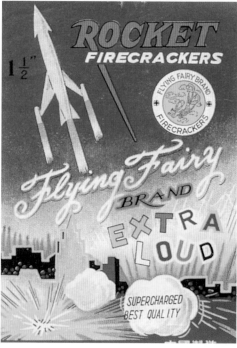

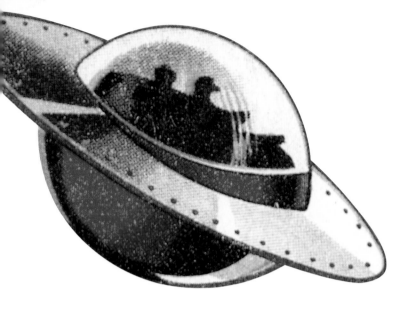

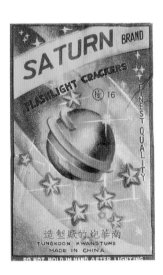

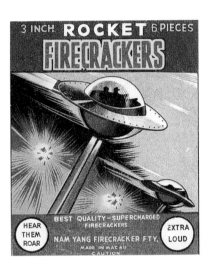

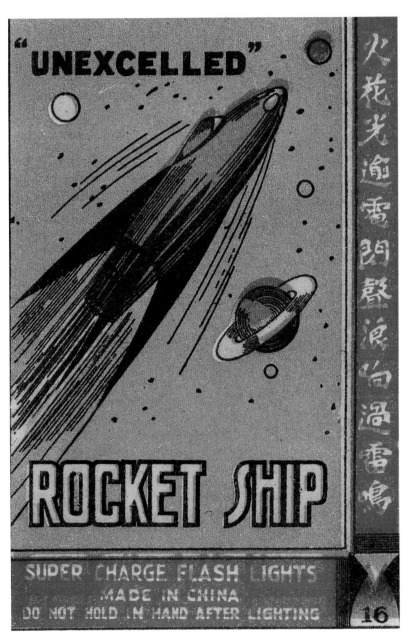

Left to right:
Saturn
Tung Koon Kwangtung
Made in China, Class 1

Rocket
Nam Yang Firecracker Factory
Made in Macau, Class 3

Rocket Ship
Made for Unexcelled Manufacturing Company
Made in China, Class 1

Right: Atomic
Po Sing Firecracker Factory
Made in Macau, Class 4

Below: Sure Fire
Kwong Yuen Hang Kee Firecracker Factory
Made in Macau, Class 3

Opposite, clockwise from left:
Atomic
Po Sing Firecracker Company
Made in Macau, Class 3

OK
Po Sing Firecracker Factory
Made in Macau, Class 5

Big Bomb
Kwong Yuen Hang Kee Firecracker Factory
Made in Macau, Class 5

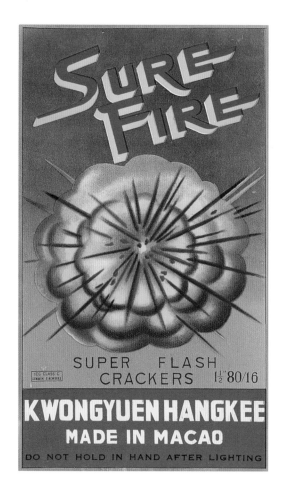

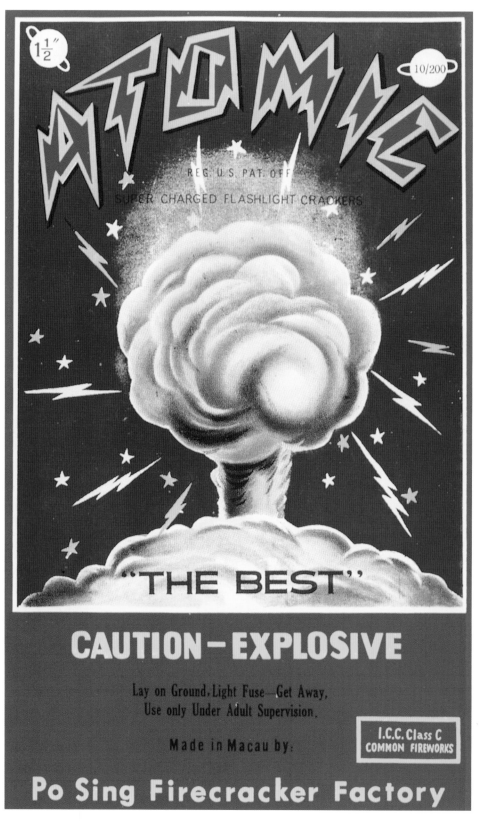

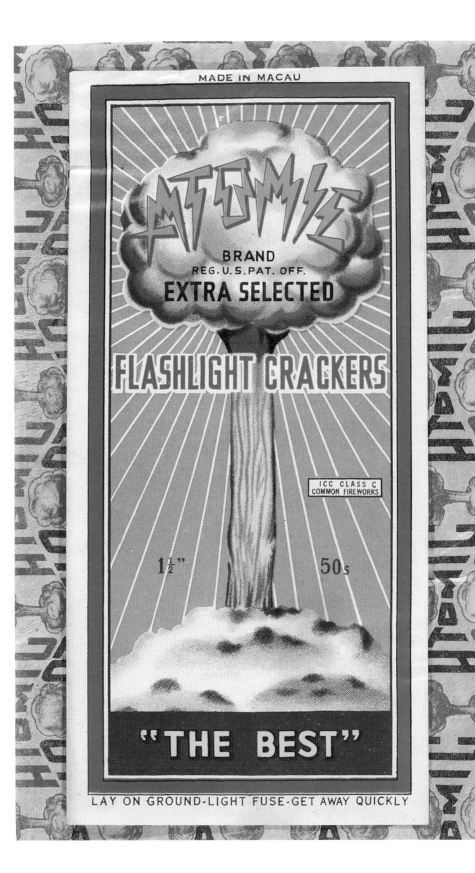

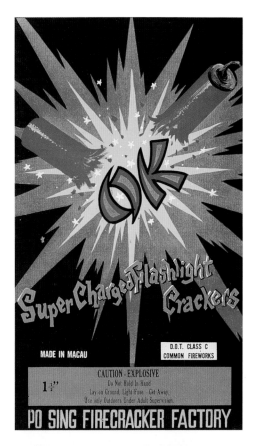

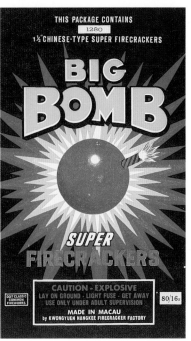

Sports and Entertainment

America loves sports, from women boxers to bullfighters. Well, maybe they missed the mark on those two. However, Home Run and Touch-Down score one for the home team.

Right: Balfour's
Made for Balfour, Guthrie & Company, Ltd.
Made in China, Class 1

Below: Mar-Hee (Circus)
E-Wo-Yeung Hong
Made in China, Class 1

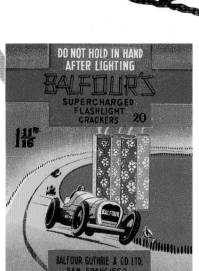

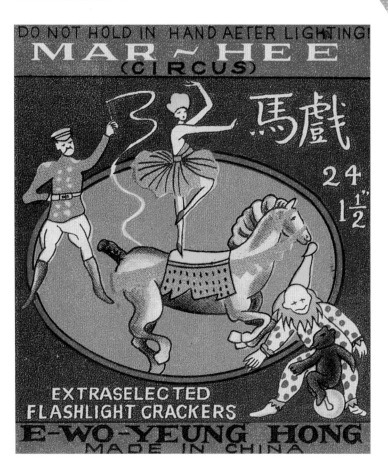

Opposite, clockwise from upper left:

Home Run
Distributed by W. L. Stewart Company
Made in China, Class 1

Champ
Unknown
Made in Macau, Class 3

Round One
Distributed by W. L. Stewart Company
Made in China, Class 1

Touch-Down
Distributed by W. L. Stewart Company
Made in China, Class 1

Bravo
Wai Yip Hong
Made in China, Class 1

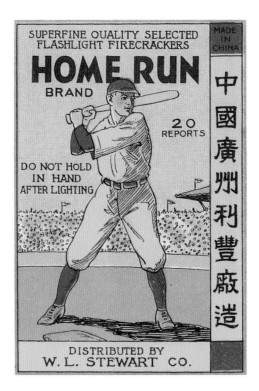

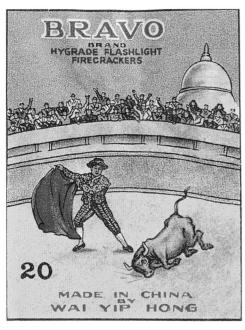

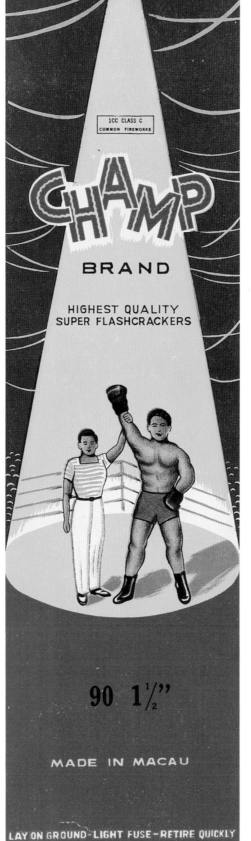

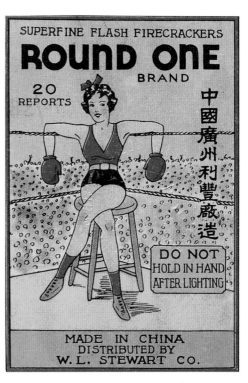

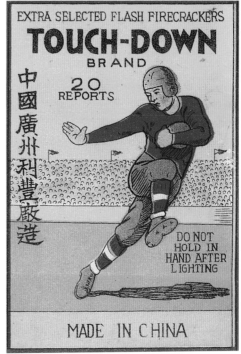

Military

A latter-day sort of warrior, featuring both Chinese and American patriotic subjects. One explanation needed: in World War I, small portable machine guns were called "typewriters" because someone thought that their clattering sound was somewhat reminiscent of the office pool back home.

Clockwise from right:
Shot Gun
Po Sing Fireworks Factory
Made in Macau, Class 4

Resistance
Kwong Wah Sing Firecracker Company
Made in China, Class 1

Atomic
Ghee Eng & Company
Made in China, Class 1

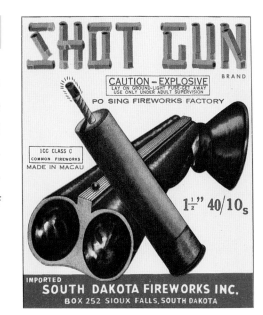

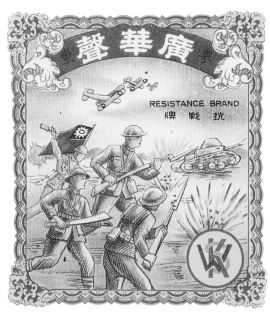

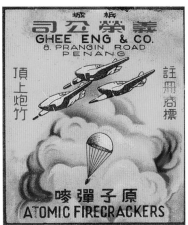

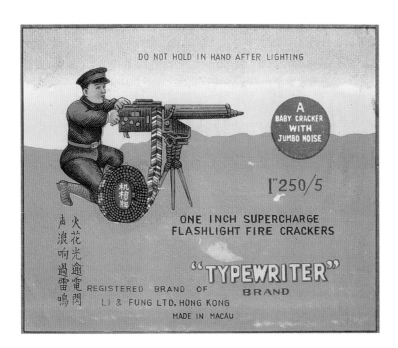

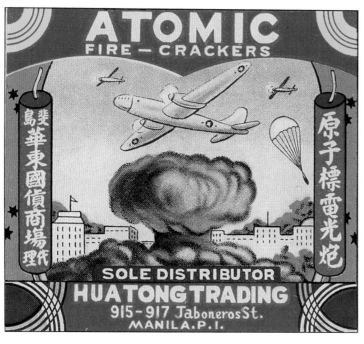

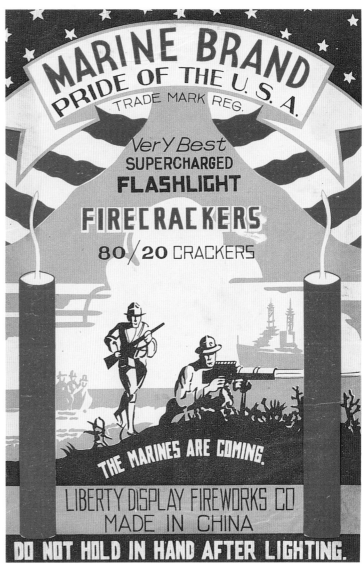

Clockwise from below:
Marine
Made for Liberty Display Fireworks Company
Made in China, Class 1

Atomic
Hua Tong Trading
Made in Hong Kong, Class 1

Typewriter
Li & Fung, Ltd.
Made in Macau, Class 2

Opposite: Victory
C. C. Tung Fireworks
Made in China for domestic use

Clockwise from right:
Lafayette
Kee Chong Hong
Made in China, Class 1

Whango
Ming Hing Factory for Li & Fung, Ltd.
Made in China, Class 1

Bazooka
Made for Charles Gitlan & Company, Inc.
Made in China, Class 1

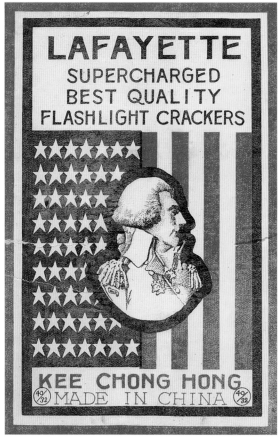

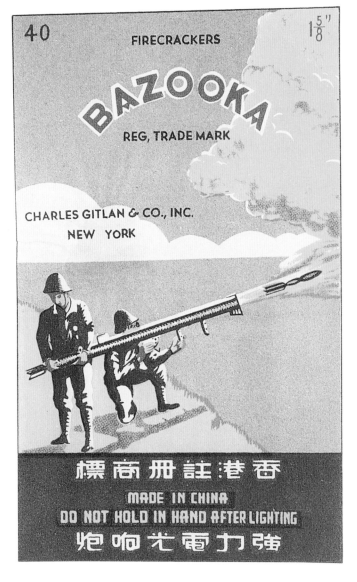

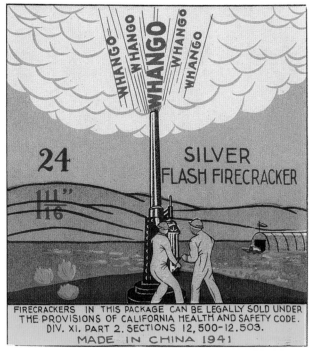

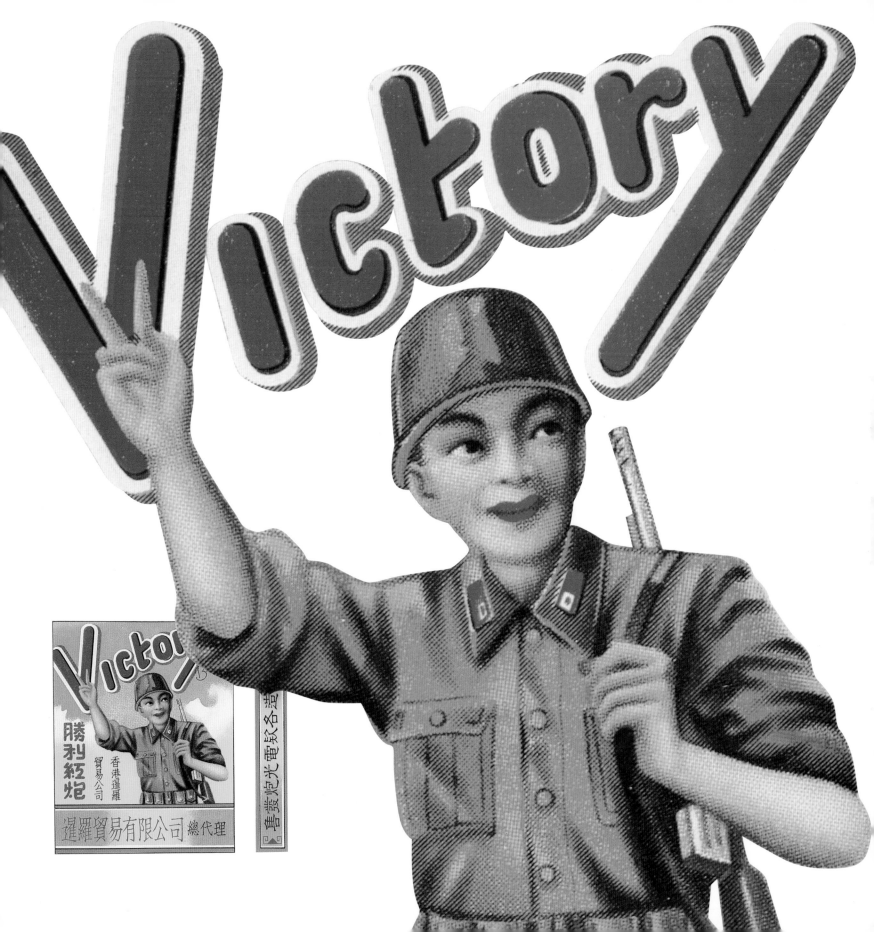

Black Americana

Although they've all disappeared in the mists of a less racially enlightened time, stereotyped images of African Americans, replete with watermelons, fishin' worms, and big white smiles, were extremely common in mainstream popular culture well into the Civil Rights era. (In fact, these were about the only depictions of blacks that were shown.)

Right: Picnic
Po Sing Firecracker Factory
Made in China, Class 1

Below: Golliwog
Yan Kee Firecracker Manufacturing Company
Made in China, Class 1

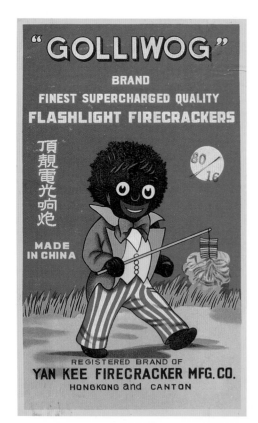

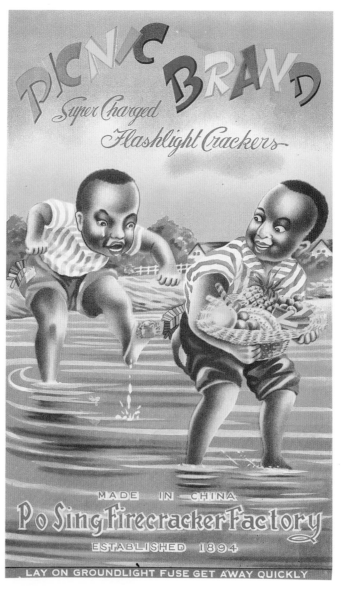

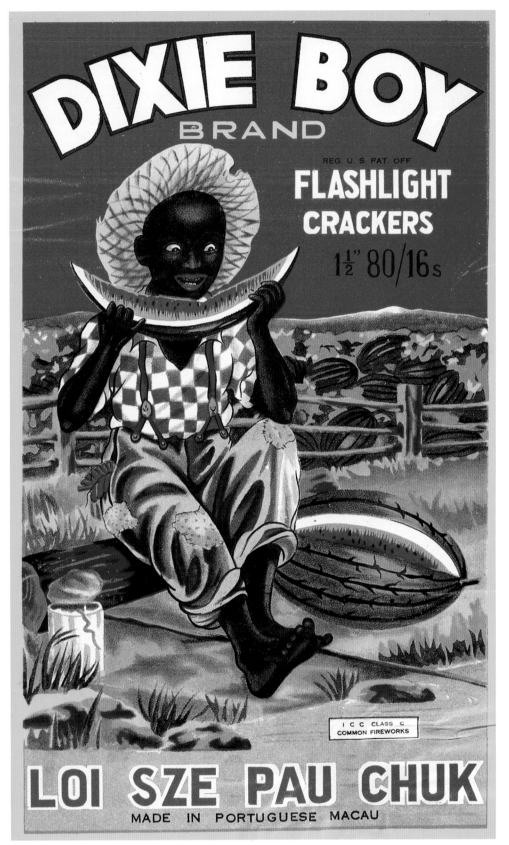

Dixie Boy
Made for Loi Sze Pau Chuk
Made in Macau, Class 3

Non-Chinese International Labels

Guatemala, Malaysia, and Vietnam are some of the places that make their own firecrackers. Vietnam has traditionally made their firecrackers for domestic use. Guatemalan firecrackers, however, can be found outside the country and throughout Central America.

These firecrackers are traditionally made in small factories and home shops and use indigenous designs in their label art, often bearing the name of the proprietor. Since the warnings used to establish classes are strictly for firecrackers bound for the United States, these labels cannot be classed.

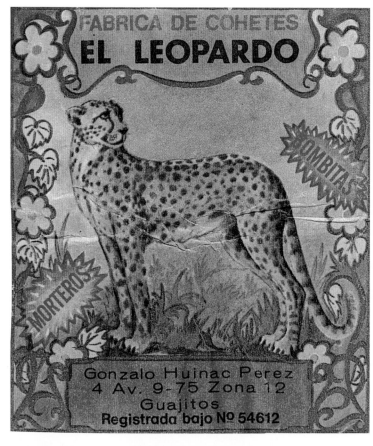

Clockwise from above right:
El Leopardo
Gonzalo Huinac Perez
Made in Guatemala

Relampago
Ofelia Fuentes
Made in Guatemala

El Pinto
Efrain Barrera Perez
Made in Guatemala

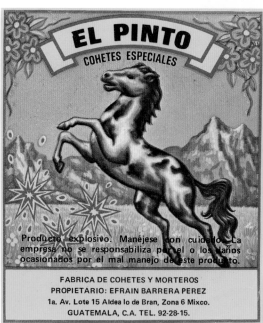

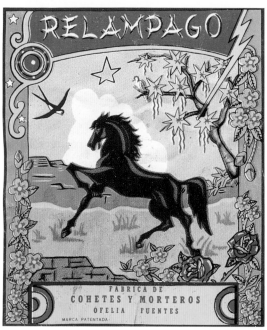

Clockwise from right:
El Condor
Fabrica Condor
Made in Guatemala

El Dragon Dorado
Pllar Boror de Curup
Made in Guatemala

Tjap Matjan
Kong Tjhiang Hoo
Made in Indonesia

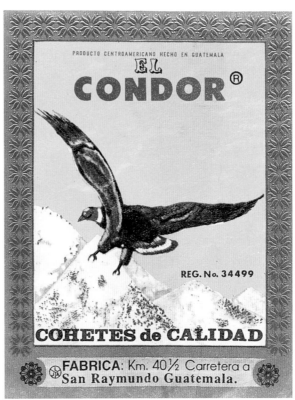

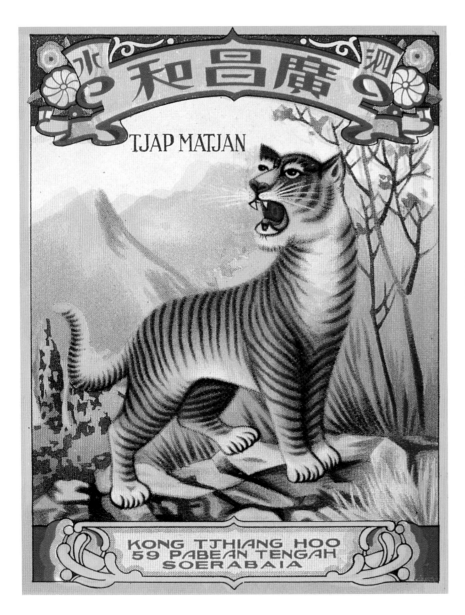

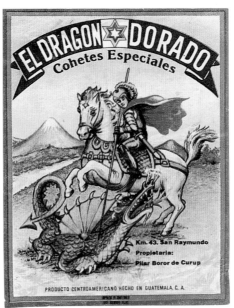

LABELS FROM INDIA

Most Indian labels owned by American collectors come from the Sivakasi region; of these, most bear the Standard Fireworks trademark. India is second only to China in manufacturing firecrackers, and much of the pyrotechnic industry is located in Sivakasi, a locale known for its dry climate, low rainfall, and proximity to the minerals needed for making gunpowder. The dominant manufacturer in Sivakasi is Standard Fireworks Ltd.

Standard rose from a humble beginning as a small match factory to became the largest of all the Indian firecracker manufacturers. While labels from other countries look very different than Chinese labels, Standard sees itself in direct competition with the Chinese. As such, they have made an effort to have their labels look very similar to China's in format and subject matter. As with other firecrackers not sold in the United States, Indian labels cannot be classed.

Right: Peacock
Standard Fireworks Ltd.
Made in India

Right, below: Red Fort
Standard Fireworks Ltd.
Made in India

Opposite, clockwise from upper left:
Indian Knight
Standard Fireworks Ltd.
Made in India

Anil 3000 Wala Garlands
Anil Fireworks Factory
Made in India

Mohini Crackers
Ruhunu Fire Works
Made in India

Taj Mahal
Standard Fireworks Ltd.
Made in India

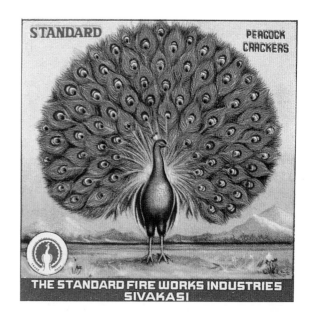

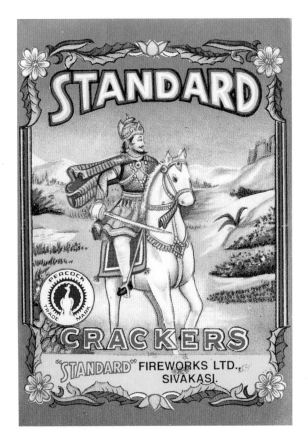

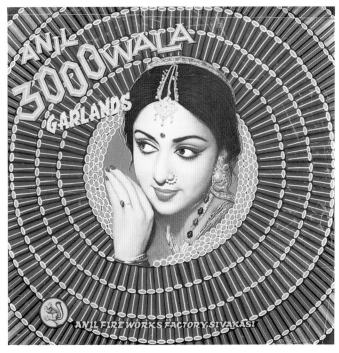

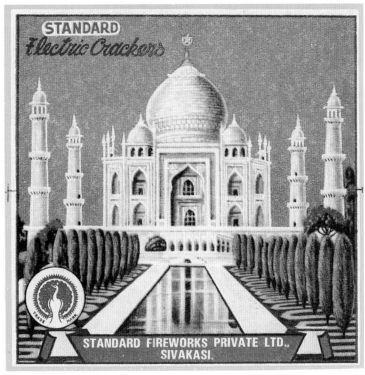

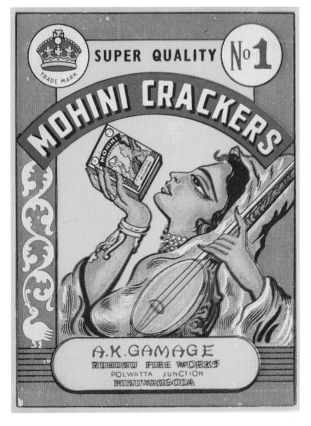

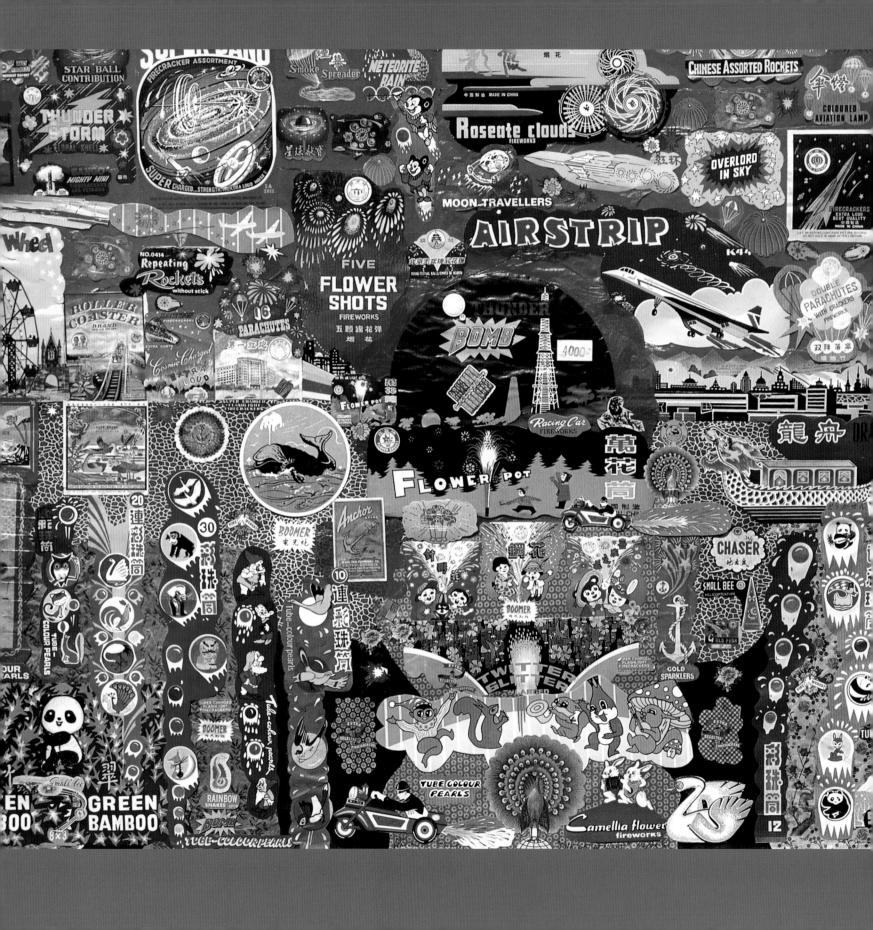

Collecting Firecracker Packs and Labels

ANYTHING CAN BE COLLECTIBLE, even when millions of the original were made. It helps, though, if the item in question is—like comic books and baseball cards—historic, fragile, colorful, evocative of your childhood, and likely to be damaged or destroyed through normal use.

Firecrackers embody all of the qualifications above, yet there are only a relatively small number of collectors. Why is that?

Well, there's not one answer, but several. To begin with, only a relatively small number of the packs have survived. The typical life of a pack of firecrackers is this: a kid buys it in late June, rips it open, and blows off the contents in the coming weeks. The most collectible part—the label—is usually no more than a mild curiosity, something to be glanced at on the way to the bang of the crackers within. Another problem is the lack of universality. Most people alive today grew up in a time and place where firecrackers were illegal, so only a comparatively few people can look at a pack of firecrackers and have it bring back any sort of childhood memory.

Finally, in many parts of the United States, collecting and storing the firecrackers—no matter if they're historic ones that will never be used—is legally problematic. Even where legal, there are laws about storing firecrackers in residences. Collectors can get special permits to own firecrackers, but it can be expensive and full of red tape, to a point that most don't bother. The result is that firecracker collectors who like to collect more than just the labels are in jeopardy of being raided and having collections destroyed by the police.

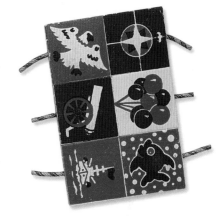

Above: Made by National Fireworks Incorporated in Boston, these square-shaped salutes were traditionally decorated with simple illustrations such as balloons, ships, and stars. Square Shooters, ca. 1940.

Opposite: Pink Sky at Night by James McNulty. Firecracker and fireworks label collage.

Starting a Collection

Since there are more than a thousand old brands to choose from, some experts suggest starting thematically—collecting, for example, packs with animals, Chinese maidens, or an astrospace theme. Other experts, on the other hand, consider that idea to be unnecessarily limiting, even if it does make the firecracker universe easier to handle.

Besides your standard labels, packs, and bricks, collectors often look for novelties in things like sizes and designs. The most common firecracker size is $1^1/_2$ inches, but some collectors take pleasure in tracking down $7/_8$-inch "ladyfingers" and the old 2 inchers from the past. (Currently, the largest firecracker made is the $1^5/_8$ inch Roller Coaster brand which, while larger, is no more powerful than the small firecrackers, thanks to the 50 milligram federal limit for flash powder in firecrackers.) Packs from the twentieth century most commonly came with sixteen or twenty firecrackers, but ones with as few as four and as many as four hundred can be found.

Then there are the various wrappers around firecrackers. Although red is the most common color for glassine pack wrappers, different colors are also sometimes found. Some collectors like collecting the varied wrappings that come around the multipackage "bricks." Others look for variations in the firecracker "shell wraps" (the decorative paper on the outside of the individual firecrackers): some feature illustrations and logos instead

GUILTY OF FELONIOUS COLLECTING

Do the police ever actually confiscate the collections of firecracker collectors? It's happened, says Dan Stephenson, a collector in Minnesota, who put up a website dedicated to his now-lost collection. He said we could quote his sad story, so here it is:

Fireworks are illegal in Minnesota without a permit. The police in their infinite wisdom decided on June 13, 1996, that I should no longer have a firecracker collection and confiscated it from my mom's garage. My collection started when I was about six or seven with labels from firecracker packs. In 1981 I started collecting whole packs. Although I didn't have anything that was really rare, I did have some good packs that were worth some money and had a lot of meaning to me. Some of my oldest crackers came from the late 1920s or early 1930s. When my mom protested against what the bomb squad was doing and told them that this was my collection, they said, "Ma'am, nobody collects firecrackers." Three years later, I still haven't been charged but I really did love these things and miss them tremendously. It's like part of my childhood was taken away.

This illustration from a 1939 fireworks catalog shows many different-sized firecrackers. Due to flash powder content restrictions, the $1/_4$ by $1^1/_2$-inch firecracker became the standard size for the U.S. market.

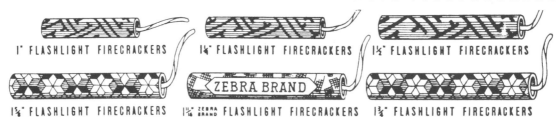

ACTUAL SIZE OF ALL KINDS OF CHINESE FIRECRACKERS

1" FLASHLIGHT FIRECRACKERS 1¼" FLASHLIGHT FIRECRACKERS 1½" FLASHLIGHT FIRECRACKERS

1⅝" FLASHLIGHT FIRECRACKERS 1½" ZEBRA BRAND FLASHLIGHT FIRECRACKERS 1¾" FLASHLIGHT FIRECRACKERS

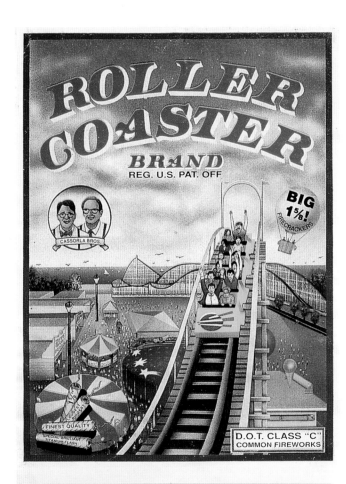

Roller Coaster brand firecrackers are the largest firecracker (1⁵/₈ inches) currently sold in the United States. A thick shell wall provides for a louder bang, and the addition of titanium flakes add to a brighter flash.

Roller Coaster
Cassorla Bros., Inc.
Made in China, Class 6

of just the generic designs that look like stars, stripes, or an old man's pajamas. Some rare vintage packs of firecrackers came with a surprise gift, such as a Chinese coin or animal picture card. Firecracker enthusiasts also even collect anything firecracker-related: postcards, fireworks catalogs, pin-up girls posed with firecrackers, posters, magazine covers—all are grist for the collector's mill.

So, where do you find items for your actual (or still theoretical) collection? Most of the packs that you find rummaging through drawers and attics will have been made in the last twenty-five years and may be worth less than a dollar, but who

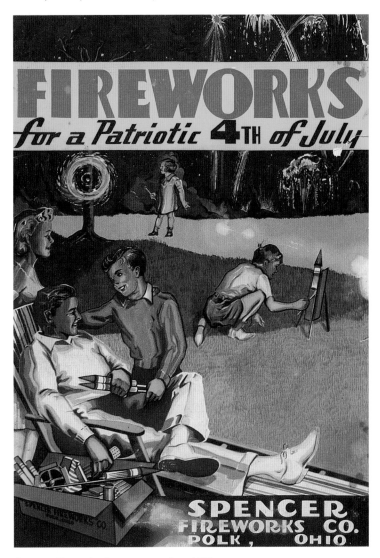

Spencer Fireworks Company catalog, 1940.

knows what you might find? Older ones can be worth dozens or even hundreds of dollars. If you're lucky, you might find a mint-quality Battleship pack out there somewhere.

Besides haunting attics and asking around among friends, acquaintances, and elderly relatives, there are collectors' conventions sponsored by the Pyrotechnics Guild International (PGI) and other pyrotechnic organizations. The PGI is a good place to go anyway, if you're a fan of firecrackers and fireworks. Their annual convention features not only dealing and trading but also elaborate pyrotechnic shows. Every year, too, the highest bidder in an auction gets to shoot off the official "Super-string" of several million firecrackers, which is impressive, even if not the longest one. (The world's record is believed to be a string set off in Malaysia in 1988 that used three million crackers strung together for three and a half miles. It took more than nine ear-shattering hours to burn.)

Some dealers have regular "mail/phone/fax/e-mail" auctions.

And if you have one of those newfangled computer things, don't forget to search online auction sites and individual collector's web pages. (See Resource Guide for more ideas.) Do be careful, though: with good-quality color scanners and printers, counterfeiting of labels by unscrupulous scoundrels is not unknown.

Saving and Storing Labels

As with about any collectible, a firecracker label is more valuable if still attached to the pack it came with. However, there may be reasons why you want to remove labels and display them separately. There are, after all, other factors that might come into consideration here: Perhaps you live someplace where you can still pick up discarded firecracker packages off the ground after the Fourth of July. Or, conversely, perhaps you feel a duty to obey your community's pesky firecracker-prohibition laws. Or maybe

Above: Chinese jewelry box made from a shard of a broken vase. Beijing, China. *Right:* Chinese snuff bottle. Guyuexuan, China.

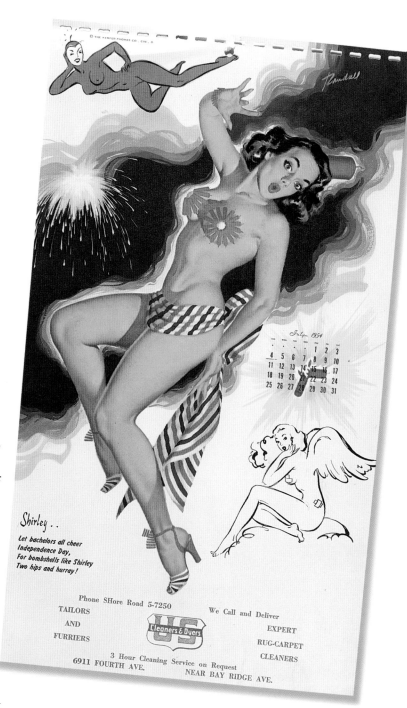

you just don't have the space for hundreds of packs and want to be able to display your collection on the wall or in a photo album.

Whatever the motivation, let's say you want to get a label off a pack, or the remains of the pack. How do you do it? "Very carefully," say the experts. Label glue is usually wheat or rice paste, and it's hardier than stamp glue. You might see if you can gently pull the label off, but if the label doesn't come off easily, the safest thing is merely clipping the wrapper around the outside.

Once you've freed the label from its wrapper, how do you store and exhibit them? First of all, never use any kind of adhesive on them, although those easily removable cellophane hinges used by stamp collectors are permissible for mounting in a photo album or a picture frame. And, of course, avoid exhibiting them in any open spot that will get direct sunlight. If you use one of those photo albums with Mylar sheets that stick to cardboard striped with a waxy adhesive backing, protect the label from the adhesive itself with a same-sized sheet of waxed paper laid underneath.

Novelty items such as playing cards and calendars with firecracker themes are among the ancillary things enthusiasts may collect.

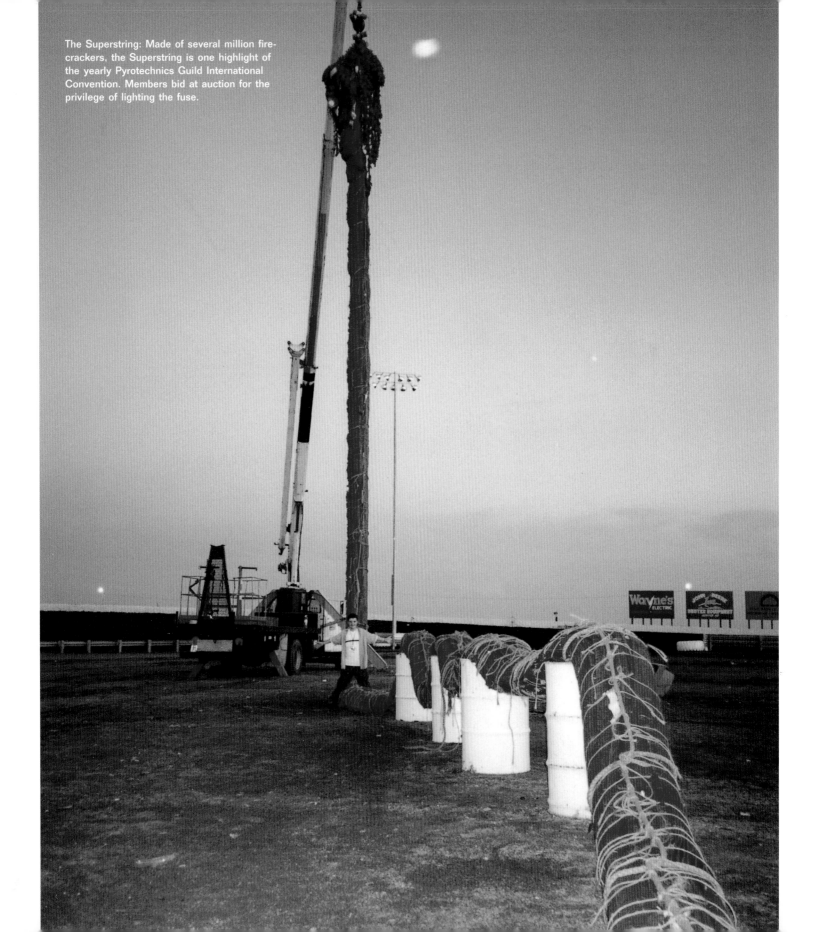

The Superstring: Made of several million fire-crackers, the Superstring is one highlight of the yearly Pyrotechnics Guild International Convention. Members bid at auction for the privilege of lighting the fuse.

Some collectors store labels, packs, and bricks in glass display cases or inside fire-resistant boxes. Labels should be stored against a flat and smooth surface without obstructions or moving parts that could harm them. Metal is a good material, but many woods give off formic acid and other chemicals that can harm paper, so covering it with two or three coats of polyurethane is a good idea.

Oftentimes labels will have been somewhat damaged, especially if the pack had been opened and the firecrackers used. Most collectors believe that touching up flaws is an abomination and that you should leave labels exactly as you found them. However, some who are little more relaxed about such things carefully repair tears, abrasions, and holes with matching paper, colored pencils, or felt-tip pens.

How Old Is That Firecracker Pack?

Really old labels from a century ago are easy to date because they're not labels, exactly, but stenciled ink or gilt on the wrapping papers of the firecrackers. However, how do you tell whether a more recent lithographed label is from 1920 or 1990? It isn't always easy, especially since some brands like Giraffe and Black Cat have lasted for a half-century or more. Luckily, the political disturbances of China and U.S. government regulations have given us benchmarks that can tell us exactly from what era a specific label has come.

Before and after World War II, a prolonged Chinese civil war convinced fireworks manufacturers to move their factories— lock, stock, and flash powder—to Macau, a Portuguese colony that also had the benefit of being close to the English colony of Hong Kong, a major shipping port. As a result, many pre-1950 firecrackers say "MADE IN CHINA," but firecrackers made from 1950 to 1972 say "MADE IN MACAU." After the U.S. reestablished trading with China in 1973, mainland firecracker factories took over the market again and since that time, firecrackers again say "MADE IN CHINA."

Great, you say: So if the pack says "MADE IN CHINA," it could be quite old or quite new. So how do I pinpoint the date?

That's where governmental regulation comes in, at least in identifying packs made for the U.S. market. As the popularity of firecrackers grew with new brands and ornately colored packs, so did the number of injuries and deaths. A clamor for regulation led to a series of governmental decrees limiting the power of firecrackers as well as mandating safety warnings. You can also tell the approximate date of a pack by the government-mandated phraseology that appears on it. Labels that are not intended for the U.S. market—those made in China or other countries for domestic use or for non-U.S. export destinations—cannot be dated in this manner, and therefore do not have class designations.

There are seven distinct eras, and collectors refer to each as a "class." (This can be confusing since "class" is also used by the Interstate Commerce Commission to refer to different strengths of fireworks, firecrackers, and other explosives: Class C includes fireworks and firecrackers you can buy from roadside stands in certain states, and bullets in all states; Class B includes all professional aerial fireworks displays; Class A includes dynamite and TNT.) Each cracker class is described on the following pages.

Firecrackers in non-traditional shapes are often sought by collectors. These Animal Crackers were made by National Fireworks Incorporated in Boston. As the package says, "Light their tails and run."

Class 1 (before 1950)

Beyond the obvious "Do not hold in hand after lighting," firecracker users were left to fend for their own well-being before 1950. Class 1 packs bore no government-decreed safety warnings whatsoever, but boasted that they were "MADE IN CHINA" (although a few say "MADE IN HONG KONG" or "MADE IN CANTON").

Golden Boys
Kwong Wah
Made in China, Class 1

Class 2 (1950–54)

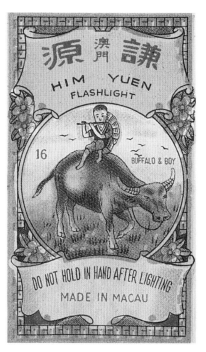

Still no required warnings on the label. Most of the world put a trade embargo on Mao's China, but luckily firecracker manufacturers had already moved to the Macau peninsula, gearing up to make sure the world's firecracker needs did not go unmet. The packs from this era say "MADE IN MACAU" or (to reassure Americans who might be spooked by Chinese communists making explosives for our Fourth of July celebrations) "MADE IN PORTUGUESE MACAU."

Buffalo and Boy
Him Yuen Firecracker Company
Made in Macau, Class 2

Class 3 (1955–68)

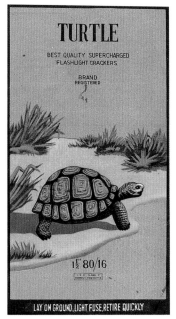

Still no mandated warnings, but packs now carry a little box that says "ICC Class C," referring to Interstate Commerce Commission's classification system mentioned on the previous page. (Why the ICC had jurisdiction and not Customs or the Bureau of Alcohol, Tobacco, and Firearms is a mystery.)

Turtle
Kwong Hing Tai Firecracker
 Manufacturing Company
Made in Macau, Class 3

Class 4 (1969–72)

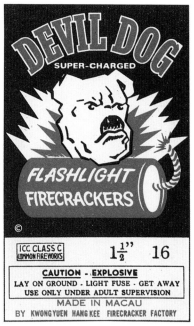

Besides the markings mentioned in Class 3, Class 4 labels add two touchingly innocent warnings: "CAUTION: EXPLOSIVE" and "LAY ON GROUND, LIGHT FUSE, GET AWAY."

Devil Dog
Kwong Yuen Hang Kee Firecracker Factory
Made in Macau, Class 4

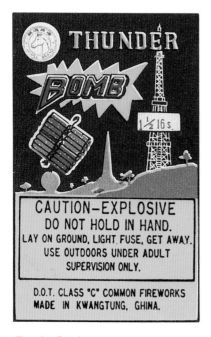

Thunder Bomb
Horse Brand
Made in China, Class 5

Class 5 (1973–76)

Congress—disgruntled with the Interstate Commerce Commission for setting transit rates and failing to halt the decline of the railroads—began slowly dismantling it, shifting its responsibilities to other agencies. (The ICC lingered until 1995 when Congress finally disbanded it.) For reasons esoteric, the grading of explosives was shifted to the Department of Transportation, so these packs say "DOT Class C Common Fireworks" along with the warnings from Class 4. Meanwhile, President Nixon made trading overtures to China, so the Macau factories followed the ICC to oblivion. A few packs from this era mention Macau, but the bulk of them again say "MADE IN CHINA."

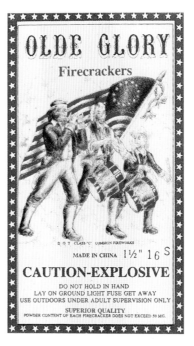

Olde Glory
Olde Glory Marketing
Made in China, Class 6

Class 6 (1977–94)

Same as Class 5, with one new addition to the package because of a government-mandated reduction of firepower: "CONTAINS LESS THAN 50 MG. FLASH POWDER."

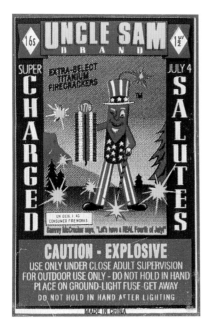

Uncle Sam
Kellner's Fireworks
Made in China, Class 7

Class 7 (1995–present)

Another obscure bureaucratic rule change required that packs display the phrase "UN 0336, 1.4G CONSUMER FIREWORKS." The UN stands for "United Nations," and the number refers to an international standard for hazardous materials. Other than that, the warnings and "MADE IN CHINA" remain unaltered.

How Much Is It Worth?

When you begin collecting—and perhaps even before—you will probably want to know how to assess the value of a particular pack or label. Obviously you do this for at least two reasons: if you are buying, you want to pay a fair price for the item you are purchasing; if you are selling, you need to know the value of the item you are selling. Firecracker labels are not all of the same value to collectors (see Rarity Guide). Common brands like Zebra or Black Cat, no matter how old they may be, will never be worth as much as some of the more obscure ones. Less common ones have sold recently in auction for anywhere from a few dollars (for example, $10 for an Alamo brand from the early 1970s) to a few thousand dollars (for example, $1,900 for a Battleship label, more than $2,000 for an Ibex, both from before 1950).

As with all collectibles, scarcity, age, quality, graphics, and condition are all factors in prices, as is what the label is attached to: an unattached label will generally be worth less than one attached to an unopened pack (containing sixteen or more fire-

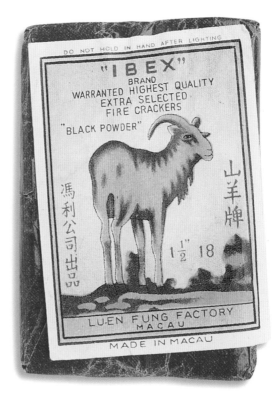

Ibex
Luen Fung Factory
Made in Macau,
Class 1

INTERVIEW WITH A COLLECTOR

To see what makes a firecracker collector click, we talked with co-author George Moyer, who provided the labels for this book and who, some say, has the most comprehensive collection in the world.

Jack Mingo: Roughly how many labels and packs do you have?

George Moyer: Probably over two thousand. Some are duplicates, but I have over one thousand different brands.

JM: At what age did you actually start collecting?

GM: I know it was when I was a kid, but I can't really recall. Maybe ten years old.

JM: What attracted you to them at that age?

GM: Well, all kids like firecrackers and fireworks. I was a child and I liked shooting them off. The graphics were nice and most of the crackers had logos on them, like Warrior, Seahorse, Turtle, Lobster . . . mostly animal themes back then.

JM: Are there a lot of serious collectors out there?

GM: Not too many serious collectors, maybe a few hundred. Altogether, there are maybe twelve hundred others that I know who are less serious. There are specialists as well: Salute collectors, people who collect just rockets or American-made stuff, people who collect only pictures of animals or something. Some people just collect the individual logo crackers, just one cracker of each type. I only collect Class 1, 2, 3, and some of the hard-to-find 4s. I won't collect anything after that. If I did, I'd have a huge collection. I feel the newer labels are less artistic—the paper got shiny and they are not as detailed.

JM: What's your most prized label or package?

GM: Well, the one I like the best is Crax Boy. That's a boy walking with a bag that says "fire-crackers" on it, and the boy is made out of packs of firecrackers. [See illustration on next page.]

JM: Do you have them in something fireproof? Do you worry about that at all?

GM: Mostly the stuff is so old that I'd to like think most of the crackers wouldn't go off. As to the danger of losing my collection, it's the same as being invested in stamps or baseball cards—you have to hope for the best and be philosophical about it.

JM: How do you store and display them?

GM: In 5 by 8-foot cases I had custom made. They're brass and black with glass shelves lined with mirrors and glass doors with gun locks on them. They light up, and they're sealed around the edges to keep moisture away from the packs. Most of the packs stand upright on

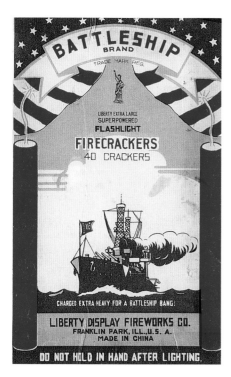

Left: Battleship
Made for Liberty Display
Fireworks Company
Made in China, Class 1

Below: The Crax Boy label
is derivative of the
Whitman's Sampler boy who
was a popular twentieth
century American advertis-
ing icon.

Crax Boy
Chan Tai Kee
Made in China, Class 1

crackers), which will be worth less than an unopened "brick" that contains many packs.

Unfortunately, the small number of collectors means that there has not been a price guide published that assesses the relative worth of various packs and labels. Our best advice is to be in touch with more experienced collectors who can give you coolheaded assessments of values, and otherwise enlighten you on the ins and outs of the hobby. Most dealers you'll encounter will be honest. Because serious firecracker collectors number in the hundreds, a dealer won't be in the business long if he or she gets a reputation for dishonesty. As part of your education, it's also a good idea to keep an eye on online auctions to get a general sense of what things are worth before you start spending money on big-ticket items.

Collecting firecracker ephem-era can be a lot of fun but— as in so many areas of life—it can also be expensive if you haven't educated yourself thoroughly. ✳✳✳

easels so you can see them. No sunlight ever hits them because that'll fade the wrappers.

JM: Where do you find new additions for your collection? Or are you beyond that stage at this point?

GM: Word of mouth gets out to collectors that if anyone wants to sell at a fair price, to call me. I have the best collection and I want to keep it there. All the auctioneers know I collect this stuff so anytime something comes up, I'm the first to get one of their pamphlets on it.

JM: What else should people know about collecting?

GM: The older the packs, the better. When they start getting into the artistry of it, is when they become more desirable. I have stuff here that was made for royalty back in the Chin Dynasty. To a collector, you want it all. That's what I do: I want it all.

JM: Before The Great Big Firecracker in the Sky comes to take you away, do you think you're going to get all the packs that you're looking for?

GM: Probably not. But I'll tell you what: I'll be the closest one to ever get to that point. I'm already closer than anybody's ever been.

JM: What will you do with your collection—donate it to a university, or let your survivors auction it off?

GM: I don't know. I never really thought of that. It's like a bottle of wine. You go out and buy a bottle of wine for thousand bucks and what are you gonna do? Let it sit there and look at it? You wanna taste it. Maybe I'll just blow them off.

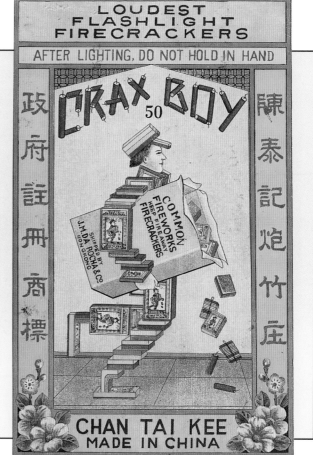

GLOSSARY

Black powder:
Same as **gunpowder**.

Brick:
A large wrapped cube consisting of dozens of **packs**.

Brick label:
The label that goes on a brick of firecrackers, similar in design to a pack label but larger.

Cherry bomb:
A cherry-shaped salute coated with a red sawdust-and-glue mix and topped off with a lacquered fuse as the cherry's "stem." Now illegal in the United States.

Cherry bomb

Clay-sealed firecracker:
Firecracker sealed with plugs of clay at the ends.

Crimped-end firecracker:
Firecracker sealed by bending the firecracker's rolled paper tube inward over the open ends.

Double Bang (also called **Double Sound** or **Double Voice**):
These are double-chambered crackers that were stood on end. The first explosion would fire it into the air and then the second shot would go off in the air.

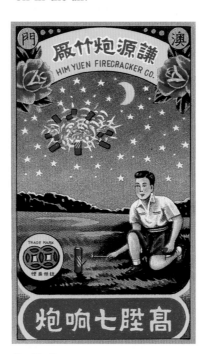

Double Bang
Him Yuen Firecracker Company
Made in Macau, Class 2

Emperor pack:
A string of firecrackers symbolically representing Chinese society before the twentieth century. Each pack contained many red shells representing the common people, and one or two green and yellow crackers representing the government and emperor, respectively.

Flashlight cracker:
A name given to differentiate the new flash powder firecrackers from the old gunpowder ones.

Flash powder:
A more explosive formulation (originally developed for photography) that replaced gunpowder in firecrackers early in the twentieth century. With added metal powders and faster oxidizers, flash powder gives a louder, stronger, brighter explosion.

Fuse:
In the case of firecrackers, a delicate twisted roll of Chinese tissue paper filled with a train of powder to give the user time to get away before the firecracker explodes.

Gunpowder:

The original explosive charge for fire-crackers from a millennium ago. It was supplanted early in the twentieth century by flash powder, a more powerful explosive. Gunpowder is made of saltpeter (potassium nitrate), sulfur, and charcoal.

Ladyfinger:

These were the thinnest and most diminutive of firecrackers, measuring seven-eighths of an inch long.

Loose pack:

A pack containing unbraided firecrackers. A stick of punk to light the cracker was provided in the space normally occupied by the braiding. American Way was a popular brand.

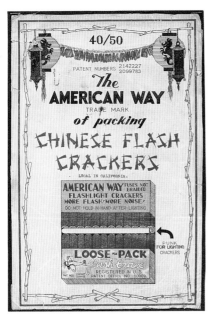

The American Way (loose pack)
Ace-Clipper Export & Import
 Company
Made in China, Class 1

Mandarin Cracker:

Also called a "Chinese cracker." This firecracker was a precursor to the modern-day firecracker. It contained black powder and was sealed with clay or tied shut with silk string.

M-80:

Originally designed for military use as a "gunfire simulator," this salute was one and one-half inches long, with a lacquer-coated fuse coming out of its center. M-80s contained sixty times the amount of powder that is now legal.

Pack:

Firecrackers, usually numbering sixteen or twenty, in a small rectangular package. Packs may contain anywhere from four to four hundred crackers.

Pack label:

The label that goes on the pack to identify the brand and attract the buyer's eye.

Pack wrapper:

The colored glassine paper wrapped around the pack.

Penny pack:

A small, unbraided pack of four to eight firecrackers that once cost only a penny. That price went up to a few pennies in the 1930s and 1940s.

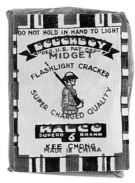

Doughboy (penny pack)
Halco
Made in China, Class 1

Punk:

A slow-burning lighting stick, shaped like a stick of incense, used to ignite firecrackers and fireworks.

Salute:

An extra-large, extra-powerful exploding device, now illegal in the United States.

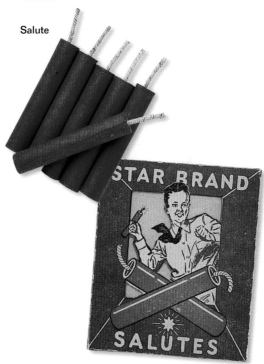

Salute

Shell:

The firecracker's hollow rolled-paper tube. The paper comprising the shell can be red, brown, or, in the case of a "begonia cracker," multicolored.

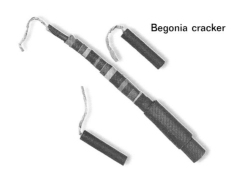

Begonia cracker

Shell wrap covers
firecrackers.

Shell wrap:

The decorative outer paper that goes
around the firecracker's shell. Most
shell wraps are generic, geometric
patterns or solid colors. A "logo" shell
wrapper has words or pictures identi-
fying the brand name, such as Zebra
stripes in the case of Zebra Brand.

String of crackers:

Firecrackers braided together with
hemp rope, designed to go off in a
continuing barrage of sound. For cele-
brations and to usher in the Lunar
New Year, the Chinese use a two-
layer string of firecrackers suspended
vertically and crowned by a hexagonal
box of firecrackers called a Po Goi
or "hex-head." These strings are
currently sold in ten-thousand- or
fifteen-thousand-cracker units.

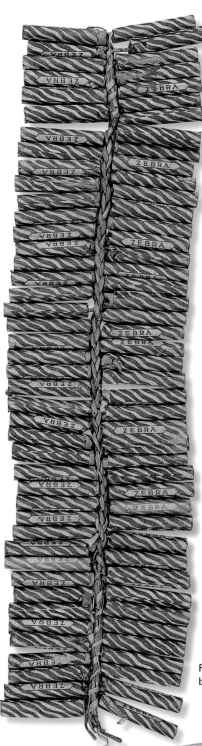

Firecracker string with Zebra
brand logo shell wrap.

RESOURCE GUIDE

ART

Firework Art Display
2955 Lakeside Drive, Suite 314
Reno, Nevada 89509
(775) 829-PYRO
Chinese firework label collages. Art works by James McNulty have been exhibited in the Pacific Asia Museum in Pasadena, California, and the Chinese Cultural Center in San Francisco.

COLLECTING

July 4th Auctions
Kevin M. Hurt
P.O. Box 6185
Battlement Mesa, CO 81636
(970) 285-7041
J4Antiques@aol.com
Specializing in Fourth of July memorabilia auctions, including old firecracker packs, labels, and fireworks items.

Manochio Enterprises
P.O. Box 2010
Saratoga, CA 95070
(408) 996-1963
Manochio@aol.com
Internet auctions of firecracker labels and fireworks memorabilia.

George Moyer
403 Adams Street
Pottsville, PA 17901-3620
(570) 622-3640
Venom1@pottsville.infi.net
Private collector and buyer of firecracker labels and firecracker memorabilia.

FILM

Red Firecracker, Green Firecracker, directed by He Ping, written by Da Ying, starring Ning Jing and Wu Gang. English Subtitles. 111 minutes, distributed by October Films.

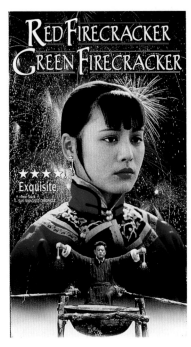

This movie takes place in prerevolutionary China, circa 1911. It uses firecracker explosions as both stunning spectacle and far-reaching metaphor. A beautiful daughter is bequeathed the firecracker factory of her deceased father, but a proviso is attached that she never marry. Enter a roving artist, an independent spirit who becomes the daughter's lover. There are a number of confrontations spawned by the spirit of the artist and the factory hierarchy. The final test of their love is set within the bounds of a spectacular firecracker contest between her two suitors: the artist and the factory foreman.

MANUFACTURERS AND IMPORTERS

Beihai Fireworks and Fire Cracker I/E Corp.
10th Floor, Foreign Trade Building, Sichuan Road
Beihai, Guangxi, China
Fax: 011-86-779 3032482
Exclusive marketing agent for Dragon, Flying Dragon, Link Triad brands.

B. J. Alan Fireworks Company
555 Martin Luther King Jr. Blvd.
Youngstown, OH 44502
(800) 777-1691
Producers of Phantom brand firecrackers.

Cassorla Bros., Inc.
Steven and Earl Cassorla
1223 7th Avenue
San Francisco, CA 94122
(415) 661-5674
Producers of Roller Coaster brand firecrackers.

Fire Art Corp.
Rex Powell
P.O. Box 1041
Clearfield, PA, 16830
(814) 765-5918
Exclusive marketing agent for Standard Fireworks, Ltd. (Sivakasi, India).

Golden Gate Fireworks, Inc.
Ralph Apel
360 Post Street, Suite 705
San Francisco, CA 94108
(415) 399-9261
www.blackcatfireworks.com
Exclusive marketing agent for Black Cat fireworks and firecrackers.

ORGANIZATIONS

American Pyrotechnics Association
P.O. Box 30438
Bethesda, MD 20824
(301) 907-8181
www.americanpyro.com
Trade association for the firecracker and fireworks industry.

National Council on Fireworks Safety
4808 Moorland Lane, Suite 109
Bethesda, MD 20814
(301) 907-7998
www.fireworksafety.com
Nonprofit organization dedicated to the safe enjoyment of fireworks and firecrackers in the United States. Information concerning consumer fireworks and state laws.

Pyrotechnics Guild International, Inc.
18021 Baseline Avenue
Jordan, MN 55352
(612) 492-2061
www.pgi.org
Nonprofit organization of amateur and professional firecracker and fireworks enthusiasts.

WEBSITES

Artifice: The Firecracker Page
www.cpages.com/crackers
Comprehensive collectible firecracker label website.

Bob Weaver's Fireworksland
www.fireworksland.com
Comprehensive fireworks and firecracker website. Extensive information and dealer listings.

Auctions

www.ebay.com
www.auctions.amazon.com
www.auctions.yahoo.com

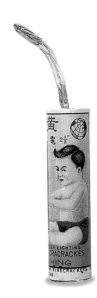

Lucky Boy
Wong Kwong Hing
 Ho Kee Fire Works
Made in Macau

WHOLESALERS AND RETAILERS

American Promotional Events, Inc.
4511 Helton Drive
Florence, AL 35630
(256) 764-6131

Atomic Fireworks
P.O. Box 190
South Pittsburgh, TN 37380
(800) 247-4713
www.atomicfireworks.com

Gulf Coast Fireworks, Inc.
8161 Rushing Road East
Denham Springs, LA 70726-7817
(225) 664-2503

Island Fireworks Company, Inc.
N. 735 825th St., Island Road
Hager City, WI 54014
(715) 792-2283

Kellner's Fireworks
RD 1 Box 113
Harrisville, PA 16038
(800) 458-6000
www.kellfire.com

Phantom Fireworks
555 Martin Luther King Jr. Blvd.
Youngstown, OH 44502
(800) 777-1691
www.fireworks.com

Schneitter Fireworks & Importing
Company
P.O. Box 248
St. Joseph, MO 64502-0547
(816) 232-3969

Shelton Fireworks Company
P.O. Box 248
Eaglesville, MO 64442
(660) 867-3354
www.sheltonfireworks.com

Thunder Fireworks
7121 Waller Road East
Tacoma, WA 98443
(253) 535-1763

Winco Fireworks
Highway 50 East
Lone Jack, MO 64070
(888) 697-2217

SAFETY TIPS

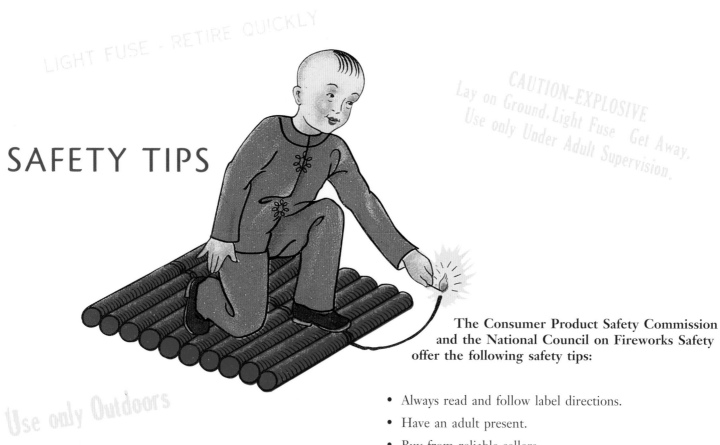

The Consumer Product Safety Commission and the National Council on Fireworks Safety offer the following safety tips:

- Always read and follow label directions.
- Have an adult present.
- Buy from reliable sellers.
- Use outdoors only.
- Always have water handy (a garden hose and a bucket).
- Never experiment or make your own fireworks.
- Light only one firework at a time.
- Never relight a "dud" firework (wait fifteen to twenty minutes and then soak it in a bucket of water).
- Never give fireworks to small children.
- If necessary, store fireworks in a cool, dry place.
- Dispose of fireworks properly by soaking them in water and then disposing of them in your trash can.
- Never throw or point fireworks at other people.
- Never carry fireworks in your pocket.
- Never shoot fireworks in metal or glass containers.
- The shooter should always wear eye protection and never have any part of the body over the firework.

Ding Ho
Wai Chu Factory
Made in China, Class 1

RARITY GUIDE

Pg.	Label	Grade
cvr	Double Dragon	3
vii	Skipper	5
4	Big Bang	2
5	Foor Horsemen	3
19	Navy	1
20	Sun Yat-sen	3
23	Ace-Clipper	4
24	Bango	2
24	Black Cat	1
26	China Bride	4
35	Farewell	3
41	Santa Claus	2
41	Father Christmas	5
41	Geo 'Gia Cracker	2
42	Santa Claus	5
54	Lakshmi	2
55	Dipavali Crackers	3
59	El Caballo	3
60	Red Child	5
61	Superior Mandarin	3
62	Fat Shan Gold label	5

Pg.	Label	Grade
63	Tarzan	5
64	Diabolo	3
64	Conqueror	4
65	Golden Dragon Chop	2
65	Dragon	3
65	Dragon and Tiger	1
66	Griffin Chop	3
66	Unicorn	2
66	Phoenix	3
67	Roger (No Cha)	2
68	The Weaving Maiden	2
69	Fairy Brand (Moon Maiden)	3
70	Maiden	3
70	Maiden	3
70	Golden Bat Brand Maiden	2
71	Peacock Brand Maiden	2
72	Big Boy	3
72	Starlight	3
72	China Town	4
72	Golden Boys	4
73	Yan Kee Boy	2

Pg.	Label	Grade
73	Double Happy	1
73	Noi-Zee Boy	2
73	Koe's Special	5
73	Sunny	3
74	Warrior	3
75	Chinese Warrior	3
75	Silver Knight	4
75	Warrior	2
76	Angel	2
77	Thunder Cloud	5
77	Red Devil	1
77	Baby Giants	4
78	Signal	5
78	Werewolf	5
78	King Kong	2
79	Pioneer	5
79	Robinson Crusoe	3
79	Flying Horse	3
79	Captain Kidd	1
80	Cowboy	1
80	Red Injun	3

Pg.	Label	Grade
81	Buck a-Roo	3
81	Bronco	3
81	Bobco Bill's Cowboy	2
81	Western Boy	1
82	Spaniel	2
82	Camel	3
83	Pelican	4
83	Giraffe	2
84	Camel	2
85	Orientals (Monkeys)	3
85	Zebra	1
85	Black Cat	2
86	Black Bat	3
86	Leopard	3
86	Tiger	3
87	Chang Grand	3
87	Elephant	5
88	Sea-Horse	3
88	Mermaid	5
89	Double Gold Fish	3
89	Alligator	1
90	Blazing Star	4
90	Cats	3
91	Lady Fingers	2
91	China Goo Boy	5
91	Cracker Boy	3
92	Mighty Mite	1
92	Boomerang	3
93	Fish	3
93	Bango	3
93	Triumph	2
94	Space Missile	1
94	Apollo	2
94	Rocket	2
94	Martian	2

Pg.	Label	Grade
95	Saturn	1
95	Rocket	3
95	Rocket Ship	4
96	Sure Fire	2
96	Atomic	4
97	Atomic	1
97	OK	1
97	Big Bomb	1
98	Mar-Hee (Circus)	2
98	Balfour's	5
99	Home Run	4
99	Champ	2
99	Round One	5
99	Touch-Down	4
99	Bravo	4
100	Shot Gun	2
100	Resistance	2
100	Atomic	4
101	Typewriter	5
101	Atomic	3
101	Marine	5
102	Lafayette	5
102	Whango	3
102	Bazooka	2

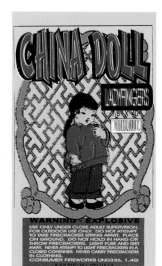

China Doll
Shelton Fireworks
Company
Made in China,
Class 7

Pg.	Label	Grade
103	Victory	3
104	Golliwog	4
104	Picnic	4
105	Dixie Boy	3
106	El Leopardo	2
106	Relampago	2
106	El Pinto	2
107	El Condor	1
107	El Dragon Dorado	2
107	Tjap Matjan	3
108	Peacock	1
108	Red Fort	1
109	Indian Knight	1
109	Anil 3000 Wala Garlands	4
109	Mohini Crackers	4
109	Taj Mahal	1
113	Roller Coaster	1
118	Golden Boys	4
118	Buffalo and Boy	2
118	Turtle	2
118	Devil Dog	1
119	Thunder Bomb	1
119	Olde Glory	1
119	Uncle Sam	1
120	Ibex	5
121	Battleship	5
121	Crax Boy	4
122	Double Bang	2
123	The American Way	5
123	Doughboy	1
128	Ding Ho	4
130	China Doll	1
133	Angel	2
135	Buck a-Roo	3
136	Lion Dance	2

IMAGE CREDITS

Unless noted otherwise, all labels, firecrackers, and ephemera are from the collection of George Moyer.

Principal photography by Richard Blair. Additional photography by Warren Dotz, Tom Weigand, Kelly Boyd, and Pat Fatula.

Front Matter

pg. v Drawing by Esther Hunt, courtesy of Warren Dotz.
pg. vi Woodcut by Paul Frenzeny, courtesy of Warren Dotz.
pg. viii Gulf Motor Oil ad, courtesy of Warren Dotz.

The Origin and Evolution of Firecrackers

pg. 2 Photograph copyright © 1990 by Corbis/Michael Freeman, used with permission.
pg. 4 Green bamboo, courtesy of Warren Dotz.
pg. 5 Pirate cigarette cards, courtesy of Warren Dotz.
pg. 6 Black Cat rockets, courtesy of Golden Gate Fireworks, Inc.
pg. 7 Marco Polo drawing used with permission of Corbis/Bettmann.
pg. 7 Powder Monk woodcut used with permission of Corbis/Christel Gerstenberg.

Firecracker Manufacturing

pg. 8 Photograph, courtesy of Golden Gate Fireworks, Inc.
pg. 9 Map by Masud Husain, courtesy of Studio West Designs, San Francisco.
pg. 10 Photograph used with permission of Corbis/Underwood & Underwood.
pg. 11 Unrolled firecracker, courtesy of Steven and Earl Cassorla.
pg. 12 Photograph copyright © 1995 by Corbis/Nevada Wier, used with permission.
pg. 13 Dyed books photograph copyright © 1994 by Corbis/Mac-duff Everton, used with permission.

pg. 13 Black Cat shell wrap photograph, courtesy of Golden Gate Fireworks, Inc.
pg. 14 *St. Nicholas Magazine* photograph, courtesy of Warren Dotz.
pg. 15 Kwong Hing Tai photograph copyright © 1953 by J. Baylor Roberts/NGS Image Collection, used with permission of the National Geographic Society.
pg. 15 Black Cat fuses photograph, courtesy of Golden Gate Fireworks, Inc.
pg. 16 Black Cat braiding photograph, courtesy of Golden Gate Fireworks, Inc.
pg. 16 Firecracker merchant, courtesy of Philip Wood.
pg. 17 *Puck* magazine cover, courtesy of Philip P. Choy Collection.
pg. 18 *Scientific American* diagram, courtesy of Warren Dotz.
pg. 21 Macau stamps, courtesy of Warren Dotz.
pg. 22 Macau wharves postcard, courtesy of Warren Dotz.
pg. 22 Kwong Hing Tai headquarters photograph, courtesy of Steven and Earl Cassorla.
pg. 25 Black Cat factory photograph, courtesy of Golden Gate Fireworks, Inc.

Chinese Celebrations

pg. 28 Illustration, courtesy of Philip P. Choy Collection.
pg. 29 Po Goi photograph, courtesy of Beihai Fireworks and Fire Cracker I/E Corporation.
pg. 29 Beijing photograph, courtesy of Professor Bo Songnian.
pg. 30 Chinatown postcards, courtesy of Warren Dotz.
pg. 30 Photograph, courtesy of George Ow Jr.
pg. 31 Photograph copyright © by Corbis/Kevin R. Morris, used with permission.
pg. 32 Chinatown postcards, courtesy of Warren Dotz.
pg. 32 Photograph copyright © 1996 by Corbis/Michael S. Yamashita, used with permission.

ACKNOWLEDGMENTS

Special thanks to: Steven and Earl Cassorla for sharing their fire-cracker expertise and some prized collectibles. We will blast their Roller Coaster crackers this Fourth. Carol Stepanchuk for her thoughtful suggestions; her wonderful book, *Mooncakes and Hungry Ghosts*, was an inspiration. Ralph Apel and Christine Shiu of Golden Gate Fireworks for their contribution of wonderful images from Black Cat Fireworks. Chinese-American culture historian Philip P. Choy, who shared his magnificent collection of vintage lithographs. Elizabeth Shrafman for her contribution of Guatemalan firecracker labels as well as the assistance of German Cerezo of the Guatemala Trade Office. James McNulty, who provided his wonderful artwork and rare Fat Shan labels. Lynn Sarkisian, who provided historical insights to our story. A. Chelladhurai, General Manager of Standard Fireworks, Ltd., for his contribution of historical monographs and labels; we toast his lifetime achievement in the fireworks industry. Carolyn and Professor Alan Dundes for loaning their unique Chinese jewelry box. The late Dennis Manochio and the publishers and contributors to *Pyro-Fax*, *The Phoenix*, and *Fireworld* magazines. Liz Zerlin for her field research in Portuguese Macau and Hong Kong. Gerry Rouff, who photographed fireworks stands. Masud Husain, a great graphic artist, collector, and friend.

The authors also wish to thank: Erin Barrett for her research and facilitation; Phil Wood, Kirsty Melville, Holly Taines White, and Nancy Austin of Ten Speed Press, without whom this book would have been impossible; Jean Blomquist for her perfect copy-editing; Huang Yan Hua, Behai Fireworks and Firecracker I/E Corporation, Jim Debonis aka "Mr. Brick Label," Hien D. Hoang; Bing Bing at China Books; Emily Wolff, photo archivist at the California Historical Society; Chinese-American culture historian George Ow Jr. and the Chinese Historical and Cultural Project; Professor David Johnson; Professor Bo Songnian; Professor Lorraine Dong; Jeannie Woo at the Chinese Historical Society of America; Vera Yip and Terry Egan at the Oakland Public Library; David Nielsen at the *Appeal-Democrat*; David Lynaugh at the University of California, Berkeley; Randy Jones; Larry Marks; Fabian Herrera; Patricia Wong; Devra Langford; Heather Marsh-Rumion at Corbis; Connie Chu; and Mary Gay Ducey, Dr. Walt Kirk, and Dr. Dennis Weiss for their wise advice and enthusiastic support.

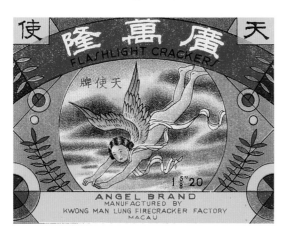

Angel
Kwong Man Lung
Firecracker
Factory
Made in Macau,
Class 2

INDEX

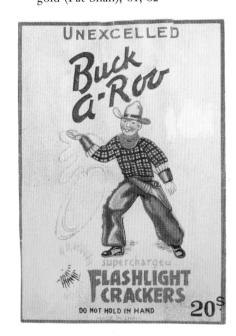

Buck a-Roo
Made for Unexcelled Manufacturing Company
Made in China, Class 1

Lion Dance
Yick Loong Fire Crackers Company
Made in Macau, Class 2

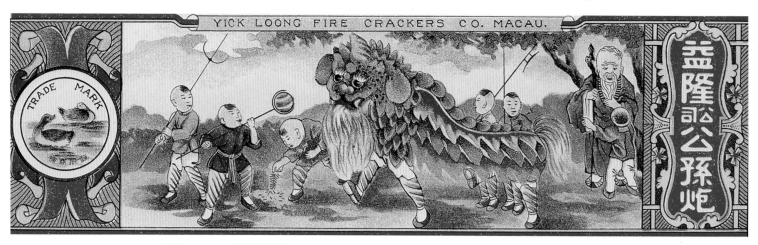